The Hand and the Soul

THE HAND AND THE SOUL

AESTHETICS AND ETHICS IN ARCHITECTURE AND ART

Edited by SANDA ILIESCU

University of Virginia Press | Charlottesville and London

University of Virginia Press
© 2009 by the Rector and Visitors of the University of Virginia
All rights reserved
Printed in the United States of America on acid-free paper

First published 2009

9 8 7 6 5 4 3 2 1

Library of Congress Cataloging-in-Publication Data

The hand and the soul : aesthetics and ethics in architecture and art / edited by Sanda
Iliescu.
　　p.　cm.
　Includes bibliographical references and index.
　　ISBN 978-0-8139-2760-2 (cloth : alk. paper) — ISBN 978-0-8139-2772-5 (pbk. : alk. paper)
　　1. Architecture—Moral and ethical aspects. 2. Art—Moral and ethical aspects. I. Iliescu,
Sanda, 1959–
　　NA2500.H28 2009
　　701′.17—dc22 2008038360

In memory of
Robert Slutzky (1929–2005)

Contents

Foreword

Thomas Jefferson, a key architect of the first modern democracy, made a lifelong study of philosophy and ethics. Aesthetics also played an important role in Jefferson's life and work. A self-taught architect, he designed his Palladian-inspired home Monticello and the original campus for the University of Virginia. Founding the university in 1819, Jefferson clearly recognized the importance of education in a functioning democracy. How appropriate, then, that the seeds for this collection of essays should have been sown at this same public institution, founded by a man who valued both ethical inquiry and aesthetic pursuits.

When I began my deanship at the University of Virginia School of Architecture in 1999, I brought with me many ideas about architectural education. My greatest interest, however, lay in the possible intersection of ethics and aesthetics. How might architectural education embrace both of these complex areas of study, particularly in guiding the design process?

In 2002, with the support of the Institute for Practical Ethics—a university-wide initiative to promote interdisciplinary discussions of ethical issues—the School of Architecture cosponsored the symposium "Ethics + Aesthetics: The Difficult Dialogue." The questions we posed became the seeds of this ambitious book: What if ethical action itself had a poetic potential that brought it within the domain of aesthetic theory? Or conversely, what if we had better means of predicting the ethical outcome of aesthetic

propositions? Of the first inquiry, we recalled the example of the landscape architects Peter and Anneliese Latz, whose innovative reuse of abandoned industrial sites has engendered a specific kind of beauty that moves us with its capacity to recapture a discarded landscape and its historical layers of information. As a means of investigating the second proposition, we examined Zaha Hadid's extraordinary architectural strategies. It is possible to understand Hadid's work not only as a sophisticated formal investigation but also as a fresh approach to urban design—one that addresses the emerging global culture by creating new urban spaces and experiences. A third possibility might be the model in which the grafting of one domain of thinking onto another results in a hybrid condition in which both aspects of the problem emerge throughout the design process. The architecture of Sauerbruch + Hutton, for example, demonstrates that beginning within a serious environmental agenda does not preclude a poetic expression of this value system.

As practitioners and theorists, we recognize the inherent tension in these different starting positions, and it will be our task to construct the *conscious* process of critical thinking that could navigate these desires. This collection of essays documents the beginning of that intention, and it is designed to inspire others both within and outside academia to take up the challenge of addressing these intriguing questions for current and future generations of designers, philosophers, planners, and artists.

Karen Van Lengen
Dean and Edward E. Elson Professor of Architecture,
The University of Virginia School of Architecture

Acknowledgments

I wish to thank the architects, artists, historians, and philosophers who contributed to this book for their tenacious and dedicated work, without which it would not have been possible to do justice to this complex subject. My students at the University of Virginia have inspired me and given me the courage to pursue this project. I am grateful for their energy, passion, and interest in the ideas contained in this book. For her help in making those ideas come across more clearly I wish to thank Holly Jennings, who worked closely with several contributors and provided thoughtful comments and questions to us all. I am grateful as well to my husband, Paul Lipkowitz, for his careful, sensitive work in editing many of the essays and in helping authors recast some of the denser theoretical writing into more graceful and accessible language. My son, Gabriel, I thank for his love and for the boundless patience he showed during the course of this long project.

Introduction

There are so many things in the world—in the cities—so much to see.
Does art need to represent this variety and contribute to its proliferation?
Can art be that free? The difficulties begin when you understand what it
is that the soul will not permit the hand to make.
—PHILIP GUSTON, "FAITH, HOPE, AND IMPOSSIBILITY"

We may well ask ourselves today, much as the painter Philip Guston did four decades ago, what role might art play in the world. Should art reflect contemporary life but refuse to address its many problems? Must it echo the exhilarating variety and contribute to its proliferation? "Can art be that free?" Or should artists and architects recognize, as did Guston, that their work begins when they acknowledge that hand and soul—aesthetic imagination and ethical sensibility—are profoundly intertwined?

Guston's questions, posed during the social upheavals of the civil rights movement and the Vietnam War, suggested that an artist might need to say no, to resist certain aestheticized ways of painting that had become disconnected from the world outside the studio. The problem of how art and life relate remains a thorny one today. In the arts, it is a time of seductive visual surfaces, ceaselessly multiplying yet very often peculiarly disconnected from the suffering and injustice in the world around us. "Artistically as much as politically," laments the art theorist Hal Foster, "almost anything goes and almost nothing sticks." For example, one would hardly know from the 2004 Whitney Biennial that a controversial war was raging abroad. Yet Foster notes, "This relative disconnection from the present might be a distinctive mode of connection to it: a 'whatever' artistic culture in keeping with the 'whatever' political culture."[1] While cynical attitudes may be tempting, they

The Eric Goodwin Passage,
Peter Waldman (with
student assistants Sam Beall
and Justin Walton), 2004

Architecture fulfills more than functional needs. Its forms alone move us and shape our experience of the world. In this memorial pavilion at the University of Virginia, a narrow water passage at the base forms a quiet counterpoint to the open canopy above. "A passage descends into the earth to trace wind and ripple water," writes Waldman. "It is a deliberately useless place, except as a necessary oasis to slow us down: to measure this world as magic, as everyday, as here and now."

can only take us so far. The practice of art and architecture—imagining with thoughtfulness and passion how to reshape materials and invent forms—will always represent acts of hope. The maker of even the most self-referential painting or theoretical architectural study believes that the work of the hand bears relevance beyond itself—that it can illuminate and challenge ways human beings choose to live their lives.

This book explores how ethical considerations may influence the practices of art and architecture. Its essays spring from a belief that artists and designers should not only adopt a critical attitude toward what they choose to make but also allow their ethical deliberations to inform and potentially transform their aesthetics. Such a position does not imply a diminished role for aesthetics or aesthetic objects (implying, for instance, as does a recent international exhibit, that "more ethics" translates into "less aesthetics").[2] Nor does this project seek to moralize aesthetics by claiming that artistic forms reflect fixed or inherent ethical values. It makes the claim, rather, that aesthetics, like ethics, should be regarded as an active, evolving process and as an evaluative discipline that requires a special openness on the part of viewers and makers to events and to circumstances of place and cultural context. This book makes the claim, in other words, that we cannot judge aesthetics solely on the basis of the forms it produces.

In this volume's first chapter, philosopher Richard Shusterman describes the experience of a work of art as an ethical-aesthetic convergence. He argues that when reading a poem or looking at a painting, we do not first appreciate certain peculiarly aesthetic delights and then become aware of ethical thoughts and feelings, or the other way around. Rather we experience "an exquisitely unified synthesis where ethical and aesthetic vision are so interlaced that one can only subsequently distinguish them by refined analytic abstraction." The hand and the soul are similarly convergent in the process of making, a process that overlays perceptions and critical evaluations, intentions and consequences. Even the simplest creative act—dripping brightly colored paint on a white surface or drawing by dragging a stick through wet mud—possesses its own distinctive practical intelligence and ethical awareness. Hardly conceivable as either purely rational or purely moral, our conscience is steeped in the hand's knowledge, in the ways each of us touches, as well as remembers and imagines touching, the world.

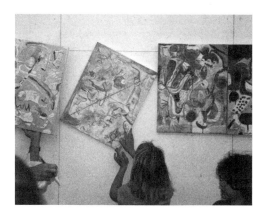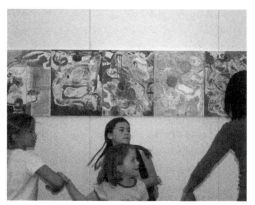

Monster-Making Machines, Third graders from Venable Elementary School, Sanda Iliescu, and students at the University of Virginia, 2006

Artists do not create in isolation; art making is always a dialogue with the work and ideas of other makers past and present. Collaborative projects are one way of highlighting art's social dimension. In this project, students in a graduate seminar worked with a class of third graders. The early paintings of Eva Hesse inspired the collaborative painting sessions. Named by the third graders, the final painting reflected the children's formal exuberance and their unique response to Hesse's own playfulness.

Even theoretical, improbable, or deliberately impractical architectural designs suggest ways individuals might interact—how they move and occupy places, or where (and if) they rest, share a meal, or contemplate the outside.[3] In her chapter, architect Robin Dripps writes, "Whether by intention or accident its [architecture's] artifacts represent possibilities for how people relate to one another and how individuals as well as communities engage the natural world." In advocating for an architecture that embraces both formal abstraction and the poetry of human function, architect Nathaniel Coleman writes, "The difference between an architecture of technical functionalism and one of emotional functionalism is that the first simply attempts to get the job done with a minimum of effort as it appeals to reason alone; the second is technically functional in *addition* to establishing a place for dreams, desires, and the intangible."

In contrast to architecture, the work of visual artists, especially those not

motivated by social narratives, is often assumed to be entirely self-referential and unconcerned with ideas of community.[4] Yet if we consider not the artistic product but the unfolding intentions, motivations, and processes involved in making and experiencing art—if, for example, we see painting, as artist and contributing author Thomas Berding has suggested, as existing "more as a testing of ideas, than as a displaying of them"[5]—then artistic engagements, as much as ethical ones, depend upon actual and implied communities. Human beings make ethical choices by evaluating and justifying potential actions with respect to others; similarly, artists make aesthetic choices and judgments that respond to the work and ideas of others. An artist might make studies that reinterpret Eva Hesse's drawings or collaborate on a painting project with a group of children. Both kinds of engagements depend on expanding networks of relations and common grounds of shared experience and knowledge. That there are multiple such grounds, which may or may not be widely accepted and which often oppose or resist each other, does not invalidate their essential roles. Like the architect, the visual artist thirsts not so much to be understood but to substantiate a profoundly ethical wish to belong—a wish that involves both participation and resistance, "both genuine belief in community and fear of the conformity a community imposes."[6]

For the cultural theorist Tobin Siebers "the heart of ethics is the desire for community."[7] In this book's afterword, architect W. G. Clark invokes a similar conception of ethics as desire: "We want our habitats and artifacts to become part of the place and to substantiate our wish to belong." Yet Clark's essay also includes another stricter sense of ethics as responsibility, as an obligation on the part of the architect to contemplate not only what buildings offer us in the way of practical use and aesthetic delight but also what they may take away or disturb. Clark discusses a mill near his hometown in rural Virginia.

> It was a tall timber structure on a stone and concrete base that held the waterwheel and extended to form the dam. One did not regret its being there, because it made more than itself; it made a millpond and a waterfall, creating at once stillness and velocity; it made reflections and sound. There was an unforgettable alliance of land to pond to dam to abutment

to building. It was not a building simply imposed on a place; it became the place, and thereby deserved its being, an elegant offering paid for the use of a stream.

The mill's stone and concrete wall reflects a practical and an aesthetic economy, its useful form heightening and multiplying our senses of the river. These seamless integrations of sensory delight with practical utility, and building with setting, evoke a more general sense of connectedness. For Clark, the mill becomes a gesture of atonement for the waste, pollution, and other destructive consequences of civilization. Architecture's "promise of happiness" springs here from its potential to compensate for senseless acts and reconcile human beings to themselves and the world.

Our desire for community seeks not only fellowship with other human beings but a connection with the broader physical world. It is becoming increasingly clear that this "world" includes interrelated ecological, technological, and cultural forces, and that subdividing such a world into strictly "natural" or "man-made" categories is not useful. Aesthetically, such an awareness of connections among diverse phenomena is hardly new, and we need only examine, for instance, Leonardo's lifelong series of landscape studies, which portray human settlements as profoundly intertwined with natural forces. In this sense the stream in Clark's essay is, and has always been, already altered: a river in flux, whose edges are impossible to fix and whose banks and bedrocks are continually transformed as much by human construction and destruction as by floods, storms, soil erosion, or the emergence of new invasive vegetation.

Yet unlike Leonardo's sense of the landscape, our contemporary vision includes a new awareness that human beings hold powers to modify and possibly ruin fragile balances, "thereby ruining our own lives, or more probably those of our descendants."[8] Architect Steven A. Moore and planner Timothy Beatley remind us in their essays that buildings play a major part in the problem of global warming, that architecture accounts for nearly half of greenhouse gas emissions, and that major cities such as London require land areas or ecological footprints three hundred times their physical size to sustain the lifestyles of their citizens. For Moore, our current situation is full of risk: a precarious condition that includes not only recently understood

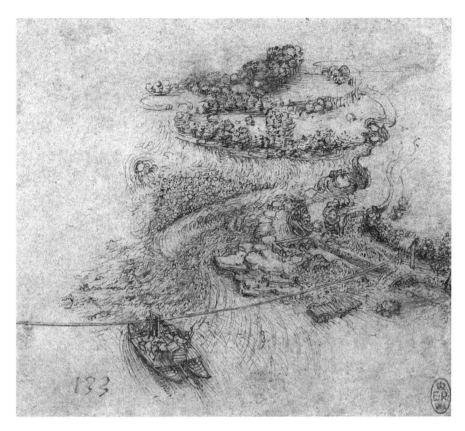

Leonardo da Vinci, *River with Rope Ferry, Bird's Eye View,* ca. 1503 or later

ecological threats but an overwhelming accumulation of age-old social, economic, and political ills. "Three years after the twin hurricanes, Katrina and Rita, ravaged the Gulf Coast in 2005," writes Moore, "housing is grossly inadequate, residents still worry about the adequacy of the levees, and the lingering environmental hazards unleashed by the storms pose significant health risks, especially to the poor and most vulnerable."

As artists and architects, we must construct aesthetic paradigms that reflect our current awareness of an extraordinarily difficult situation—one

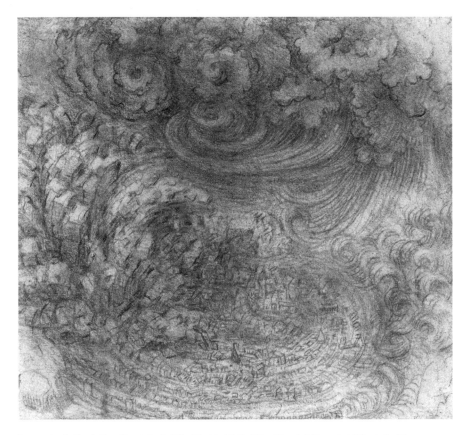

Leonardo da Vinci, *Cloudburst: End of the World with Swirling Clouds & Town Laid Waste by Waves,*
ca. 1515

of unprecedented ecological dangers and continuing human suffering. Yet
our new artistic paradigms need not rely on radical ruptures with history
but rather may emerge developmentally from past ways of seeing. Architect
William Sherman's poetic concept of the wall as transparent mediating fil-
ter reaches back to ancient myths of architecture as a social space defined
not by literal, constructed boundaries but by the warmth of the bonfire.
Like Sherman's "fire wall," the open-ended fields with ambiguous, porous
edges and nuanced figure-ground reversals that Robin Dripps discusses in

Renaissance frescoes, Marey's photographic "motion studies," and the architecture of Zaha Hadid offer compelling new ways of imagining places and forms—ways that have the potential to reflect as well as critique our contemporary situation.

In their chapters, architect Nathaniel Coleman and artist Thomas Berding argue that neither aesthetic nor ethical thoughts and emotions may be relegated to the background of our consciousness. Nor can either function as dominant figures for too long. Like the open-ended grounds and mediating figures that Dripps discusses in her essay, the ethical and aesthetic qualities of experience might be imagined as overlapping transparent layers, each holding multiple figural potentials.

Authors in this collection develop different metaphors and visual models for exploring the ethics-aesthetics relationship. Richard Shusterman speaks of an "intertwining" or "interlacing" of multiple threads that, like strands of a rope, wrap around each other, composing a synthesis. Steven Moore argues for "simultaneity"—for designers, planners, and theorists to simultaneously address diverse and potentially conflicting issues. In a diagram that recalls Leonardo's *Vitruvian Man,* Moore defines sustainability as a democratic, transdisciplinary discourse concerned with relationships among four distinct interests: ecology, economics, ethics, and aesthetics. In an argument that expands Umberto Eco's 1962 concept of "the open work of art,"[9] Phoebe Crisman defines a process of architectural composition that celebrates fluid, serendipitous ethical-aesthetic intersections. Crisman argues for an "open" design process in which diverse factors such as a project's physical site, social history, or functional and structural requirements interact with and challenge each other without the restraints of an "a priori" aesthetic agenda. For Elissa Rosenberg, our understanding of the world's interrelated ecosystems suggests a need for a similarly nonhierarchical landscape aesthetic that does not overvalue the beauty of idyllic "countryside" over that of urban or industrial environments. Planner Timothy Beatley also advocates an inclusive and nonhierarchical aesthetic in the experience of the city. "Every space, every venue, every pole, every park and parking deck," Beatley writes, "represents the possibility of injecting exhilaration and invoking contemplation. Every crack in a façade or sidewalk can express and celebrate the wildness and beauty all around."

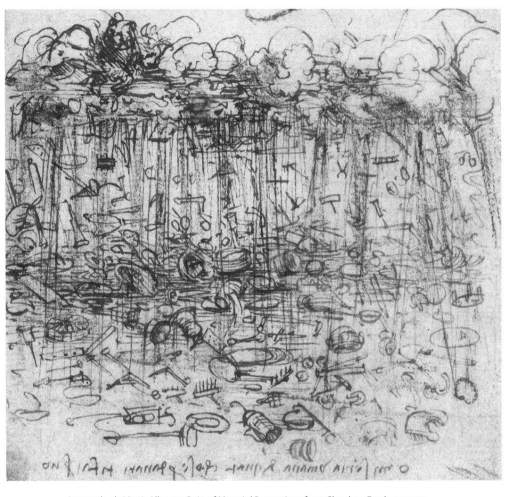

Leonardo da Vinci, *Allegory: Rain of Material Possessions from Clouds to Earth,* ca. 1498

In outlining beginnings for a "lyrical ethic" in contemporary art and architecture, this book brings together authors who differ widely in their areas of expertise, research methodologies, and writing styles, and who occasionally rely on divergent ethical and aesthetic premises. In the disciplines of art and architecture, spanning as they fluidly and unpredictably do from the production of handheld artifacts to vast landscape structures and from theoretical investigations to the humblest levels of practice, this broad field seemed necessary—a precondition of the effort to disentangle nuances and complexities in the ethics-aesthetics overlap and to discern without professional complacencies where risks of confusion or obfuscation might lie.

The literary critic Charles Altieri recently criticized academics responsible for the wide proliferation of "ethical" pronouncements over the past two decades: "Our claims to understand and use ethics seek a self-promoting and perhaps an unwarranted dignity for what we do, while they also displace the domains of pleasures and thrills and fascinations and quirky sensualities that may in fact be what we produce for our clients. At the least then we need a theoretical stance that can acknowledge our self-interest without then succumbing to the temptation to defend ourselves by assuming the mantle of ironic distance."[10] In the two decades since the publication of Tobin Siebers's *Ethics of Criticism,* it has perhaps become too convenient to invoke ethics. What is more difficult is to reject cynicism and attempt to bring one's ethical sensibility to bear on one's aesthetic practices while also taking seriously the real dangers of the theoretical manipulation of art, of reductive, self-serving conflations of moral and aesthetic qualities.

Aesthetics, Ethics, and Morality

The word "should" in Socrates' ethical question "how should one live?" appears antithetical to the freedom and subjectivity of the aesthetic mode of attentiveness.[11] Yet, while Plato condemned mimetic art and banished poets from his ideal Republic, his views were equivocal, as his philosophical search relied on aesthetics, though not art or artists, as an essential motivating and revelatory experience. In Plato's *Symposium,* the desire for beauty is the source of philosophy, an exquisite ladder reaching toward the ideal good.[12]

In the modern West, it is only with Kant that aesthetics becomes decisively

severed from the intentionality of practical-moral judgment. "Flowers are free natural beauties. Hardly anyone apart from the botanist knows what sort of a thing a flower is meant to be; and even he while recognizing it as the reproductive organ of a plant pays no attention to this natural purpose when he judges the flower by [aesthetic] taste."[13] In contrast to disinterested aesthetics, Kant's moral judgment concerns purposes, actions, and intentions. Whereas in aesthetics there can be "no objective rule of taste," moral inquiry, at least for Kant, is founded upon generally applicable principles. We can, for instance, ask ourselves, "What if everybody did that? If the answer is that something would go especially wrong if everybody did it, then we are supposed to feel badly about it."[14] In claiming an exemption for ourselves that we might not allow for people in general, we would act unethically. From "the golden rule" to Kant's categorical imperative or Jeremy Bentham's utilitarianism,[15] Western philosophy offers diverse methods for determining moral value. Kant's enduring aesthetic "purposelessness" seems to oppose them all. It is hardly possible to argue rationally why one flower is more beautiful than another.

Aesthetics, however, is by no means reducible to questions of beauty, just as ethics does not always invoke Kantian morality. In their long, complicated histories the two terms have acquired many meanings. In aesthetics, for example, we might not inquire whether a flower is more "beautiful," but rather whether it is more "fitting" in a specific situation. In its context, a flower may be "appropriate" or "moving" or "startling," none of which are the same as "beautiful." Some aesthetic criteria do not concern sense perceptions: choosing one flower over another (for example, dandelions instead of roses) may render it "provocative" or "original" or "authentic," all qualities dependent on cultural context. Similarly, ethics should be understood to mean more than "goodness." John Dewey, for instance, differentiated three independent ethical variables: the good (concerning happiness, pleasure, and self-realization), the virtuous (implying widespread feelings of admiration and approbation), and the right (concerned with the law, reciprocal rights and duties).[16] Just as independent ethical criteria may conflict (what is pleasurable may not be what is right; what is virtuous may not promote happiness), so aesthetic qualities may be mutually exclusive. Elissa Rosenberg's chapter, "Gardens, Landscape, Nature," shows that in the history of

landscape architecture the "sublime" emerges as oppositional to other aesthetic considerations. For Rosenberg, the park designs of Peter and Anneliese Latz are fittingly harmonious and profoundly moving precisely because they are not "sublime," their aesthetics subverting the concept of the work of art that refuses to open, that "closes in on itself in indifference, cold splendor, and silence."[17]

Richard Shusterman points out that both ethics and aesthetics encourage, indeed depend upon, the proposal and contestation of rival definitions and standards. We evaluate ethical and aesthetic worth, not through a blind application of a priori rules, but by carefully considering a particular situation's unique properties in relation to general principles. In a process that is neither formulaic nor predictable, we summon past experiences and exercise our intuition, imagination, and taste. Since aesthetics entails complex evaluations and the weighing of alternatives, artistic practices can play educational roles in ethical systems. Confucian philosophy, for instance, relies on music and ritual for establishing and preserving ethical harmony. In Eastern philosophies, Shusterman notes, ethical virtue tends to exercise its power not though moral commandments but by inspiring emulation and love. Moved by acts of compassion, delicacy, or kindness, the ethical individual seeks to "stand shoulder to shoulder with" virtuous persons, much as an artist attracted by an artwork might emulate its aesthetics. Such ethical and aesthetic engagements stress not duty and guilt but free will and the construction of imaginative analogues carefully attuned to the circumstances of a particular situation.

Compared to Confucius's embrace of aesthetic practices or Plato's "desire for beauty," modern Western examples of ethic-aesthetic mergers may appear moralistic or reductive. In her chapter, historian Joan Ockman discusses "Ornament and Crime," in which the designer Adolf Loos linked architectural decoration to "inferior" groups such as primitives and criminals that tattoo their bodies, or women with their "ingrained penchant to adorn themselves." While for Loos ornamentation was a sign of moral debasement, for his contemporary Louis Sullivan it belonged, still as a feminine attribute, to a higher realm valuing individuality and fantasy. Sullivan envisioned an architectural synthesis of sensuous ornament and rational engineering that would advance American society toward a more democratic way of life.

Ockman notes that the dramatic difference between Loos and Sullivan is a compelling example of the situational nature of ethics-aesthetics links. Both architects challenged certain limiting assumptions in their cultural milieus: Loos's rejection of ornament can be appreciated in the context of a decadent Viennese society that deliberately repressed art's social and political content, while Sullivan's embrace of decoration is best understood when viewed alongside America's "hard-nosed commercial metropolis schooled in the stockyards."

Notwithstanding its role in Loos's development of an exquisite syntax of architectural forms, the conjunction of "ornament and crime" brings to mind disturbing notions of eugenics and ethnic purity. Even less moralizing artistic agendas that challenged limiting or exploitative conditions by linking moral and artistic ideals have led to perversions and abuses. In the light of examples such as Nazi propaganda art, or contemporary advertising's manipulative conflations of ideas of "beauty" and "goodness," the essential separateness of ethics and aesthetics merits serious consideration. In his chapter, "Ethics, Autonomy, and Refusal," Howard Singerman explores historical and theoretical aspects of aesthetic autonomy. In contrast to the ethical individual who owes certain things to others and expects being owed in return, the aesthetic subject is free to resist or deny the "other," turning inward to experiences of delight or awe. Coming full circle from Plato's banishment of irresponsible artists, Singerman argues for their binding ethical responsibility to choose exile by refusing participation in corrupt, cruel, or debasing communities. For example, as a protest to his government's oppressive practices, Venezuelan artist Javier Tellez withdrew from the prestigious 50th Venice Biennale. For Singerman, however, this ethical-political gesture remains separate from Tellez's aesthetics. The ethical, writes Singerman, is "primarily a responsibility, a first and binding responsibility that precedes and even precludes freedom, aesthetic or otherwise."

Significantly, theories arguing for aesthetic autonomy also emphasize notions of ethics as morality. Although both ethics and morality derive from custom or habit (*ethos* in Greek, *mores* in Latin), morality is usually reserved for inquiries into the specifics of particular systems of rights and responsibilities, while ethics is open to multiple and more general ideas of how to live. Shusterman notes that not only was Kant the philosopher who most

decisively distinguished aesthetics from ethical-moral judgment, but he was also the thinker who gave the obligation-based notion of morality its most influential formulation. "The situation is very different in the modern West," writes Shusterman, "where the aesthetic dimension of Greek virtue ethics has been largely replaced by the idea of morality as a comprehensive system of laws, rights, and obligations that should dictate proper behavior." For Howard Singerman, morality and aesthetic taste are two kinds of "bindings": the moral binding of self to others, and the very different binding of the artistic object to itself or its own presentation. Conflating these two kinds of "bindings" is a risky proposition. When coupled with aesthetics as narrowly formalized style, restricted understandings of ethics as morality tend to limit the ethics-aesthetics relation to narrow applications in specific contexts. Decontextualized links between style and morality become reductive prescriptions, such as notions that decorated (or undecorated) architecture—or abstract (or representational) painting—are morally inferior.

Yet Singerman points out that even within the discourses of moral imposition, of the "should" or "ought," art may at times mirror ethics, but only from a distance and as metonymic reflection. "Once a painter who accepts the basic premises of modernism becomes aware of a particular problem thrown up by the art of the recent past," wrote Michael Fried in 1965, "his action is no longer gratuitous but imposed." For Fried, modern painting is simultaneously autonomous from the concerns of society and ethically evocative, its poetics taking on "more and more of the denseness, structure, and complexity of moral experience—that is, of life itself."[18]

But artistic positions are rarely a matter of choosing either strict autonomy or radical social engagement, just as ethical experiences and deliberations do not always entail strict distinctions between ethics as moral obligation and ethics as virtue based on emulation and free choice. In caring for a sick parent, a daughter's or son's sense of responsibility may be interlaced with feelings of empathy and love. Similarly, modern artists and designers struggled to construct alternatives and find balances between ideas of art as an untethered aesthetic enterprise and as ethically relevant activity. As Joan Ockman shows, although formalism has been maligned as a retreat into an autonomous safe haven, it could also represent critical, reflective positions that continued to develop ethically evocative narratives while acknowledg-

ing the foreclosure of direct political and social action. The artists and de-
signers Josef and Annie Albers, for example, defined an open, lyrical ethos
of abstraction. In a direct analogue between the space of abstract painting
and an egalitarian, democratic society, Josef Albers argued that every square
inch of a painting is equivalent to every other square inch. Similarly, textile
designer Annie Albers's interweaving of precious materials such as silver or
silk with common, inexpensive jute or sackcloth accomplished a delicate,
complex synthesis of beauty and hope—of aesthetic precision and the dream
of an equitable, open, and fair society.

The Distancing of Theory and Practice: Postmodernism and Cynicism

"Postmodern knowledge," wrote J.-F. Lyotard in 1979, "refines our sensibil-
ity to differences and increases our tolerance of incommensurability."[19] Yet
despite Lyotard's early emphasis on *sensibility,* postmodern critics over time
became increasingly disinclined to address aesthetics and the senses.[20] In
developing ethically ambitious agendas that challenged the dominant ide-
ologies of the modern West, postmodern theory tended to focus on art's
social and political content, while de-emphasizing tangible forms and the
phenomenology of perception. For artist Thomas Berding, this "dissociation
of the theoretical and the sensory, and the realm of action from the realm of
thought" is exacerbated not only by theory's "hermetic and hyper-rational-
ized" character but also by our contemporary fascination with technological
innovations that appear to negate the need for sensory, embodied experi-
ences.[21] This disjunction between what the Greeks called "noēta" (imma-
terial concepts that cannot be apprehended by the senses and can only be
thought) and "aisthēta" (material concepts directly related to sense experi-
ence or "aisthesis") can hardly be constructive and may have led to mutual
diminishments.

In contemporary architecture, there are signs that schisms between criti-
cal theory and aesthetic practice are deepening. In his 2004 essay "Critical-
ity and Its Discontents," the architecture theorist George Baird noted that
prominent architects have become disenchanted not only with particular
theories but also, more worrisomely, with intellectual critique itself. In 1994
the architect Rem Koolhaas declared that there was "in the deepest motiva-
tions of architecture something that cannot be critical." More recently, the

educator Michael Speaks attacked the "resistance" of critical theory in favor of a "new, alternative and efficaciously integrated architecture that would take its cues from contemporary business practices."[22] Not unlike the contemporary art market, architecture seems ready to assign mute, even anti-intellectualist roles to designers whose work is increasingly idealized as ineffable, beyond the power of words to illuminate or critique.

The distancing of practice and intellectual critique seriously hinders many contemporary efforts to formulate substantive relationships between ethical ideas and aesthetic practices. Two recent international exhibitions, one in architecture, the other art, offer typical examples of the kind of superficial and tendentious arguments that can accompany practitioners' attempts to align themselves with what has come to be known as "the ethical turn" in the humanities.

Titled "Città: Less Aesthetics More Ethics," the 2000 Architecture Venice Biennale envisioned a utopian future that was as sublime as it was uncompromising.[23] The exhibit's curator, designer Massimiliano Fuksas, advocated a heroic disregard for the past, along with what may be described as a nostalgia for an information-driven future. Fuksas's preference for "constantly mutating urban magmas" and "virtual architecture and its shapeless, liquid masses" was less an ethically inspired choice than a purely visual fascination: the buttressing of an aesthetic style with unrelated moral claims. In the exhibit's "search for a new house for Man," cities from Bogota to Bucharest and Budapest appeared strangely alike, reduced to intangible phantasms "seen" from a space station.[24] Meanwhile, the predicament of individual human beings living and suffering in particular places and social situations went largely unexplored. Instead of asking specific questions and offering tangible insights, the biennale's most successful moments were certain poignant aphorisms, for example, one offered by French designers who stated that "the function of the ethical was to bury the political."[25] Yet if the "political" was dead, the "ethical" as articulated in this exhibition could have hardly claimed much vitality. The complex desire for community was reduced to little more than an anxiety on the part of designers at being left out, a fear of occupying the margins of dominant technological and economic flows.

In the art world, self-serving "ethical" rhetoric has been similarly deployed as a replacement or sublimation of politics. Howard Singerman notes

that ethics in recent art discourse is often gutted to mean "politics without a target or rift, and community without identity or membership or exclusion." For instance, Francesco Bonami, curator of the 2003 Venice Art Biennale, quoted Martin Luther King's "I Have a Dream" speech as he advocated art's "creative irrelevance to attack the absurdity of war, violence and discrimination."[26] It was difficult, however, to discern from Bonami's essay whether art was "irrelevant" or "powerful," or what its specific relation to politics and economic power might be. Bonami's long list of persecuted, disenfranchised groups (from homosexuals, to women, to Iraqis, to Palestinians) was so vastly inclusive as to be meaningless. Like its architectural counterpart, this exhibit displayed some worthy projects yet failed to illuminate how aesthetics might contribute to ethical or political thought.

Aside from unsubstantiated and often self-promoting claims to a moral position, what might we discern in the two biennales just discussed—or for that matter in other recent exhibitions? What lies beneath the dazzling visual spectacle of smoothly flowing, digitally manipulated surfaces or the cool juxtapositions of shocking cut-and-paste imagery? What, in other words, is the ethos of our contemporary artistic practices? In the best of cases, it is an elegant cynicism: the intellectual position of sophisticated practitioners adopting what Charles Altieri called "the mantle of ironic distance." At the conclusion of her chapter, Joan Ockman poignantly describes this new cynical attitude as an "intellectual stance in which one understands the disparity of power and pain in the world but behaves as if there were nothing to do about it."

Contemporary Dilemmas

In late 2004 the main public hall of Philadelphia's 30th Street train station was transformed by enormous black banners, forty by sixty feet each, hung from the stone walls. Against carefully proportioned fields of darkness, gray pigeons usually flying through the hall seemed to glide more slowly and gracefully in a landscape inspired by minimalist art. That this was an advertisement was not immediately clear. Blocks of text in crisp, white letters addressed visitors not as consumers but as people whose emotional lives needed public validation. "For once you'll know exactly what she's thinking," promised one text; "Imagine the resolutions she'll make," whispered

another. The logo "A diamond is forever," in small letters discreetly placed at the bottom of each banner, made the sales pitch clear. The viewer might have been forgiven for asking what this all meant—why such a presumptuous, self-serving display should take over a public space.

Regardless of our intellectual or moral defenses, debased ethics-aesthetics conjunctions are becoming inescapable, infiltrating our every waking moment and no doubt our dreams and nightmares as well. In the train station installation an impoverished ethic (manipulating what another "thinks") is merged with a cool, nonobjective visual presentation. This aesthetic is not arbitrary: the neutrality of stark block letters insinuates an "objectivity" confirming supposedly real, practical consequences in the viewer's life, in how "he" knows and controls others. Yet how exactly aesthetic forms (vast black surfaces, or a diamond's permanence or luminosity) are supposed to accomplish this, is not addressed. Viewers are encouraged neither to examine ethical ideas on their own terms nor to judge the merits of their implied relationship to aesthetics in terms of a particular life situation. Ethics and aesthetics are not transparent but singularly opaque, incapable of interfering with or challenging each other. Potential interplays between ethical and aesthetic qualities of experience—the exciting give-and-take and mutual resistances—are foreclosed.

Enhanced by fascinating visual surfaces, even worthy intentions may slip into seductive symbolism and comforting moral certainties. Just as easily, virtuous agendas can obscure the essential aesthetic aspects of art or architecture. It becomes difficult, for example, to question an award-winning "sustainable" design or a building celebrating Native Americans' profound respect for nature. It may be even harder to evaluate genuine attempts by contemporary artists to challenge the divide between art and everyday life by orchestrating literal interactions between artist and audience. In his 1992 *Untitled (Still)*, Rirkrit Tiravanija cooked and served Thai food to gallery visitors, thus subverting lingering notions of art as objectified presentations staged in "white box" galleries. Yet while smelling the aroma of cooking food and sharing a meal are potentially rich ethical-aesthetic experiences, relationships between artist and audience are not so predictable. What if a visitor is sick, having approached the gallery seeking relief from the nausea of cancer treatments? Moreover, it is not such a great leap from

enticing audiences with free food to implying certain types of relationships are authentic or "cool" and therefore better than others. The art critic Claire Bishop shows that "relational" art is itself on the verge of becoming manipulative as it presumes viewers undergo certain communal experiences whose social or ethical worth remains in doubt.[27] What is often not doubtful is that the aesthetics of the making or performing process may be unattended to. As the figure of the intentional author as maker recedes, those of curators or interested institutions grow larger. Like any formalist object, art as "participatory experience" is ready to be coopted by institutions increasingly focused on selling not just products and services, aesthetic or otherwise, but lifestyles—ways of being and relating.

In a culture more inclined to obscure than to illuminate connections between aesthetic form and ethical content, how might artists and architects approach the problem? Ignoring or repressing one approach, the ethical or the aesthetic, always leads to a state of mutual impoverishment. Aesthetics by itself, even as a highly developed formal or phenomenological construct, is always on the verge of becoming a predictable exercise. Untethered and self-absorbed, art becomes even more available for crass reductions to manipulative, seductive signage like Philadelphia's diamond installation.

As Joan Ockman suggests, artists and designers can "problematize" the issue of "good form," of form functioning simultaneously at aesthetic and ethical levels. Such an approach recognizes that connections between aesthetic and ethical ideas cannot be forced or generalized as immutable laws and that the two can most productively engage each other only as free and equal partners, not as one serving the needs of the other—for instance, as aesthetics buttressing particular moral, social, or political agendas, or as ethics promoting arbitrary preferences for a style or artistic method. Difficult to predict and impossible to force, their interactions can only be evaluated within the surrounding atmosphere of a particular place and historical moment.

Paradoxically, ethics and aesthetics can enrich each other by also remaining distinct from one another. The potentially unsettling presence of ethical thought can render tangible forms not only relevant in social, political, or moral senses but also more touching at the subjective level of individual experience. A painting evoking ethical possibilities engages more of our

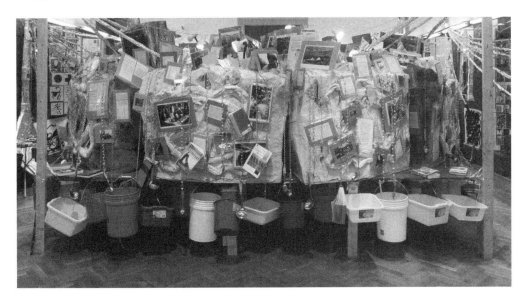

Thomas Hirschhorn, *Jumbo Spoons and Big Cake,* 2000

memories, passions, and thoughts. Similarly, "seen" within an aesthetic medium, ethical deliberations may become more accessible as well as relevant. Ethics may embrace art's tangible specificity along with its rich nuances and ambiguities. The aesthetic mode of attentiveness—its peculiar ability to connect sense perceptions with rational thought—may suggest ways toward empathy or gratitude while facing the "other," and perhaps pity or shock in facing the self.

The contemporary artist Thomas Hirschhorn describes his work as an attempt "to connect what cannot be connected." Occasionally this artist's startling accumulations of raw, common materials—plastic pails, aluminum-foil tentacles, metal chains, shattered mirrors—manage to connect disjunctive forms to each other and to a world outside. In the context of present-day commercialism, planned obsolescence, and waste, Hirschhorn's installations are not unlike the Virginia mill described by W. G. Clark: although their visual surfaces could not be more different, they too substantiate an ethical "wish to belong." Like Hirschhorn, many artists and designers today strive

to articulate an idea that the troubled, conflicted life of the "soul" might yet be reconciled with the crude or vulgar materials our hands may at times touch.

Transparent Overlaps: Notes Inspired by the Work of Robert Slutzky

How then may we understand this paradoxical relationship? How might we imagine tactile or spatial metaphors for the difficult relationship of ethics and aesthetics, these two resolutely independent modes that are nevertheless so profoundly interdependent? Can the things we make and touch with our hands show us how we might "connect what cannot be connected"?

Working in the 1950s and '60s, the painter Robert Slutzky and the architectural theorist Colin Rowe explored a very different paradox, one focused on a purely aesthetic problem: can certain insistently opaque compositions, such as Ferdinand Léger's paintings or Michelangelo's façade studies, be simultaneously experienced as deeply transparent? How can an experience of resolute flatness of paint or stone also imply depth? In their two seminal "Transparency" essays, Rowe and Slutzky distinguished two kinds of visual transparency, literal and phenomenal. Literal transparency, which they discerned in examples such as Robert Delaunay's paintings or Gropius's design for the Bauhaus, implies an awareness of unambiguous depth akin to a superimposition of glass planes.[28] Imagine two fragments of colored glass, one blue, the other yellow. When viewed from certain angles and in certain light conditions, their superimposition forms an entirely new quality of "greenness," a condition that is neither stable nor yet a matter of literal blending. Yet although this "literal" overlap is both fluid and contingent, it does nevertheless imply stable spatial hierarchies (for example, at any one moment either the yellow or blue glass is experienced as in front of or on top of the other). Slutzky and Rowe proposed that, in the aesthetic experience of certain paintings and works of architecture, this see-through awareness of literal transparency is replaced by a very different phenomenal overlap.

At the beginning of the first "Transparency" essay, Slutzky and Rowe quote Gyorgy Kepes:

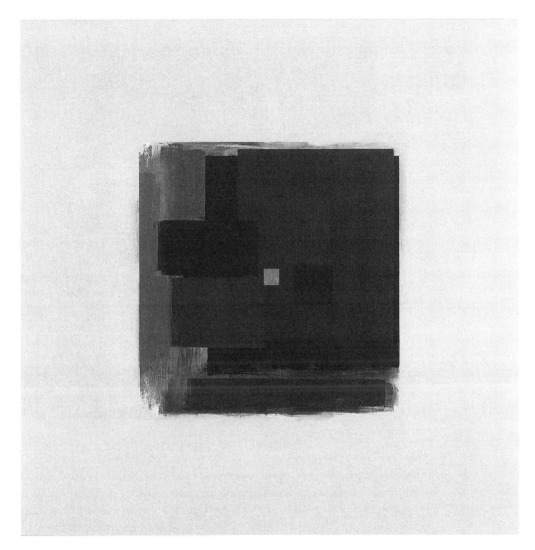

Robert Slutzky, *Untitled E,* 1984. Acrylic on canvas, 64 x 64 in.

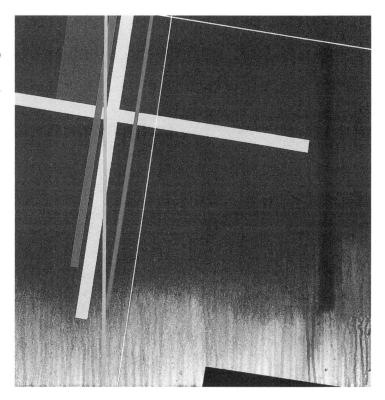

Robert Slutzky, *Untitled Q*
(detail), 1997–98. Acrylic on
canvas, 48 x 48 in.

If one sees two or more figures overlapping one another, and each of them claims for itself the common overlapped part, then one is confronted with a contradiction of spatial dimensions. To resolve this contradiction one must assume the presence of a new optical quality. The figures are endowed with transparency: that is, they are able to interpenetrate without an optical destruction of each other. Transparency however implies more than an optical characteristic, it implies a broader spatial order. Transparency means a simultaneous perception of different spatial locations. Space not only recedes but fluctuates in continuous activity. The position of the transparent figures has equivocal meanings as one sees each figure now as the closer, now as the further one.[29]

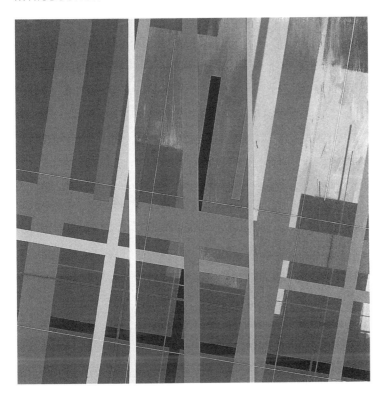

Robert Slutzky, *No. 6,*
1996. Acrylic on canvas,
66 x 66 in.

Phenomenal transparency may be imagined as an overlap of planes, an awareness of stacked parallel layers giving us "a sensation of looking through a first plane of significance to others behind." The spatial location of each plane remains ambiguous, an ambiguity experienced as an oscillation of planes that appear to come forward then recede.

Robert Slutzky's paintings suggest dense substances like granite, slate, or concrete, their insistent opacity emphasizing nonliteral or phenomenal transparencies. When first glancing at *Untitled E* (p. 23), a viewer might imagine several parallel planes: a background set by the painting's peripheral neutral gray, in front of which is the nearer black surface of a monumental dark square, its center pinned by a much smaller, delicate square. Seemingly

Robert Slutzky, *Untitled,*
1999. Acrylic on canvas,
48 x 48 in.

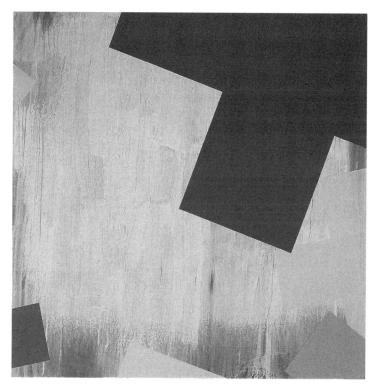

floating in front, this diminutive square suggests a third, front-most plane. Yet the instant it is formulated, this simple spatial structure of background, middle ground, and foreground dissolves. In color, the tiny square holds the same light gray as the background, an equivalence that, once noticed, leads to spatial rearrangements. The gray background may come forward, aligning itself with the little square, while the middle black recedes. The large black square is less a singular figure and more a collection of distant fields, perhaps a view seen through a window at night. At the window's edges are the painting's most vivid chromatic passages, a "frame" of bright slivers nudging against one another where the black and the gray adjoin, where the cut for the window has been made. The viewer might imagine a landscape of multiple, nuanced layers: a bluish black rectangle, a greenish black square, a

charcoal gray sliver . . . No singular blackness or blankness, the night land-scape vibrates, its inhabitants shifting from figures to receding grounds and back to figures again.

Like the multiple spatial configurations in one of Slutzky's paintings, the experience of a work of art or architecture is a complex phenomenon. It has ethical planes and aesthetic ones; how they overlap is a complex, situational condition. A viewer's individual and cultural particularities matter and can never be fully imagined in advance. Depending on who one is, each plane will have its own inner structure and cohesiveness, its own organization of shapes, colors, and textures. In the aesthetic plane one might recognize qualities such as sublimity, balance, and authenticity, each capable of its own peculiar vibrations, while in the ethical plane one might distinguish Confucian virtue ethics along with ideas of Kantian morality. Through windows in one plane we may glimpse areas in another. Occasionally we may encounter alignments or serendipitous convergences: perhaps a perception of an aesthetic quality will echo an ethical configuration. This may cause a change in spatial locations: whereas at first aesthetics was experienced as a frontal, dominant surface and ethics was a recessive background, we now experience the opposite. At times, layers within different planes may appear to oscillate or "fluctuate in continuous activity without the diminishment or destruction of either." Like the eminently flat, resistant color slabs in Robert Slutzky's paintings, which the architect John Hejduk once described as "cities of the mind," planes remain distinct.[30] Aesthetics remains aesthetics, and ethics remains ethics. Despite and also because of this stubborn opacity, we experience a synthesis, a moment of phenomenal overlap: "We enjoy the sensation of looking through one plane of significance to others lying alternately in front or behind."[31]

Notes

The epigraph is taken from a 1965 presentation at the New York Studio School, reprinted in Michael Auping, *Philip Guston: A Retrospective* (Fort Worth: Thames & Hudson, 2003); first published in *Art News Annual*, October 1965, 93.

1. Hal Foster, "An Archival Impulse," *October* 110 (Fall 2004): 3–4.

2. Massimiliano Fuksas, "Less Aesthetics More Ethics," introductory essay to *Città: Less Aesthetics More Ethics*, exhibition catalog for the 7th International Architecture Exhibition (Venice: Marsilio, 2000), 10–17.

3. See Karsten Harries, *The Ethical Function of Architecture* (Cambridge, MA: MIT Press, 1997).

4. See Alberto Pérez-Gomez and Louise Pelletier, *Architecture, Ethics, and Technology* (Montreal: McGill-Queen's University Press, 1994), 3.

5. Thomas Berding, "On The Company I Keep: An Artist Reflects on Art History," *The Art Book* 10 (January 2003): 31.

6. Linda Shearer on Vito Acconci, quoted in Suzanne Lacy, *Mapping the Terrain: New Genre Public Art* (Seattle: Bay Press, 1995), 193.

7. Tobin Siebers, *The Ethics of Criticism* (Ithaca: Cornell University Press, 1988), 202.

8. Simon Blackburn, *Ethics: A Very Short Introduction* (Oxford: Oxford University Press, 2001), 1.

9. Umberto Eco, *The Open Work* (Cambridge, MA: Harvard University Press, 1989).

10. Charles Altieri, "Lyrical Ethics and Literary Experience," in *Mapping the Ethical Turn: A Reader in Ethics, Culture, and Literary Theory,* ed. Todd F. Davis and Kenneth Womack (Charlottesville: University Press of Virginia, 2001), 30.

11. For a discussion of Socrates' question, see Bernard Williams, *Ethics and the Limits of Philosophy* (London: Fontana Press/Collins, 1985), chap. 1.

12. *The Symposium of Plato,* trans. Tom Griffith (Berkeley and Los Angeles: University of California Press, 1985), §211.

13. Immanuel Kant, *Critique of Judgment* (1790), trans. Werner S. Pluhar (Cambridge: Hackett, 1987), §16, p. 76. On Kant's ethics, see Thomas Hill, *Dignity and Practical Reason in Kant's Moral Theory* (Ithaca: Cornell University Press, 1992).

14. Blackburn, *Ethics: A Very Short Introduction,* 100–103.

15. Jeremy Bentham, *An Introduction to the Principles of Morals and Legislation* (Buffalo: Prometheus Books, 1988).

16. John Dewey, "Three Independent Factors in Morals," in *John Dewey: The Later Works,* vol. 5 (Carbondale: Southern Illinois University Press, 1984), 286–87.

17. Emmanuel Levinas, from "Reality and Its Shadow," cited in Robert Eagleston, *Ethical Criticism: Reading after Levinas* (Edinburgh: Edinburgh University Press, 1997), 117.

18. Michael Fried, "Three American Painters" (1965), in *Art and Objecthood: Essays and Reviews* (Chicago: Chicago University Press, 1998), 219.

19. Jean-François Lyotard, *La condition postmoderne* (Paris: Minuit, 1979), quoted in Craig Owens, "The Discourse of Others: Feminists and Postmodernism," in *The Anti-Aesthetic: Essays on Postmodern Culture,* ed. Hal Foster (1983; New York: New Press, 1998), 57.

20. For a practicing architect's reflections on our current aesthetic malaise, see Jorge Silvetti, "The Muses Are Not Amused," *Harvard Design Magazine,* Fall 2003/Winter 2004, 22–33.

21. Here I am thinking of Hal Foster's 1983 seminal volume *The Anti-Aesthetic,* and also of work by visual artists such as Martha Rosler, Jenny Holzer, and Barbara Kruger.

22. George Baird, "Criticality and Its Discontents," *Harvard Design Magazine,* Fall 2004/Winter 2005, 16.

23. Fuksas, "Less Aesthetics More Ethics," 12.

24. "International Space Station: in search for a new house for Man," "Special Projects," Alenia Spazio, in *Città: Less Aesthetics More Ethics*, 388.

25. Jean Novel, François Geindre, Henri-Pierre Jeudy, and Hubert Tonka, "In the Shadow of Ethics," in *Città: Less Aesthetics More Ethics*, 2:70.

26. Francesco Bonami, "I Have a Dream," introductory essay, *Dreams and Conflicts: The Dictatorship of the Viewer*, exhibition catalog for the 50th International Art Exhibition (Venice: Marsilio, 2003).

27. Claire Bishop, "Antagonism and Relational Aesthetics," *October* 110 (Fall 2004): 51–79.

28. Written in 1955–56, the first "Transparency" essay was published in 1963. For a summary of the historical and cultural contexts of the two essays, see Joan Ockman, *Architecture Culture 1943–1968: A Documentary Anthology* (New York: Columbia University and Rizzoli International Publications, 1993), 205.

29. Colin Rowe and Robert Slutzky, "Transparency: Literal and Phenomenal," in Rowe, *The Mathematics of the Ideal Villa, and Other Essays* (Cambridge, MA: MIT Press, 1976), 160–61; quotation from Gyorgy Kepes, *Language of Vision* (Chicago: Poole Bros., 1951).

30. John Hejduk, "Painting as City of the Mind," in *Robert Slutzky: 15 Paintings, 1980–1984*, exhibition catalog, Modernism Gallery, San Francisco, November 16–December 22, 1984.

31. Rowe and Slutzky, "Transparency: Literal and Phenomenal," 161.

1 Difficulties and Dilemmas

The Convergence of Ethics and Aesthetics: A Genealogical, Pragmatist Perspective

RICHARD SHUSTERMAN

In his *Tractatus-Logico Philosophicus*, Wittgenstein boldly claims (without further argument or even elucidation) that "ethics and aesthetics are one."[1] The truth of this claim is far from obvious, as even its syntax expresses the clear plurality of the terms. The assertion of identity is thus meant not to report a fact but to overcome the presumption of evident difference. Most intellectuals, in Wittgenstein's time and in our own, tend not only to distinguish the ethical and the aesthetic but even to set them in oppositional contrast. Ethics and aesthetics are seen as designating two divergent domains of the general realm of value, governed by very different goals, methods, and criteria, and even embodied in rival, conflicting stereotypes: the amoral aesthete and the philistine moralist. While the ethical attitude is concerned with action and its real-world purposes and practical consequences, the aesthetic attitude is defined by our dominant post-Kantian tradition in stark opposition to the practical and regarded as purely purposeless, disinterested contemplation. It was Kant, of course, who decisively defined the aesthetic in terms of disinterestedness and purposiveness without purpose and in contrast to practical functionality.

As a proponent of pragmatist aesthetics who celebrates the richly multiple and diversely important roles of art and aesthetic experience, I resist the standard opposition of the ethical and aesthetic. Though Wittgenstein's blunt and cryptic assertion of their identity is inspiring, it does not take us

very far, so in my work I have tried to show their convergence not only by elaborating how ethical and political factors are usefully integrated into our responses to artworks but also by presenting an aesthetic justification of democracy and by elaborating the idea of philosophy as an ethical-aesthetic art of living.[2] Rather than trying to reformulate all these arguments here in summary form, I want to challenge the presumed simplistic opposition of ethics and aesthetics in another way. By exploring, in very brief and broad strokes, some historical moments of the ethics/aesthetics connection, we will see that one problem in determining any simple relationship between them (whether of contradiction or of identity) is that both notions have been given different meanings or interpretations in their very long history of use.

Though pragmatism was defined by William James as a forward-looking philosophy, he and other pragmatists equally recognized that the problems and concepts of philosophy bear the imprint of human history, and can thus be rendered clearer (even if also more complex) by examining their tangled historical roots. Genealogical analysis will not render the difficult dialogues between ethics and aesthetics into univocal simplicity. But some of the frustrating, obfuscating difficulties that derive from failing to distinguish the different historical meanings and relations of these terms can be avoided, so that the opposition of the ethical to the aesthetic does not seem a conceptual necessity that renders all the brave and apparently successful attempts of artists (and thinkers) to unite the two seem a ludicrous illusion that compares with squaring the circle.

I

Ethics is as old as philosophy, and perhaps in some sense even older. For ethics encompasses more than the discursive philosophical inquiry about the nature of goodness, rightness, virtue, and the best rules for the conduct of life. It also connotes a general pattern or way of life (from the Greek notion of ethos—custom or habit) that may not be discursively formulated in a specific code and, even if so formulated, may not be the subject of formal philosophical discussion. Moreover, though the previous sentence ran together the notions of the good, the right, and the virtuous, these concepts, as John Dewey argued, are actually three independent variables of ethical judgment that derive from different sources and cannot be totally reduced to

each other.[3] As the notion of the good has principally to do with satisfaction of our "desires and purposes" (such as happiness, pleasure, self-realization), so the notion of right instead invokes ideas of law with their reciprocal rights and duties "that are socially authorized and backed," while the notion of the virtuous, for its part, rests on feelings of "widespread approbation" that go beyond the simple calculation of desired satisfactions or socially enforced duties. In expressing their virtue, saints and heroes do more than what is merely good or what we have a right to require from them.

Dewey's point in distinguishing "these three elements" as "independent variables" was not to deny that they are intertwined in actual moral situations, but to insist that they were irreducible to one supreme ethical value or scale and that they could often conflict in the ethical judgment they would suggest. Hence their combined presence and conflict in moral situations would make it impossible to reach a simple rational solution that could be mechanically derived from a single, supreme, ethical criterion or consistent set thereof. In certain situations and in certain periods, some ethical factors seem to take precedence over others, but it is frequently controversial which should be preferred. This complexity is part of what makes moral deliberation often very difficult. The plurality of basic factors, with their shifting emphasis in different contexts and problem situations, is also, I believe, what makes ethical judgments and justifications very much like critical judgments and justificatory arguments in aesthetics. In both cases one cannot appeal to one simple criterion or set of fixed rules that mechanically determine a uniquely correct verdict. Instead one has to use one's perceptive insight, imagination, and taste to ascertain what would be appropriate. And the plurality of basic factors in ethics, by making the concept of ethics more complex, also makes the comparison of ethics and aesthetics more complicated.

Aesthetics—the word derives from the Greek term for sensory perception (*aisthesis*)—exhibits a somewhat similar complexity. Aesthetic judgments are not governed by the single criterion of beauty. There are not only other aesthetic qualities such as sublimity or intensity or vividness that function in aesthetic judgment yet are not reducible to beauty, but there are also criteria used in judgments of art that are not based on purely perceptual (and in that sense purely aesthetic) properties at all. Such important criteria, such as novelty and originality, clearly depend on historical rather than

merely perceptual factors. The complexity of meanings and criteria of ethics and aesthetics is partly a function of the evaluative dimension of these fields, which encourages the proposal and contestation of rival definitions, uses, and standards. But it is also a result of the long history of these disciplines and the varied roles they have played at different times in different cultures. One way to dispel the post-Kantian presumption of the essential opposition of ethics and aesthetics is to look back to ancient Greek and classical Chinese cultures.

II

Though aesthetics was officially established as a formal philosophical discipline only in the 1750s by Alexander Baumgarten, most of its major topics and problems were already discussed in ancient times. This was partly because art, along with religion and rhetoric, was one of the rivals that philosophy had to displace to gain its cultural hegemony as the supreme source of wisdom, happiness, and the proper conduct of life. But another reason was because the Greeks recognized the very powerful formative influence that beauty and art could exercise on the human character and on ethical conduct. Because of Socrates' and Plato's often savage critique of the arts and of the ignorance of artists, we sometimes forget just how important beauty and even art were to their ethical thought and to subsequent theories of ethics. Though Plato broadly condemned the mimetic arts of his time in Book 10 of *The Republic*, he did so precisely because he affirmed a very deep and powerful connection between ethics and aesthetics. Plato argued that these mimetic arts corrupted character by deploying illusion and sensationalism to appeal to the lowest part of our minds and to stir up passions that were likely to corrupt character and provoke unethical behavior.

 In earlier parts of *The Republic*, however, Plato insists on the crucial role of beauty and art in creating the ethical character necessary for justice. Arguing that justice is essentially a mental virtue constituted by the ruling of the proper order in the human soul, Plato then projects that view of the right ruling order onto the public order of the state. A state is just when it is ruled by the proper order of its different kinds of citizens, each group doing what it can do best for the better benefit of the whole community, the philosophers being charged with the highest role of governing guidance,

teaching the ruling group of guardians. But to secure the proper education of the guardians and ensure more generally the proper order of mind that constitutes the virtue of justice in the individual, Plato insists that we must address aesthetic issues. Not only our intellects but our feelings and desires must be educated to recognize and appreciate the right order, so that we will desire and love it. The harmonies of beauty are therefore advocated as crucially instrumental in such education (*Republic* 401–2). As paradigmatic of good order that is desirable and loved and that is not fixed by rigid, mechanical rules, beauty not only provides an excellent tool for educating people to appreciate and recognize good order but can also serve as a model of good political order that cannot be reduced to unchanging laws or codes that rigidly prescribe all our conduct.

The crucial connection of aesthetics and ethics is also affirmed in Plato's account of the philosophical life as the pursuit of ethical-aesthetic perfection whose inspiring model is beauty. In the *Symposium* (198–213), he praises the desire for beauty as the source of philosophy, and he lovingly describes the philosophical life as a continuous quest for greater beauty that ennobles the philosopher ethically while gratifying him aesthetically. This quest is not simply to view or possess things of beauty but to create or give birth to the beautiful: "beautiful and magnificent speeches and thoughts" and "beautiful pursuits and practices" that serve our basic life-drive for immortality (as does the begetting and rearing of good children) by remaining after our death as beautiful memorials of our life. Heroes have readily sacrificed their lives to acquire that "immortal memory of virtue." But the philosopher's ethical quest aims for still more—an abiding vision of the perfect Form of Beauty itself, which provides not only the greatest joy of beauty but also the perfect knowledge to continuously give "birth to real virtue," rather than simply beautiful images or occasional memories of it.[4]

The aesthetic thus played a central role in the ethical thought and lives of the beauty-loving Greeks. An exemplary life of virtue was seen as a beautiful life; and the beauty of virtue was seen as an important reason why such a life was desirable and valuable. Virtue commands our admiration and emulation by its attractiveness rather than by relying on the imposition of moral rules through a fixed code that stipulates obligations and punishments for noncompliance. The Greeks thus did not sharply distinguish the beautiful from

the ethically good, as we can see not only from their common use of the composite term *kalon-kai-agathon* (beautiful and good) but also from their frequent use of *kalon*, the specific term for "beautiful," to designate also ethical goodness. I think that our ethical and aesthetic vocabulary still expresses to some extent their important convergence or overlap. We speak morally of things being "right," "just," "fair," or "appropriate," but all these terms have clear aesthetic connotations and uses, as does the concept of balance, which we frequently use in judging what would be right, just, fair, or appropriate. The concept of order that Plato saw as the basis of justice is likewise a term with a clear aesthetic sense connected with the value of unity. Conversely, in our aesthetic discourse we use the paradigmatically ethical predicate "good" (e.g., in describing works of literature, drama, and painting) just as much as, if not more than, the paradigmatically aesthetic "beautiful."

If we turn from Plato and Europe to the Confucian tradition that defines so much of Asian ethical thought, we see a similar but even stronger emphasis on the connection of ethics and aesthetics. In *The Analects*, Confucius insists on the ethical importance of "achieving harmony" rather than mere obedience to fixed moral codes or commandments, and he likewise stresses the important ways that aesthetic practices such as music and ritual help establish and preserve such harmony (1.12).[5] An exemplary person who serves as a model for ethical conduct thus must be aesthetically shaped by attuning his character through "the rhythms of ritual propriety and music" (16:5). But the Confucian linking of virtue with aesthetic appearance is further strengthened by its emphasizing the "proper countenance," "demeanor," and "expression" that virtue should display and that contributes to successful harmony (8:4). Entire passages of *The Analects* are thus devoted to describing the kind of bodily posture and comportment, facial expression, and clothing that demonstrates such virtue.

Confucius emphasizes that exemplary virtue exercises its power not by moral commandments, threats, and punishments but by inspiring emulation and love. "The exemplary person attracts friends through refinement, and thereby promotes authoritative [i.e., virtuous] conduct (*ren*)" (12.24). "Exemplary persons understand what is appropriate," and because of their attractiveness, one strives "to stand shoulder to shoulder with them" by

being likewise virtuous (4.16–17). Since the Confucian tradition still largely dominates Chinese thought, the very strong connection between ethics and aesthetics is axiomatic for contemporary Chinese philosophers. They would not dream of seeing these notions as inimical opposites because they realize that one cannot really understand Confucian ethics without understanding the aesthetic dimension. Aesthetics in contemporary China is thus one of the most central disciplines of academic philosophy.

III

The situation is very different in the modern West, where the aesthetic dimension of Greek virtue ethics has been largely replaced by the idea of morality as a comprehensive system of laws, rights, and obligations that should dictate proper behavior. Though this system is now largely explained and justified in purely philosophical terms, it was historically grounded in the idea of an absolute God (that of the Judeo-Christian tradition) who created the universe and its values and who still governs it in terms of absolute laws of both nature and morality. The terms "ethics" and "morality" are often used entirely synonymously and both derive from the same notion of habits or customs (*ethos* in Greek, *mores* in Latin). But contemporary philosophers frequently use these different terms to distinguish the idea of ethics as *the general question of values and how to live* from the idea of morality as *a specific coherent, comprehensive system* of obligations, imperative laws, and rights that should determine proper behavior.

It is worth noting that Kant was not only the philosopher who gave this obligation-based notion of morality its most influential formulation, he was also the thinker who most decisively distinguished the realm of aesthetics from the ethical-moral realm of practice by scrupulously distinguishing the (ethical-moral) notion of good from the aesthetic notion of the beautiful. Aesthetic judgments of the beautiful were based on the subjective experience of pleasure, were free from practical interest or purpose, and did not depend on any concept, yet they made the same kind of claim to universal assent as did judgments of the good, which were based on objective interests, purposes, and concepts.[6] Kant's meticulous differentiation of the aesthetic from the ethical or practical and the purely cognitive or scientific[7] is

not the mere product of his own remarkably discriminating intelligence and flair for drawing analytic distinctions. It is also the expression of the wider cultural forces of modernity and its logic of cultural specialization.

Max Weber described this logic in terms of the rationalization, secularization, and differentiation of culture that disenchanted the traditional unified Christian Weltanschauung of the West and carved up its organic domain into three separate and autonomous spheres of secular culture: science, art, and morality, each governed by its own inner logic of theoretical, aesthetic, or moral-practical judgment.[8] The sharp distinction of aesthetics from ethics in modernity was extremely important in promoting the idea of art's autonomy and thus freeing art from its traditional role of serving the ideology of the church and the political authorities. This notion of pure aesthetic autonomy, which finds its strongest expression in the doctrines of "art for art's sake," has been historically valuable in the development of modern art. But the idea that art and aesthetic judgment should be seen as totally distinct from ethical considerations and sociopolitical factors is no longer very useful or credible. Much contemporary art quite explicitly makes ethical concerns and even political protest central to its displayed content, and there is no doubt that the very institutions that structure the production and reception of art (museums, galleries, special exhibitions, art journalism, art schools, etc.) are implicated in a network of ethical and political commitments that are often reflected in their aesthetic activities. As even the high modernist T. S. Eliot came to realize, a "pure artistic appreciation" that is free from the wider ethical and social concerns of both author and audience is an "illusory abstraction" or "figment."[9]

IV

History shows that the sharp oppositional distinction between ethics and aesthetics is neither ubiquitous nor necessary. Nevertheless, there are reasons why drawing such a sharp contrast between these areas has been attractive and important in modern thought and culture. I want to close with a more general methodological point about making distinctions and drawing conclusions from them. In arguing for the connection between ethics and aesthetics, I am not claiming that there is no reason to distinguish between them and that there is never a point in contrasting an ethical to an aesthetic

point of view. I am simply cautioning against taking what in certain contexts can be a very useful distinction or contrast and turning it into an essential dichotomy or opposition. In certain contexts, it makes considerable sense to distinguish the aesthetic technique of an artwork from its moral message, such as when we admire the former but deplore the latter (or vice versa). Here we want to say that while the work is, in some way, aesthetically admirable, it is morally weak (or vice versa). But from the validity of such specific contextual contrasts, it does not follow that there is a general contrast or opposition between ethical and aesthetic values such that the terms "ethics" and "aesthetics" should be thought to denote two ontologically different and essentially opposed kinds of properties or values.

Theorists often make the error of taking a distinction that can be usefully made in a particular context and then reifying it into a universal contrast of opposing essences and then further reading that opposition back into the phenomena themselves. We typically experience the value of noble deeds and exemplary artworks first as a unified whole of value without distinguishing, as separate or opposed, the ethical and aesthetic dimensions of this nobility. In our appreciation of a Shakespearean tragedy or a Henry James novel we do not first appreciate their artistic skill and moral intelligence as separate factors and then combine them. We instead experience an exquisitely unified synthesis where the ethical and the aesthetic vision are so interlaced that one can only subsequently distinguish them by refined analytic abstraction. Though such abstractions are sometimes useful (e.g., for projects of technical analysis of style), this does not justify construing the ethical/aesthetic distinction as an essential contrast that inheres either in the ontology of or in the actual experience of such value. This "intellectualist" fallacy is common and stubborn, since we are so often captivated by the distinctions we make to explain our experience that we take them to be inherent in the basic structure of that experience and of the world.

The fallacy of such logic is clearer when we use notions other than ethics and aesthetics. We can, for example, in certain contexts and for certain purposes, distinguish and even contrast health and fitness or happiness and pleasure. But this clearly does not entail that health and fitness (or happiness and pleasure) are essentially opposing and conflicting values and that when we encounter them we should be experiencing them in distinction and in

tension. We could suggest a similar point about the philosophical distinction I previously cited between ethics and morality. One can appreciate the point of that distinction without concluding that morality is essentially opposed to ethics such that moral considerations could not figure significantly and usefully in an ethical life.

Once we recognize that the sharp division drawn between ethics and aesthetics is not an essential feature of human experience and the ontology of value but mainly a brief historical chapter of the culture of Western modernity, we are better prepared to explore the rich dialogue between theories of ethics and theories of art, between factors that we call ethical and those we call aesthetic. The dialogues will never be easy, since they concern complex phenomena and cherished values whose precise meanings and applications have long been hotly contested. But such exploratory dialogues will at least be free of unnecessary theoretical baggage that constrains discussion by presuming essential opposition.

Notes

1. Ludwig Wittgenstein, *Tractatus Logico-Philosophicus* (London: Routledge, 1963), 147. For further explanation of Wittgenstein's remark, see Richard Shusterman, *Pragmatist Aesthetics: Living Beauty, Rethinking Art* (Oxford: Blackwell, 1992; 2nd ed., New York: Rowman & Littlefield, 2000), chap. 9.

2. See my *Pragmatist Aesthetics,* and also *Practicing Philosophy: Pragmatism and the Philosophical Life* (New York: Routledge, 1997) and *Performing Live: Aesthetic Alternatives for the Ends of Art* (Ithaca: Cornell University Press, 2000).

3. John Dewey, "Three Independent Factors in Morals," in *John Dewey: The Later Works,* vol. 5 (Carbondale: Southern Illinois University Press, 1984), 279–88, citations from 286–87.

4. Citations are from W. D. Rouse's translation in *The Great Dialogues of Plato* (New York: Mentor, 1956), 103, 105, 106.

5. I cite from *The Analects of Confucius,* trans. Roger T. Ames and Henry Rosemont Jr. (New York: Ballantine, 1998), referring to book and paragraph number rather than to page number.

6. For a more detailed critical analysis of Kant's views and their underlying interests, see Richard Shusterman, "Of the Scandal of Taste: Social Privilege as Nature in the Aesthetic Theories of Hume and Kant," in *Surface and Depth: Dialectics of Criticism and Culture* (Ithaca: Cornell University Press, 2002).

7. This is executed in detail in "The Analytic of the Beautiful," in Kant's *The Critique of Judgement,* but it is also reflected much more generally in the division of labor of his three

major works: *The Critique of Pure Reason, The Critique of Practical Reason,* and *The Critique of Judgement.*

8. For an interpretive study of this aspect of Weber, see, e.g., Bryan Turner, *Max Weber: From History to Modernity* (London: Routledge, 1994).

9. See T. S. Eliot, *The Use of Poetry and the Use of Criticism* (London: Faber, 1964), 98, 99. For a more detailed account of Eliot's position, see Richard Shusterman, *T. S. Eliot and the Philosophy of Criticism* (New York: Columbia University Press, 1988).

Ethics and Aesthetics after Modernism and Postmodernism

JOAN OCKMAN

After the style games of postmodernism, the undecidability of poststructuralism, the negativity of ideology critique, the relativism of pluralism, and the divisiveness of identity politics, it is not so surprising that architects should turn to ethics these days in search of a new point of orientation. Yet for architecture to open such a "dialogue" with moral philosophy is indeed difficult, even dangerous, inasmuch as it conjures up the ghosts of the master narratives, codes, and sentimental or sanctimonious creeds that have been successively embraced and discarded over the last 150 years. If the cause of architecture as politics that once animated modernism was discredited over the course of the twentieth century, that of architecture as ethics now has the whiff of being a "soft" politics: in place of the ambition to reform the world, a fuzzy and generalized embrace of humanistic values. A skeptic might wonder whether the "new ethics" is not a neoliberal apologetics, the benevolent side of a profession hand in glove with the capitalist marketplace.

Yet reserving such questions with respect to familiar and now obligatory mantras of diversity, sustainability, public space, and the like, architecture indubitably remains an art and science that involves human and communal well-being. And as such one cannot deny that rethinking the role of architectural aesthetics in the construction—literal as much as metaphorical—of a more life-affirming and equitable environment remains an urgent task. This

is all the more so in a cynical period when architecture is an increasingly commodified and media-driven practice, when judgments of what is "good" often amount to choices among signature styles, when "culture"—once imagined as separable from other social spheres and so relatively uncontaminated by them—is inevitably entangled with business, and when local identities, heritages, and forms of knowledge are either receding or becoming increasingly militant in the face of globalization's ongoing inroads.

As an architectural historian, I would like to offer a preliminary contribution to such a rethinking by tracing an admittedly selective series of episodes and debates from the mid-nineteenth century to the present that dramatize the often ambiguous relationship between architecture as an aesthetic product or project and architecture as an ethical practice. By the latter I still mean a practice concerned with constructing a good society. But in order to avoid putting forward another set of essentializing prescriptions about what constitutes such a society, I prefer to shift the discussion from *ethics* to *ethos*. The dictionary defines *ethos* as "the distinguishing character, sentiment, moral nature, or guiding beliefs of a person, group, or institution." From this standpoint it is possible to reconsider architecture as engaged in an ongoing and historically specific dialogue—or, more properly, dialectic— between aesthetic ideals and social or moral ideologies.

Among the main issues at stake will be that of "good form" and the way modern architecture in particular proposed to see itself as a metaphor for, if not an actual instrument of, good society. Since the rise of modernism, the conflation of aesthetic values with ethical ones has been a reflexive habit in architectural thinking, as pointed out by a line of architectural commentators—not surprisingly, many with strong ambivalence about modernism's social claims—from Geoffrey Scott to Peter Collins.[1] Invoking ideas like "structural honesty," "truth to materials," "good design," and "form follows function," architects from the nineteenth century on borrowed the mantle of morality to cloak or buttress value judgments based on aesthetic criteria or taste, as these writers have emphasized. While it may generally be true to say that living in a beautiful environment offers a better quality of life than living in an ugly one, it is not true to say that an aesthetically remarkable architecture is necessarily an ethically virtuous one; just as it is fallacious to suggest that an ethically correct design—one that is "green,"

say, or generous with public amenities—automatically possesses significant aesthetic qualities. Moreover, while firmness, commodity, and delight may be enduring values in architecture, with both social and aesthetic dimensions, these qualities can vary in relation to each other and have different contextual meanings. Thus, while syllogisms like "good form" are to some extent inevitable products of the metaphoric nature of language itself, it is well to be aware that aesthetic preferences—and not just modern ones—are frequently underwritten by value judgments that are arbitrary. On occasion they can also have more irrational implications, as when a short leap leads from a "streamlined" pencil sharpener or vacuum cleaner to promises about speed and efficiency, or, more perniciously, when the preference for a pitched roof over a flat one is a coded expression of xenophobia. It is clear, in any case, that the relationship between form and virtue is a situational and perspectival one.

In what follows, I will focus on successive moments in architecture's development over the last 150 years, tracking some variations on two apparently polar positions or *ethoi:* at one extreme is the conception of architecture as primarily a means, an instrumental practice in the service of society; at the other is its conception as primarily an end, an art, and as such a relatively autonomous form of cultural production. As will be seen, neither of these positions in itself ensures or precludes "good" architecture. While it may be assumed that the more architecture disengages from society, the more indifferent it becomes to moral-ethical matters, it may also be argued—as philosophers from Viktor Shklovsky to Theodor Adorno to Manfredo Tafuri have done—that only by establishing a radical distance between itself and the "real world" is a cultural practice like architecture able to envision and project a different type of future. Yet ultimately it will be necessary to ask to what extent it is possible to sustain this latter position under contemporary conditions.

I

Two symptomatic aesthetic movements emerged between the second half of the nineteenth century and the first decade of the twentieth in reaction to the traumatic new contents of modernity. In the view of both, the onslaught of modernization portended the decline of Western civilization.[2]

The first was rooted in a romantic or tragic worldview, and it took flight into a realm of sublime and beautiful forms. Crystallized in the philosophy of Art for Art's Sake, it found expression in secular-sacred rituals, cultic art colonies, and the aesthetics of the *Gesamtkunstwerk*. From Kant's definition of art as purposiveness without purpose to Keats's "Beauty is truth, truth beauty," the "world of art" turned its back on the harsh realities of a modernizing, urbanizing world, substituting art worship for the older forms of religiosity. Around the turn of the twentieth century, with art nouveau, there was an exorbitant outburst of artistic fantasy. If Marx's prophecy in the *Communist Manifesto* that capitalism would cause all that is solid to melt into air has come true, finally and literally, in our own age of virtuality and electronic communications, the high-bourgeois epoch of the fin de siècle mounted a last-ditch effort to turn iron and steel into something liquid and organic—to give the coldness and hardness of machine technology the flowing qualities of nature.[3]

In contrast to this escapist mind-set but no less antagonistic to industrial capitalism was the contemporaneous arts and crafts movement. Fathered in England by William Morris and John Ruskin, it aspired to put aesthetics in the service of social reform. Morris's adherents wished to turn the clock back to a premodern, handicraft-based way of life unsullied by bourgeois materialism and the alienating work world of the factory. Simple, honest labor and the pursuit of art for life's sake were the ideals of this aesthetic whose primary aim was to improve and regenerate mankind. Like the aestheticist tendency, the arts and crafts was both compensatory and totalizing: an effort to forge a more perfect world out of a contingent and threatening present. Unlike the former, however, it combined its anti-industrial stance with a progressive social program.

Adolf Loos, an architect who occupies a seminal place in the inception of twentieth-century modern architecture, and an Anglophile, was strongly influenced by the arts and crafts movement at the outset of his career. Harboring almost equal contempt for the overwrought *Gesamtkunstwerk* designs of his Viennese contemporaries—foremost among them Joseph Olbrich and Josef Hoffmann—and for the decorative superficialities and ostentations of Hapsburg taste, he extolled the virtues of simple, everyday, functional forms perfected over time by human use and custom. He admired the English for

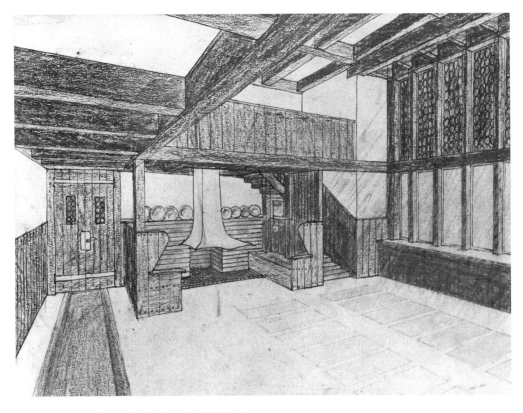

Adolf Loos, sketch of interior with fireplace, ca. 1899, 21.8 x 30 cm.

Josef Hoffmann, letter openers for Secession exhibition, Vienna, 1899

their practical reforms in clothing styles and the Americans for their efficient and hygienic plumbing. Only the monument and the tomb, he believed, belonged to the realm of "Art"; the rest—everything that served a purpose—belonged to everyday life and required little architectural improvement. His famous diatribe against decoration, "Ornament and Crime" (1908), is a paradigmatic statement moralizing aesthetics, and it demonstrates the way the ethical-aesthetic imagination at this early moment of modernism was driven by a Social Darwinist narrative. Influenced by the writings of the Italian psychiatrist and criminologist Cesare Lombroso, Loos associated ornament with three groups whom he deemed culturally degenerate or inferior (perhaps partly with tongue in cheek): primitive tribes that tattooed their bodies, criminals who practiced tattooing as the ritual token of their membership in an outlaw group, and women, whom he saw as having an ingrained penchant to adorn themselves.[4]

Ironically, at the same moment Loos was developing his polemic against ornament in Vienna, the American architect Louis Sullivan was advancing a philosophy of ornament in Chicago that reflected precisely the opposite attitude with respect to cultural evolution. I say ironically because Loos spent time in Chicago in the 1890s and might just as well have been influenced by Sullivan, a dominant architectural figure there at this date. Instead, Loos's views on ornament bear more affinity to those of another Chicagoan, Thorstein Veblen, a gloomy critic of capitalism, who notoriously stated that the backs of American buildings were superior to their frivolously embellished fronts.[5] Like Loos, Sullivan considered ornament a feminine attribute. But precisely as such, he believed, it belonged to a realm of higher rather than lower values, a realm in which sensuousness, individuality, and fantasy were desirable rather than regressive qualities.[6] No less a social critic than Loos, Sullivan envisioned the new architecture of his time as one in which the emancipatory and feminine values of ornament would coexist organically with the rational and masculine ones of engineering. Their synthesis was to be the basis of a true modern architecture, a way of building that would inevitably—by yet another yoking of the social and aesthetic imagination—advance American society toward a more democratic way of life. Sullivan's creed of organic architecture would subsequently be adopted and elaborated by his disciple, Frank Lloyd Wright. As suggested by these opposite attitudes

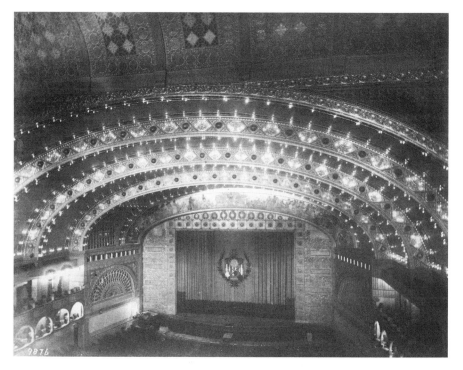

Louis Sullivan, Auditorium Hall: Interior view from the balcony, Chicago, Illinois, ca. 1895

toward ornament, the phenomenon of modernization that so unsettled European society at the turn of the century seemingly had a less traumatizing impact on American artists and architects. Perhaps this was because their collective memory of preindustrial life was far shorter: as Gertrude Stein once commented, America was the oldest country in the world because "it is she who is the mother of the twentieth century civilization."[7] Thus, in the visionary American Sullivan—to whom a direct line can be traced back to the New England sculptor and transcendentalist philosopher Horatio Greenough, credited with the axiom "Form follows function"[8]— the theory of functionalism received a more forward-looking interpretation than in the English proponents of the arts and crafts. The disparity

between Sullivan's and Loos's attitudes toward ornament is a clear example of the situational relationship between ethics and aesthetics. While Loos militantly rejected ornament in the context of a decadent and effete Viennese society, Sullivan embraced it as a spiritual and essential value within the milieu of a hard-nosed commercial metropolis schooled in the stockyards.

At the same time, if "Ornament and Crime" would be taken as one of the emblematic documents of modern architecture's dehumanizing and reductivist ethos, the rather rich interiors of Loos's own architecture belie his polemic against ornament. These contradictions inherent in ornament's meaning would be revisited several decades later, in the context of the Italian Neoliberty movement and then postmodernism. But first let us consider the period of high modernism, the 1920s, when a full-fledged social and aesthetic vision emerged.

II

With modernity and its accompanying transformations a fait accompli in most European countries by the 1920s, one of the fundamental objectives of the new architecture became the amelioration of the oppressive living conditions of the new class of urban-industrial workers and, more broadly, the facilitation of society's transition to twentieth-century civilization. While variously addressed within the different "isms" of the modern movement, these architectural objectives were especially framed in terms of new solutions to the factory, collective dwelling, and the city. Such was the materialist thrust of Le Corbusier's manifesto *Vers une architecture* (1923), in which he issued his famous challenge: "Architecture or Revolution. Revolution can be avoided."[9] "Liberated living"—what Sigfried Giedion, Le Corbusier's supporter and one of the leading historians and theorists of modernism, called *befreites Wohnen*—demanded not just new techniques but more healthful and egalitarian social arrangements. Among the radically new "social condensers" produced by modern architects were communal day-care facilities, functional kitchens, and working women's dormitories, such as those realized in the housing estates built by Ernst May in Frankfurt; and the workers' clubs, theatrical sets, and clothing celebrating proletarian life produced by constructivist designers in the Soviet Union. The slogan "Art into life" now

mobilized an avant-garde for whom both Parnassian aestheticism and Luddite attitudes to industrialization were equally regressive.

With their machine-inspired forms and "space-time" aesthetics, the various architectural avant-gardes brilliantly captured the *esprit nouveau* of the period, even if their iconography was more symbolic than actually transformative. As the critic Reyner Banham, who was trained as an engineer, would point out, the forms of functionalist architecture for the most part represented a superficial translation and utilization of the new technologies.[10] Likewise, from a social standpoint, as feminists were to argue later, the provision of amenities like efficient kitchens and laundry equipment

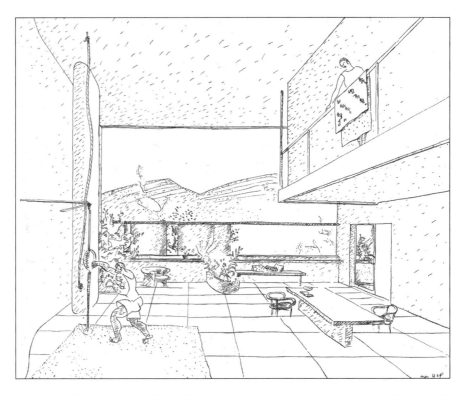

Le Corbusier, Wanner apartment block, Geneva, 1928–29; drawing showing apartment as "suspended garden"

Varvara Stepanova, designs for sports
clothing, 1923

was inadequate in itself to liberate women from the root cause of their op-
pression, namely, a patriarchal society committed to keeping women in the
home. Conversely, rationalist aesthetics and advanced industrial technolo-
gies were susceptible of being mobilized for reactionary purposes. In Na-
tional Socialist Germany, regime-built munitions plants and airports had
more stylistic affinity with the buildings designed by Erich Mendelsohn and
Ludwig Mies van der Rohe than with the Hansel and Gretel vernacular of
outright Nazi architects like Paul Schulze-Naumburg (indeed, some were
designed by architects educated at the Bauhaus, like Ernst Neufert). In any
case, by the first half of the 1930s, the idea of an inherent linkage between
radical aesthetics and revolutionary politics was exposed as a chimera in
both Germany and the Soviet Union.

The Marxian philosopher Walter Benjamin, associated with the Institute
for Social Research in Frankfurt, experienced this disillusionment firsthand.
Initially enthusiastic about new technologies like film and mechanical re-
production, he also understood that they had a more complex and mediated
relationship to social and political reality than the battle cry "Architecture
or revolution" implied. Still, he believed that culture had a crucial role to

play in society. Taking modern architecture's vocation, like that of modern literature, to be fundamentally *allegorical,* Benjamin saw its task as to educate and condition the New Man (and new woman) of modern times for the revolution in consciousness that would inevitably have to accompany any actual revolution. To live in a house by Le Corbusier or J. J. P. Oud, he declared in his essay "Surrealism," is "a revolutionary virtue par excellence"; an architecture of transparent glass is "an intoxication, a moral exhibitionism, that we badly need."[11] Architecture was thus to be understood in educational as much as material terms—as "equipment for living" in the twentieth century.[12] Yet the monumental buildings and spectacles of Albert Speer and the propaganda films of Leni Riefenstahl demonstrated, as Benjamin soon realized, how readily modernism's technological aesthetics could be hijacked.[13]

III

In Europe after World War II, the disenchantment that had already crept into the social project of modernism converged with an equally acute crisis of values engendered by the revelations of the death camps and the atom bomb to further undermine belief in the benevolence of technocratic rationalism. The Frankfurt School philosophers, most of them now relocated to the United States in the wartime diaspora (with the exception of Benjamin who, in an act of despair, had committed suicide at the French-Spanish border in 1940), theorized the dangerous contradictions between enlightened and instrumental reason that were being played out in the modern world.

In postwar Italy, modern architects pursued a tendency that paralleled neorealism in cinema. Like the films of Roberto Rossellini and Vittorio de Sica, a new "realist" architecture purported to be an ethical correction to the grandiosity and oppressiveness of fascist monumentality as well as to the emotional sterility and abstraction of rationalism. The postwar slogan "A house for everyone" not only dramatized the need of citizens for basic exigencies but partook of the pathos of the recent antifascist struggle. A new hero of Italian society emerged: the partisan, a figure identified with the salt of the earth and the existential dignity of working-class life, whether in the countryside or the big city. In the Tiburtino housing district in Rome, built in 1949–55 by the modernist-trained architects Ludovico Quaroni, Mario Ridolfi, and others, the affectation of a vernacular idiom ennobled the

BBPR (Lodovico Belgiojoso, Enrico Peressutti, Ernesto Rogers), Monument to the Dead in German Concentration Camps, Milan, 1946

laundry hanging from apartment windows as the banner of an authentic way of life.

Among the Italian architects who would be most centrally engaged in formulating a conscientious critique of the previous period was the Italian architect Ernesto Rogers, based in Milan. There, where the rationalist aesthetics of the 1930s retained stronger hold, at least temporarily, Rogers's firm, the BBPR—an acronym for the four founding partners, who had been in the forefront of Italy's modern movement during the 1930s—constructed a monument to those who died in German concentration camps. Rogers, a Jew, had survived the war by fleeing to Switzerland; less fortunate was his partner Gian Luigi Banfi (whose initial "B" the firm would retain in its name as a permanent homage). Designed by the three remaining partners, the monument was an abstract steel cage, yet in it the minimalist aesthetics of the almost empty cube, now rendered delicate and lyrical, took on a moving new symbolism. The same year, Rogers acceded to the editorship of the journal *Domus*, writing in his opening editorial: "Confronted with so many

[wartime] disasters, our impulse would be to translate moral feeling into the precision of an economic fact: How many families are without a house? How much material is necessary? How much time?"

He continued, "What value does beauty have for these people?," going on to recount his experience of attending a concert and feeling guilty for succumbing to the sublimity of the music at a moment when so many of his countrymen were suffering. But he ended by rejecting this moralistic thinking, arguing that "poetry" was ultimately as essential to human existence as a kitchen or bathtub. In this vein, he proceeded to formulate an original editorial program for *Domus*. Putting out a journal of architecture was integral to creating a new culture, he affirmed, to "building a society." It was "a matter of forming a style, a technique, a morality as terms of a single function."[14]

Rogers's synthetic and high-serious program was not to succeed at *Domus*. An expensive journal founded in the late 1920s by the architect Gio Ponti, it continued in the postwar period to function as an elite tastemaker, and within two years Rogers was obliged to publish his farewell. Five years later, however, he would be offered another opportunity to shape the architectural direction of his time at an even more influential and equally venerable publication. Taking on the editorship of *Casabella* in 1953 and appending the word *Continuità* to its name, he managed over the next decade to infuse Italian and international architectural discourse with both critical intelligence and moral authority.

It was, however, a different historical moment. By the second half of the 1950s, Italy had left behind the privations of the postwar years and was enjoying the "miracle" of a burgeoning consumer economy. Neorealist pathos had given way to a more heterodox and bourgeois tendency called Neoliberty. The latter name referred back to the turn-of-the-century Liberty style, or art nouveau. Once again, architects sought to introduce elements of fantasy and richness into architecture, repudiating Loos's proscription of ornament and modernism's orthodoxy. Rogers, who became one of Neoliberty's most visible promoters in his editorial role at *Casabella*, now framed the burning question of the day as one of "continuity" or "crisis." Could the current architectural revisionism be understood as an elaboration and expansion of the modern movement's original tenets? Or had modernism run its course?[15]

Rogers sought to argue the former, and the debate congealed around an

office skyscraper completed by his own firm in 1958 in Milan, the Velasca Tower. Technologically advanced but flaunting a medievalizing silhouette, the building was denounced as a schismatic departure and eclectic pastiche by those still upholding modern architecture's "great tradition." Responding in both the pages of *Casabella* and the folds of the International Congresses of Modern Architecture—or CIAM, the international organization of modern architects founded in 1928 as the modern movement's standard-bearer—Rogers defended the tower's historicist imagery as connected to its Milanese context and heritage: "We found it necessary that our building breathe the atmosphere of the place and even intensify it."[16] Once again, however, the line between aesthetics and ethics proved contentious and blurry.

Among Rogers's chief opponents within CIAM were the young British architects Peter and Alison Smithson. Members of a slightly younger generation than Rogers—those who, as their colleague Banham put it, interrupted their architectural training "to fight a war to make the world safe for the Modern Movement"[17]—they too fomented a major revision of modernist thinking during these years. Different from Rogers's, it was no less ethically driven or committed. Ultimately, as the instigators of a breakaway group within CIAM called Team 10—including other polemical personalities like Aldo van Eyck, Jacob Bakema, and Shadrach Woods—they would succeed in bringing about their parent organization's demise by the end of the 1950s. The Smithsons described their own approach, which they baptized, slightly facetiously, the New Brutalism, as "socioplastics": an infusion of modern architectural form with a new set of social, anthropological, and ethical concerns. The subject of a long article written in 1955 by Banham, which he later republished in book form as *The New Brutalism: Ethic or Aesthetic?*, the Smithsons defined their new "ism" as rooted in existing patterns of human association. Incorporating as-found materials and nonformal sources, it exalted the nitty-gritty of urban life and embraced a multifarious mass culture in all its manifestations from advertising to science fiction and automobile styling. Yet as the question mark in Banham's title implied, and as with Neoliberty, not everyone was persuaded that the New Brutalism was much more than another formal tendency. In response to the doubts raised by their contemporaries, the Smithsons insisted: "Any discussion of Brutalism will miss the point if it does not take into account Brutalism's attempt

Alison and Peter Smithson, Golden Lane housing, 1950–54, vignette patterns of life and sky

to be objective about 'reality'—the cultural objectives of society, its urges, its technique, and so on. Brutalism tries to face up to a mass-produced society, and drag a rough poetry out of the confused and powerful forces which are at work. Up to now Brutalism has been discussed stylistically, whereas its essence is ethical."[18] The argument would remain moot, however, as the Smithsons had little opportunity to test their polemical ideas in the 1950s in actual buildings.

IV

In the United States, modern architecture underwent a major sea change after World War II, ceasing to be an ideology rooted in European social thought. Actually, this mutation was already anticipated in the famous International Style exhibition staged at the Museum of Modern Art in New York in 1932 by Philip Johnson and Henry-Russell Hitchcock. Shrewdly

repackaging the modern architecture they had imported from Europe for American consumption, the two curators sought to make it "safe for millionaires," as the writer and urban reformer Catherine Bauer said at the time—or "safe for capitalism," as the architectural historian Colin Rowe would put it later.[19] Modern architecture's compass was now recalibrated to the needs of a society organized around an emergent consumer lifestyle. Yet within this context too there were architects and designers who sought to construct a conscientious environment.

Their priorities, or course, were different. Among the first orders of business in the United States in the late 1940s was to keep the economy from sliding back into a recession. How to retool the war machine as a peacetime engine? How, more specifically, to put aircraft technology in the service of affordable housing? asked the visionary inventor-designer Buckminster Fuller. Over the course of the next decade, the architect of the Dymaxion house, car, and bathroom would turn his attention to the solution of ever larger global and environmental issues facing an interdependent and demographically expanding world with shrinking resources. Not without contradiction, his far-reaching schemes combined military-industrial thinking with his own original brand of critical-utopian speculation.

Another progressive and humanistically inclined designer was the Bauhaus émigré László Moholy-Nagy, who sought to chart a path for modern architecture from Europe to America. As director of the Institute of Design in Chicago (originally named the New Bauhaus) in the late 1930s and early 1940s, he focused on the question of how to adapt and update the education he had helped to pioneer at the Bauhaus for the postwar era, calling for an integrated approach: "seeing, feeling and thinking in relationship."[20] By infusing art with social responsibility, he believed, the design profession in America could take on a leadership role in society, counteracting the negative effects of specialization and competition endemic in capitalist civilization. Moholy-Nagy did not live long enough to carry out his program, however. After his premature death in 1946, his successors were unable to sustain his ideals and idealism for long, and the school was soon absorbed by the Illinois Institute of Technology. Nonetheless, his book *Vision in Motion*, published posthumously in 1947, was read as an inspiring blueprint for the ethical potential of design education in an advanced technological society.

Charles and Ray Eames, Eames House (Case Study House #8), Pacific Palisades, California, 1945–49

If Fuller and Moholy-Nagy were among those who struggled, in their re-spective ways and with mixed success, to integrate innovative design ideas with a social-environmental agenda in postwar America, plenty of other ar-chitects in the United States turned their back on reformist aspirations. In line with the general depoliticization and professionalization that occurred in all fields in the late 1940s and 1950s, they focused more narrowly on for-mal and technological concerns. While this led in some cases to significant aesthetic innovations as well as fruitful technological experimentation—as in the work of architects like Eero Saarinen, Paul Rudolph, and the firm of Skidmore, Owings & Merrill—the work of these practitioners mostly failed to project any especially principled vision of American society. As Matthew Nowicki—another émigré architect with strong humanistic convictions about architecture—described it, architecture in the 1950s could best be characterized as a matter of "form follows form."[21]

Two other significant exceptions with respect to this normative formal-ism (again in different ways) were Charles and Ray Eames and Louis Kahn. The Eameses, while affirming a patriotic cold war agenda in projects like their installation for the U.S. government at the Moscow Fair of 1959—one of the dramatic encounters of the era between Soviet and American ways of life—also invented a fresh and optimistic architecture. They made their open, easy-going, and vivacious designs available and affordable to an ex-panding middle class of American consumers. Kahn likewise projected a powerfully "democratic" vision of architecture, although in his case more in the high-aesthetic, monumental tradition of Sullivan and Wright. Following his early social housing projects in collaboration with Oscar Stonorov and George Howe, he went on to design a series of buildings that at once human-ized and dignified postwar cultural and scientific institutions like libraries and laboratories, combining classical-modern formal poetics with a redis-covery of the values of civic space.

V

In terms of an ethics of architecture, certainly one of the most "difficult" figures in both the interwar and postwar, European and American, contexts, and at the same time the one whose work most profoundly and ambiguously raises moral-philosophical questions, is Mies van der Rohe. I mentioned



earlier that Walter Benjamin's optimism about the glass house—the transparent milieu that was supposed to prepare the new citizens of modernity for life in a free and open society—had proven illusory by the 1930s. After World War II an explicit rejoinder to Benjamin's call for "a moral exhibitionism that we badly need" would come from the philosopher Ernst Bloch. As Bloch (a close colleague of Benjamin's during the Weimar period) wrote in 1959 in an essay entitled "Building in Empty Spaces," "The wide window filled with a noisy outside world needs an outside full of attractive strangers, not full of Nazis; the glass door down to the floor presupposes sunshine that looks in and comes in, not the Gestapo."[22]

Undoubtedly the new glass houses—high-rise buildings constructed for prestigious corporate and government clients—were impressive in their structural virtuosity. Skidmore Owings & Merrill's seminal Lever House in Manhattan, completed in 1952, was the new face and space of benevolent capitalism. As Lewis Mumford wrote, just after it opened, of its well-planned accommodation for the postwar cadre of white-collar workers, many of them women: "Even the least-favored worker on the premises may enjoy the psychological lift of raising her eyes to the clouds or the skyscape of not too near-at-hand adjoining buildings. I know of no other private or public edifice in the city that provides space of such quality for every worker."[23]

Yet as Lever House's technology and aesthetics rapidly lent themselves to a profitable formula for speculative office building, they increasingly proliferated an urban environment that was banal and "one-dimensional," the very embodiment of empty form. For many critics, the chief merit of a building like Lever House, the headquarters for a soap company, was—in a memorable phrase of Bloch's—to give washability a face. Moreover, as Mumford too realized, the glass-curtain walls were subliminally permeated by the chilly cold war atmosphere of containment and bureaucracy; at this point, the shadow cast on modernism's radiant poetics of glass came not just from memories of fascist brutality but also from the specter of Big Brother.[24]

No twentieth-century architect was to give as intense a representation to this utopian-dystopian dialectic as Mies. Was he an "ethical architect"? Surely not by conventional measures. One of the least socially engaged of the architects associated with the modern movement in Weimar Germany and the Bauhaus, he did not hesitate to take commissions from the Nazis in

the mid-1930s before deciding, for purely professional reasons, to emigrate to the United States. Once in the United States, he continued to pursue his own rigorist aesthetic with far more passion for abstract space than for the lives that would inhabit it. A client like Edith Farnsworth would say of the exquisitely minimalist house he designed for her in 1946–51 that it made her feel like a caged animal.[25] Yet somewhat like Ezra Pound in the world of poetry and Martin Heidegger in philosophy, Mies's work unquestionably engages ethical problematics. Uncompromising in its formal realization, his work gives fundamental expression to the epoch's doubts concerning the perpetuation of a humanistic culture in a world dominated and transformed by technology.

It is this "psychomachia," to borrow a term from the literary critic Charles Altieri, who has proposed a "lyrical" and Nietzschean interpretation of ethics as an alternative to the moralistic one,[26] that leads to a discussion

Mies van der Rohe, Farnsworth House, Plano, Illinois, 1946–50, exterior view from 1951

of Mies's work, although not an apology for it, in the context of the defini-
tion of *ethos* given above. Far from the stance of, say, Walter Gropius in this
period—whose last book, *Apollo in the Democracy* (1968), like the work of
his firm TAC, is redolent with conventional and no longer credible pieties—
with Mies we arrive at an aesthetic that might, in fact, be more appropriately
characterized as *anaesthetic*. In its dispassionate passion, its cold refusal of
humanistic affects, its unsentimental repression of modernism's utopian de-
sire, it registers, dialectically, precisely the period's ethical depletion.

VI

In the 1960s, famously a decade of political upheaval and protest, the ar-
chitectural divide between aesthetic and social practices became a schism.
The most significant architects responded in opposite ways to the contem-
porary situation. On the one hand, they tried to align their architecture
with the antiestablishment politics of the day; on the other, somewhat like
their nineteenth-century forebears, they distanced themselves from social
and political struggles, retreating into the safe harbor of autonomous form
making.

For the first group, Jane Jacobs's assault on modern architecture, un-
leashed in her book *The Death and Life of Great American Cities* (1961), was
a major rallying point. From her streetside vantage, she fearlessly stepped
up to challenge the top-down, "statistical" urban prescriptions of Le Cor-
busier, Mumford, and Robert Moses.[27] In one fell swoop, she indicted the
three men—all known for their outsize egos—on fundamentally ethical
grounds: the isolated towers in parks, the hyperregulated Garden Cities, and
the scaleless blocks and business-driven development that they respectively
championed were not just antiurban conceptions but inimical to the gre-
garious sociability of real, everyday urban life. Jacobs's David-versus-Goliath
attack inspired a new breed of city-minded architects to turn to causes like
advocacy and historic preservation. Yet she was a journalist, not an architect.
Her empirical, essentially nonformal prescriptions tended to be written off
by many professionals as amateurish. Meanwhile antimodernists were quick
to embrace her as La Pasionaria of neotraditionalist aesthetics.

Other young architects in the 1960s, also shunning the professional es-
tablishment, pursued alternative avenues for practice in countercultural and

Jane Jacobs on Hudson Street in the
West Village, New York, March 1961

"non-pedigreed" ways of building. They variously set out for Latin America's barriadas, set up ecological communities in the American desert, and sought out "authentic" non-Western traditions like those superficially captured in the images of Bernard Rudofsky's influential exhibition Architecture without Architects (1964). Unlike many architects of the 1920s, however, who saw aesthetic experimentation as the concomitant of revolutionary politics, the social-protest architects of the 1960s distrusted avant-garde posturing and rejected a formalistic architecture.

At the same time, a second group of architects took precisely the opposite tack, that of disengagement. Insisting that architecture's proper domain was its own disciplinary language, laws, and history, they retreated into hermetic forms of research, obsessively working over modernism's repertory and asserting the "purity" of their mostly paper projects against the compromises and corruption of real-world practice. This tendency was exemplified by, among others, the architects grouped around Aldo Rossi in Italy and around the Five Architects in Manhattan.

In the late 1960s and 1970s, the Italian Marxist critic and theorist Manfredo Tafuri gave formidable intellectual credibility to this purist position.

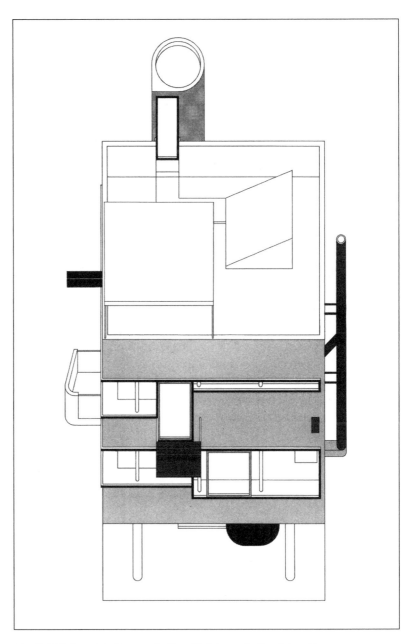

John Hejduk, Bernstein House, unbuilt, 1968. Color projection: ink and tempera on paper, 19¼ x 20 in.

Beginning his most polemical book, *Architecture and Utopia: Design and Capitalist Development* (1973), with the statement, "To ward off anguish by understanding and absorbing its causes would seem to be one of the principal ethical exigencies of bourgeois art," he criticized modern architecture for acquiescing to the role of being consoling and compensatory. He disavowed the "pathetic 'ethical' relaunchings" of the avant-garde as useless within capitalist society, "adapted solely to temporarily placating preoccupations as abstract as they are unjustifiable."[28] Indeed, Tafuri proclaimed, in his most nihilistic, post-1968 mood, that to speak of architecture "for a liberated society" or to entertain "hopes in design" was absurd short of full-scale transformation of the existing relations of power. From this standpoint, architecture could do nothing but function negatively—as a critique of the dominant ideology.[29] In this context, he found that the work of architects like Rossi, Peter Eisenman, John Hejduk, and James Stirling possessed an undeniable poignancy and critical intensity. Yet it was ultimately a manifestation of "architecture in the boudoir"—an effort on the part of an increasingly impotent profession to shore up its authority by enclosing itself in a magical and hermetic world of forms in which mastery still seemed possible.[30] This vain and belated salvage operation was, in Tafuri's implacable diagnosis, nothing but the symptom of a moment in the history of modern architecture when a synthesis of the social and the aesthetic appeared definitively foreclosed.

VII

Out of this existential crisis and professional cul-de-sac a new paradigm would necessarily emerge in the 1970s: postmodernism. In a hedonistic transvaluation of values, the "languages of battle" forged by the heroic avant-gardes of the 1920s were now recuperated as "languages of pleasure." "Nothing is really antagonistic, everything is plural," wrote Roland Barthes.[31] Heralded by Robert Venturi and Denise Scott Brown in the United States, a new architecture of "complexity and contradiction" celebrated an end of modern architecture's prohibitions and a release from the tyranny of its master narratives. From their academic berth in the profession, the Venturis enjoyed the scandal of "deferring judgment," both aesthetic and ethical, about the popular places they deemed "almost all right," from Main Street to Las Vegas and Levittown. At the same time—and revealing their own Anglo-

modernist formation—the Venturis' militantly critical position with respect to the "high" architecture of their colleagues was no less moralistic than that of their more puritanical predecessors. Reversing Loos's injunction against ornament, they made the case for "decorated sheds" over "ducks," offering an equally proscriptive argument. Only now it was the sculptural expressionism pursued by architects like Paul Rudolph and Eero Saarinen that was the "crime." Scott Brown wrote in 1968:

> Our thesis is that most architects' buildings today are ducks: buildings where an expressive aim has distorted the whole beyond the limits of economy and convenience; and that this, although an unadmitted one, is a kind of decoration, and a wrong and costly one at that. We'd rather see the need admitted and the decoration applied where needed, not in the way the Victorians did it but to suit our time, as easily as the billboard is pasted on the superstructure. . . . This is an easier, cheaper, more direct, and basically more honest approach to the question of decoration. . . . It may lead us to reevaluate Ruskin's horrifying statement, "architecture is the decoration of structure." But add to it Pugin's warning: it is all right to decorate construction, but never construct decoration.[32]

Such a statement returns us to the syllogistic logic whereby an aesthetic preference is justified by a moral claim. Ornament was now a virtue, according to the Venturis, but only when it was applied and not constructed, only when it is "honest" enough to acknowledge its superficial nature as ornament—only, that is, when it was not (contra Sullivan and Wright) integral or "organic." Ironically, Loos himself had suggested something similar in an essay of 1898 entitled "The Principle of Cladding": "I have derived a very precise law which I call the law of cladding. . . . The law goes like this: we must work in such a way that a confusion of the material clad with its cladding is impossible. That means, for example, that wood may be painted any color except one—the color of wood."[33]

VIII

In the computer-driven decade of the 1990s, the debate over ducks and decorated sheds morphed into one—no less formalistic—over blobs and boxes. Frank Gehry's Guggenheim Museum in Bilbao, which opened three years

before the end of the century, was undoubtedly a duck, and an extravagant one, even if computer-aided design and fabrication were beginning to render the Venturis' strictures about economy less applicable. As an architect Gehry himself harks back to the old nineteenth-century genius-artist figure; his buildings are "art"; they flaunt their originality and will to form. Yet unlike the aestheticism of the earlier architects, buildings like the Bilbao museum and the Disney Concert Hall in Los Angeles, completed in 2003, have willingly entered into the media circuits (or circus) of mass culture. Indeed, Gehry's crowd-pleasing work has succeeded in blurring the line between high culture and low far more effectively than the Venturis'. In the case of Bilbao, the building had an immediate effect on the economy and political fortunes of the turbulent region of Spain into which it was inserted like an alien object, while at the same time it participated in a global culture of spectacle that for the last decade has attempted to replicate its effects.

Today, it goes without saying, avant-garde form makers no longer covet the aura of virtuous purity they did in Tafuri's day. The work of elite architects like Gehry, Zaha Hadid, and Daniel Libeskind, for example, is driven predominantly by aesthetic considerations, but as these architects—more boutique than boudoir—take on high-profile projects, they are inevitably enmeshed in social, political, and ethical contexts and controversies. This is the case with another project of Gehry's that is underway at the time of this writing, a $200 million American-sponsored Museum of Tolerance in Jerusalem. Intended to help heal one of the most divided places on earth, the project was characterized by the *New York Times* when it was first announced as one of a new generation of cultural institutions that "rather than displaying wondrous objects"—the traditional function of museums—"seek to foster values." Presumably Gehry was chosen for the project because, apart from his celebrity status and perhaps his Jewish heritage, his expressionistic style gives generalized expression to desirable "values" like freedom and democracy. All too ironically, however, Gehry's scheme—described in the Israeli newspaper *Ha'aretz* as "so hallucinatory, so irrelevant, so foreign, so megalomaniac"—has already realized its client's purpose, eliciting rare unanimity between the Israelis and Palestinians in denouncing it.[34]

Meanwhile, on the side of boxes rather than blobs, the Swiss architects Herzog & de Meuron have offered more paradox than certainty with respect

to the issue of ornament. In projects like their Ricola Storage Building in Mulhouse (1992–93) and University Library in Eberswalde (1994–99), they have artfully extended the debate opened by Hoffmann and Loos at the beginning of the twentieth century and continued in the post–World War II discourse of transparency. Like Mies, they understand how to problematize rather than moralize the questions of ornament, nature, and craft that have returned to the forefront in architecture, reasserting their relevance in a postindustrial, post-Enlightenment, digital age. In their best work of the last fifteen years, their sensuous and materially complex surfaces reflect an experience of the modern "glass house" deepened by a sophisticated historical consciousness.

Finally, another contemporary star architect, Rem Koolhaas, has, with his brutal-cool style, polemically refused to allow "ethical exigencies" to inflect his architecture. While his body of work, both written and built, has undoubtedly provided one of the most brilliantly imaginative and incisive analyses of a postmodern consumer society and its globalized architectural

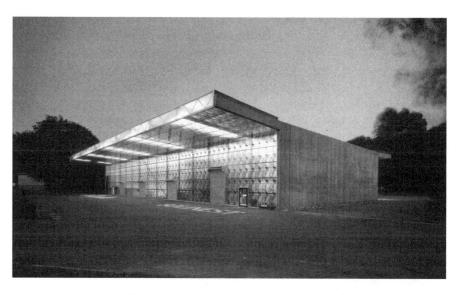

Jacques Herzog and Pierre de Meuron, Ricola-Europe SA Production and Storage Building, Mulhouse-Brunstatt, France, 1993

context, his "postcritical" stance with respect to it is a high-wire performance that negotiates precariously between the Dutch "moral modernism" to which he is heir and an embrace of his clients' seductive yen-euro-dollar regime (¥€$, as he puts it).[35] While he appears to revel in the transgressiveness of his position, he has, on rare occasions, betrayed a certain conflictedness about which side of the divide he is on. For the most part, though, he has not hesitated to venture into whatever highly charged fields arouse his restless curiosity, from the hyperconsumerism of shopping culture, to the chaotic urbanism of Africa and China, to the political complexities of the New Europe, conducting his architectural "research" with the calculation of a military tactician.

In his *Critique of Cynical Reason,* the German philosopher Peter Sloterdijk defined "enlightened false consciousness" as an intellectual stance in which one understands the disparity of power and pain in the world but behaves as if there were nothing to do about it.[36] Architecture that acts in this manner seeks to suppress the vital and inherent tensions between aesthetics and social reality. If the history of modern architecture teaches anything, it is that the failure to acknowledge pain is its own pathology. The coolness of today's "postcritical" practice is no less symptomatic of our period than its opposite: the fervent desire for a new ethics.

Notes

1. See Geoffrey Scott, *The Architecture of Humanism: A Study of the History of Taste* (1914) (New York: W. W. Norton, 1999), esp. chap. 5, "The Ethical Fallacy," 97–126; and Peter Collins, *Changing Ideals in Modern Architecture, 1750–1950* (1965; Montreal: McGill-Queen's University Press, 1998), esp. 107–10. This line of argument has origins in the nineteenth-century "battle of styles" and has not infrequently been mobilized in the interest of defending classical architecture against critics like Pugin and Ruskin. More recently, it has been taken up by an antimodernist historian like David Watkin in *Morality and Architecture: The Development of a Theme in Architectural History and Theory from the Gothic Revival to the Modern Movement* (Oxford: Clarendon Press, 1977). Colin Rowe's *The Architecture of Good Intentions* (London: Academy Editions, 1994) should also be situated within this lineage.

2. I will use *modernization* in this essay as an umbrella term to denote the new relations of production and the processes of transformation—among them industrialization, urbanization, secularization, the rise of the nation-state, the ascendancy of the bourgeoisie—that bring into being the condition or state of *modernity.* The term *modernism* will refer to the spectrum of cultural and aesthetic ideologies that emerge in response to this condition,

from progressive to reactionary. By analogy, we may speak of *postmodernity* and (to avoid a neologism like *postmodernization*) its associated socioeconomic processes—globalization, deindustrialization, computerization, the rise of an information or media society, and so on. *Postmodernism,* in turn, may be understood as a range of cultural and aesthetic responses to postmodernity.

3. See Walter Benjamin's "excursus on Jugendstil" in "Paris, the Capital of the Nineteenth Century" (1935), where he writes of "the flower as symbol of a naked vegetal nature confronted by the technologically armed world." Benjamin, *The Arcades Project* (Cambridge, MA: Belknap Press of Harvard University Press, 1999), 9.

4. See Cesare Lombroso, "The Savage Origin of Tattooing," *Popular Science Monthly,* April 1896, 793–803. Lombroso (1835–1909), who was also an advocate of eugenics, may have had a direct effect on Loos's thinking at this moment; cf., besides "Ornament and Crime," Loos's essay "Ladies Fashion" (1902), which has a Lombrosian ring. "The Savage Origin of Tattooing" begins as follows:

> I have been told that the fashion of tattooing the arm exists among women of prominence in London society. The taste for this style is not a good indication of the refinement and delicacy of the English ladies: first, it indicates an inferior sensitiveness, for one has to be obtuse to pain to submit to this wholly savage operation without any other object than the gratification of vanity; and it is contrary to progress, for all exaggerations of dress are atavistic. Simplicity in ornamentation and clothing and uniformity are an advance gained during these last centuries by the virile sex, by man, and constitute a superiority in him over woman.

5. Thorstein Veblen, *The Theory of the Leisure Class* (1899) (New York: Penguin Books, 1979), 154: "Considered as objects of beauty, the dead walls of the sides of these structures, left untouched by the hands of the artist, are commonly the best feature of the building."

6. See, e.g., the essays "Ornament in Architecture" (1892) and "Emotional Architecture as Compared with Intellectual" (1894), in Louis Sullivan, *Kindergarten Chats and Other Writings* (New York: Dover, 1979), 187–201.

7. Gertrude Stein, "Why I Do Not Live in America," *Transition,* Fall 1928, reprinted in *How Writing Is Written,* vol. 2 of *The Previously Uncollected Writings of Gertrude Stein,* ed. Richard Bartlett Haas (Los Angeles: Black Sparrow Press, 1974), 51.

8. Greenough declared in 1852 that Beauty is "the promise of Function." Horatio Greenough, *Form and Function: Remarks on Art, Design, and Architecture* (Berkeley and Los Angeles: University of California Press, 1969), 71.

9. "The various classes of workers in society to-day no longer have dwellings adapted to their needs; neither the artisan nor the intellectual. It is a question of building which is at the root of the social unrest of to-day; architecture or revolution." Le Corbusier, *Towards a New Architecture,* trans. Frederick Etchells (New York: Praeger, 1960), 250.

10. Reyner Banham, *Theory and Design in the First Machine Age* (New York: Praeger, 1960), 320–30.

11. Walter Benjamin, "Surrealism: The Last Snapshot of the European Intelligentsia" (1929), in *Selected Writings*, vol. 2, 1927–1934 (Cambridge, MA: Belknap Press of Harvard University Press, 1999), 209.

12. I borrow the concept of "equipment for living" from Kenneth Burke's essay "Literature as Equipment for Living," first published in the magazine *Direction* in 1938.

13. See Walter Benjamin, "The Work of Art in the Age of Mechanical Reproduction" (1936), in *Illuminations* (New York: Schocken Books, 1969), 241–42. On the paradoxical fusion of progressive technology and conservative ideology, see Jeffrey Herf, *Reactionary Modernism: Technology, Culture, and Politics in Weimar and the Third Reich* (Cambridge: Cambridge University Press, 1984).

14. Ernesto N. Rogers, "Programma: Domus, la casa dell'uomo," *Domus* 205 (January 1946): 3–4; translation in *Architecture Culture 1943–1968: A Documentary Anthology*, ed. Joan Ockman, with the collaboration of Edward Eigen (New York: Rizzoli, 1993), 78–79.

15. Ernesto N. Rogers, "Continuità o crisi," *Casabella-Continuità* 216 (April–May 1957): 3–4.

16. Ernesto Rogers, "The Torre Velasca," in *New Frontiers in Architecture: CIAM '59 in Otterlo*, ed. Oscar Newman (New York: Universe Books, 1961), 93. See also Rogers, "L'evoluzione dell'architettura: Risposta al custode dei frigidaires," *Casabella-Continuità* 228 (June 1959): 2–4; translation in *Architecture Culture*, 300–307.

17. Reyner Banham, "Revenge of the Picturesque: English Architectural Polemics, 1945–1965," in *Concerning Architecture: Essays on Architectural Writing Presented to Nikolaus Pevsner*, ed. John Summerson (London: Penguin, 1968), 265.

18. Alison and Peter Smithson, "The New Brutalism," *Architectural Design*, April 1957, 113.

19. Catherine Bauer's comment appears in a letter to Lewis Mumford, January 29, 1932, cited in *The International Style: Exhibition 15 and the Museum of Modern Art*, ed. Terence Riley (New York: Rizzoli, 1992), 209; Rowe's in the introduction to *Five Architects: Eisenman, Graves, Gwathmey, Hejduk, Meier* (New York: Wittenborn, 1972), 4.

20. László Moholy-Nagy, *Vision in Motion* (Chicago: Paul Theobald, 1947), 16, 153, and throughout.

21. Matthew Nowicki, "Origins and Trends in Modern Architecture," *Magazine of Art*, November 1951, 273; reprinted under the title "Function and Form" in Lewis Mumford, *Roots of Contemporary American Architecture* (New York: Reinhold, 1952), 411; and in *Architecture Culture,* 150. On Nowicki, a Polish émigré who died in a plane flight returning from Chandigarh, where he was to have designed the new Indian capital complex (a job that subsequently went to Le Corbusier), see Mumford's four-part article "The Life, the Teaching and the Architecture of Matthew Nowicki," *Architectural Record,* June–September 1954.

22. Ernst Bloch, "Building in Empty Spaces," in *The Utopian Function of Art and Literature: Selected Essays,* trans. Jack Zipes and Frank Mecklenburg (Cambridge, MA: MIT Press, 1988), 187. Bloch continues: "The house without an aura . . . corresponds to the machine that no longer resembles the human being. Functional architecture reflects and doubles the

icy realm of the commodity world [in its] automation, its alienation, its labor-divided human beings, its abstract technology" (196). For Bloch, the utopian function of architecture was to invest the empty space of utilitarian and technical instrumentality with "stimulus, humanity, and fullness"; this fullness he called "organic ornament."

23. Lewis Mumford, "The Sky Line: House of Glass," *New Yorker,* August 8, 1952, 48.

24. For Mumford, see "The Sky Line: House of Glass," 49, and "The Sky Line: United Nations Headquarters: Buildings as Symbols," *New Yorker,* November 15, 1947, 104. Bloch in fact made this remark about washability shortly after World War I, in his book *Spirit of Utopia,* but it comports with his thinking on glass architecture and ornament throughout his career and especially after World War II; see *The Utopian Function of Art and Literature,* 79. More generally on the alienation of postwar life, see Herbert Marcuse, *One-Dimensional Man* (New York: Beacon Press, 1964); and Max Horkheimer and Theodor W. Adorno, *Dialectic of Enlightenment* (1944; New York: Continuum, 1972).

25. See Joseph A. Barry, "Report on the American Battle between Good and Bad Modern Houses," *House Beautiful,* May 1953, 266.

26. Charles Altieri, "Lyrical Ethics and Literary Experience," in *Mapping the Ethical Turn: A Reader in Ethics, Culture, and Literary Theory,* ed. Todd F. Davis and Kenneth Womack (Charlottesville: University Press of Virginia, 2001), 30–58. See also Peter Berkowitz, *Nietzsche: The Ethics of an Immoralist* (Cambridge, MA: Harvard University Press, 1995).

27. Jane Jacobs, *The Death and Life of Great American Cities* (New York: Vintage Books, 1961), esp. 16–25, 433–39.

28. Manfredo Tafuri, *Architecture and Utopia: Design and Capitalist Development* (Cambridge, MA: MIT Press, 1976), 1, 178.

29. Tafuri, *Architecture and Utopia,* 179–82.

30. See "'L'Architecture dans le Boudoir,'" in Manfredo Tafuri, *The Sphere and the Labyrinth: Avant-Gardes and Architecture from Piranesi to the 1970s* (Cambridge, MA: MIT Press, 1987), 267–90.

31. See Tafuri, "The Ashes of Jefferson," in *The Sphere and the Labyrinth,* 301, 303. The passage by Barthes originally comes from *The Pleasure of the Text* (New York: Hill and Wang, 1975), 31.

32. Denise Scott Brown and Robert Venturi, "On Ducks and Decoration," *Architecture Canada,* October 1968, 49; reprinted in *Architecture Culture,* 448.

33. Adolf Loos, "The Principle of Cladding," in *Spoken into the Void: Collected Essays 1897–1900,* trans. Jane O. Newman and John H. Smith (Cambridge, MA: MIT Press, 1982), 67.

34. Samuel G. Freedman, "Frank Gehry's Mideast Peace Plan: Something Israelis and Palestinians Can Agree On: They Hate the Simon Wiesenthal Museum of Tolerance," *New York Times,* August 1, 2004, sec. 2, p. 1. Comment from *Ha'aretz* cited by Freedman.

35. "During some recent work at OMA," Koolhaas said in a lecture in 2000, "we noticed that the signs of the world's major currencies, put together, spell YES. We are working inside this global YES." See Joan Ockman, "The ¥€$ Man," *Architecture* 91, no. 3 (March 2002): 76–79.

36. See Peter Sloterdijk, *Critique of Cynical Reason,* trans. Michael Eldred (Minneapolis: University of Minnesota Press, 1987), 6:

> The characteristic odor of modern cynicism is of a more fundamental nature—a constitution of consciousness afflicted with enlightenment that, having learned from historical experience, refuses cheap optimism. New values? No thanks! With the passing of defiant hopes, the listlessness of egoisms pervades. In the new cynicism, a detached negativity comes through that scarcely allows itself any hope, at most a little irony and pity. In the final analysis, it is a matter of the social and existential limits of enlightenment. The compulsion to survive and desire to assert itself have demoralized enlightened consciousness. It is afflicted with the compulsion to put up with preestablished relations that it finds dubious, to accommodate itself to them, and finally even to carry out their business.

Ethics, Autonomy, and Refusal

HOWARD SINGERMAN

Writing about Chris Burden's *Shoot* for his 1988 retrospective, I didn't think to raise the question of—or to use the term—ethics. For the piece, performed in a storage space turned alternative gallery in Santa Ana, California, in 1971, Burden had arranged to have himself shot at by a friend armed with a .22-caliber long rifle; he was hit—a flesh wound—in the left upper arm. Ethics wasn't a central term in debates around art at the time, at least as I knew them; the "ethical turn," as it is called in recent discussions in the humanities, hadn't yet happened. I read *Shoot* in two directions, first in relation to the war in Vietnam, its actual violence and its televised images, and then with Michel Foucault's brief against humanism in "Revolutionary Action 'Until Now.'"[1] I took Burden's act as an emblematic refusal to surrender power over the body—to inflict pain or to discipline—to the state and its specialists; and even as an attempt to force the state to exercise its power visibly and bluntly, in the name of the law. I read it, then, as critical, and even political; though Burden's own clean, uninflected, even sculptural presentation of the work and its documentation refused to speak on behalf of a political subject. The realness of Burden's act and the specificity of his experience and pain were crucial to the work, and surely there is a suffering or a sacrifice at work, but I didn't think to speak of empathy—ours or his audience with him, or his with the victims of war and violence. Rather than an ethical risking of the self as a way of opening the self out to the other, I read

it, with the artist and critic Robert Horvitz, as a pragmatic instantiation of the self; not a sacrifice of the ego, but a clarifying of it: "Pain, risk, violence, and vulnerability are less salient to the conception of the work than are self- and situational control. . . . He is responsible for, and in that sense has power over, his own fate."[2]

The questions for me then were those of real experience, action, and power, and even now, I must admit, I'm not sure how to address the ethics of Burden's performance, either to judge it ethically or to read it as though that is where its lessons lay. Is it ethical to hurt oneself or worse, to place another through coercion or friendship or power in the position of having to hurt another? Emmanuel Levinas writes that "it is through the condition of hostage that there can be pity, compassion, pardon, and proximity in the world—even the little there is," but is it ethical to turn an audience for a work of art—those assembled that November evening in Santa Ana—into witnesses, to take them, in essence, hostage?[3] Is it ethical to refuse affect or emotion or position? There is an ethics to work on the body, and an ethi- cal dimension to contemporary art practice more broadly, but it's not clear to me what it is, or that it can be given beforehand or produced as a way of judging. And I'm not sure how the questions or demands raised by an ethical criticism relate to or impinge upon aesthetic judgments. I did, by the way, speak briefly about Burden's aesthetics, or cite him on the subject: "They are pretty crisp and you can read them pretty quickly, even the ones that take place over a long period of time. . . . With my pieces there is one thing and that's it."[4] Burden says that rather colloquially, but it might offer, if not a defi- nition, then a contingent description of the object of aesthetics: singular, coherent, bound. Ethics too is a kind of binding, not so much of the object to itself or its self-presentation, but of self to others. It's not clear how those bindings hold together, or maybe it is clear that they don't.

Freedom

First exhibited in Chicago in 1988, about the same time that Burden's ret- rospective was up in California, Mike Kelley's *Pay for Your Pleasure* is some- thing of a primer for the troubled, and even impossible, relationship between ethics and aesthetics. An installation of forty-three large oil-on-plastic ban- ners and one fairly small painting of a sad clown, in oil on canvas, *Pay for*

Chris Burden, *Shoot,* F Space, Santa Ana, California, November 19, 1971

At 7:45 p.m. I was shot in the left arm by a friend. The bullet was a copper jacket and was fired from a .22 long rifle. My friend was standing about fifteen feet from me.
(Chris Burden)

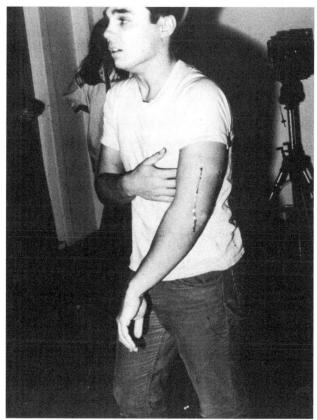

Your Pleasure begins as a survey of those painters, poets, writers, and phi-
losophers who have insisted that the artist should not be bound—and in-
deed cannot be bound—by law or custom, or the community standards that
are usually, and conventionally, what is meant by ethics. One after another
down the hallway in the statements lettered on the sign painter's portraits
Kelley has commissioned, art turns its back on the standards of normative
ethics; proclamations of the artist's separateness resound from every cor-
ner, from the sixteenth-century Pope Paul III ("Men like Benvenuto Cellini
. . . ought not to be bound by law") to romantics like Keats ("What shocks
the virtuous philosopher delights the chameleon poet") to the nineteenth-
century aesthete Oscar Wilde ("The fact of a man being a poisoner is noth-
ing against his prose"). Artists cannot be bound because art requires destruc-
tion, even criminality (Bakunin: "Destruction is creation"; Mondrian: "I
think the destructive element is too much neglected in art"; Degas: "A paint-
ing is a thing which requires as much cunning, rascality, and viciousness as
the perpetration of a crime"). Art and its makers stand perilously close to
the edge of ultimate destruction (Balzac: "I erect myself at the exact point
where knowledge touches madness, and I can erect no safety rail"; William
Carlos Williams: "The imagination will not down . . . if it is not art it be-
comes a crime"; Rimbaud: "I do not understand laws. I have no moral sense.
I am a brute").[5] Kelley's banners, each nearly eight feet high, insist on the
Dionysian destructiveness of art and the absolute freedom of the artist. The
lone argument for an opposing point of view, for the Apollonian or at least
the ameliorative power of art, when *Pay for Your Pleasure* was first installed
at the Renaissance Society of the University of Chicago, hung at the end of
the corridor: a small painting of a clown, in oil on canvas, painted in prison
by the Chicago serial killer John Wayne Gacy. (When the work was installed
later in Los Angeles, that painting was replaced, in a nod to site specificity,
with a drawing by William Bonin, the LA "freeway killer.") "I want to sing
murder, for I love murderers," proclaims Jean Genet from one of Kelley's
banners, but it's not clear that Gacy, who was convicted of the murders of
thirty-three teenage boys in the 1970s, or Bonin, who was convicted of the
murders of fourteen in 1980, is who Genet had in mind. Gacy might fulfill
the vision of the artist as criminal mastermind, driven by his unquenchable
desire ("Those who restrain desire do so because theirs is weak enough to be

constrained," says William Blake from one of the banners), but only when he wasn't painting. The painting that represents him might be the only work of art in the exhibition Kelley has arranged, but from the point of view of the faces and statements that line the corridor, Gacy's painting is the very image of constraint, of the norm; this isn't the murderer Genet sings of, or the brute Rimbaud imagines himself to be, but rather the socialized and broken artist purveying cheap, popular, regularized sentiment and art as therapy.

If one cannot credit either Gacy or Genet with an ethical perspective, perhaps it is Kelley himself who thinks ethically, or who thinks critically about the ethics of the aestheticians he has arrayed to speak for Gacy, or to speak about murder. There are, however, no winners in the face-off Kelley offers. Kelley too has his ethical lapses: one can expect an artist to be responsible for his or her work, and for its making, but Kelley has neither made the banners nor painted the paintings that are exhibited under his name, nor, more troublingly, does he underwrite or secure a meaning or position. And even if these are easy enough to dismiss as part of the practice and the local community standards of contemporary art, there is the far worse problem raised by the museums' acquisition and display of work by mass murderers such as Gacy and Bonin that Kelley makes a condition of the installation as it travels: an exhibit of the work was cancelled in Seattle in 1999 after the local press attacked an assistant curator at the Seattle Art Museum for a four-month-long search on the APB Serial Killers Bureau Web site and elsewhere for a local killer who makes art. There is an active black market for paintings by serial killers and other infamous criminals, a market that has burgeoned thanks to the Web and clearly plays on and profits from the suffering of victims and their families, even as it allows its collectors and exhibitors to imagine, once again, the avant-garde's transgressions, Gacy's crimes, and their transactions as though they were all of a piece. The paintings as art, as Kelley has exhibited them or as they have come to be exhibited in other gallery spaces without even the critical frame he has offered, raise questions and quandaries, and always seem to come to a kind of moral exchange that matches a financial one: "Unlike, say, a Robert Mapplethorpe SM photograph, Gacy's images are innocuous—circus pictures, mostly," writes one Canadian artist and critic. But Gacy's paintings and the critic's liberalism, or perhaps avant-gardism, allow him, once again, to critique community

standards. "In a stirring example of tabloid hypocrisy, the *Winnipeg Sun* reproduced one of the Gacy paintings on its 17 September front page while in the same issue demanding that the paintings not be shown publicly. Obviously, Gacy is not an artist of the caliber of a Picasso, who was a wife abuser, or a Caravaggio, who was a murderer, or a Francis Bacon, who was a thief and a prostitute."[6]

The statements Kelley has lined up along the corridor are inflammatory, or at least that is the way they read here, faced with the mocking face of Gacy's clown. But when Kelley found them in paperback anthologies of artists' writings and art history texts they were, I would imagine, part of an argument for the separateness and specificity not so much of the artist as an individual but of the aesthetic, for beauty as a law, or a responsibility—an ethos—of its own. "Among the ancients," wrote Gotthold Lessing in his *Laocoön*, first published in 1766, "beauty was the supreme law of the visual arts," but it was inseparably linked to the good both performatively and legally: beauty, he reminds us, was legislated by the civil code, however laughable we moderns might think that to be. "The plastic arts in particular—aside from the inevitable influence they exert on the character of a nation—have an effect that demands close supervision by the law. If beautiful men created beautiful statues, these statues in turn affected the men, and thus the state owed thanks also to beautiful statues of beautiful men."[7] Beauty as a law makes demands on the artist in relation to the artistic medium—that is the thrust of Lessing's *Laocoön*, that painting cannot narrate and poetry cannot depict without risking deformation—but it also has real ethical or social effects and responsibilities: beautiful men create beautiful art and vice versa.

Purposelessness

Less than thirty years later, the link Lessing had tried to forge in the figure of the ancients was sundered, or at least troubled, in Kant's *Critique of Judgment*. There Kant argues that the relationship between the beautiful and the good is not a causal but a reflective one; his argument insists from the outset on the aesthetic as a separate mode of apprehension, one that disinterests beauty, and disinvests from the social. If "the beautiful is the symbol of the moral good,"[8] it can be such a symbol—it can symbolize—only through and from its distance: their relationship, Kant explains, is one of analogy rather

than a direct correspondence. The beautiful can figure the good because both are conceived of as wholes or unities, and in and as freedom. The judgment of the beautiful represents "the freedom of the imagination"; that of morality, "the freedom of the will." Wherever there is will, though, there is interest, and while the beautiful "pleases *apart from any interest* (the morally good is indeed necessarily bound up with an interest . . .)" (§59, 199). This distinction situates the beautiful and the good and their images of freedom and of the whole at very different addresses. As Jean-François Lyotard has put it, in Kant, "the disjunction between the aesthetic and the ethical seems final." "Interest is what results in ethics," Lyotard writes. "Disinterest is what initiates in aesthetics."[9] If the beautiful is a sensible symbol of the good, an image of unity of form and thought as it strives toward the unity of reason and the ideal good, this representation, for Levinas, comes at too high a cost and from too great a distance. The beautiful work of art is a façade: it is not open to the world or to the other; it "does not reveal itself." Rather, Levinas argues, it closes in on itself in "indifference, cold splendor and silence": "This is not the disinterestedness of contemplation but of irresponsibility. The poet exiles himself from the city. There is something wicked and egoist and cowardly in artistic enjoyment."[10] I will not try to retrieve the beautiful for the project of contemporary ethics or for the "ethical turn" in the face of Levinas's early critique, for it is not in the image of the whole that Kant and Levinas agree, but in the figure of pain.

For Kant, beauty is tied to the sensible world; it requires an object fitted to and formed in the image of perception: "natural beauty (which is independent) brings with it a purposiveness in its form by which the object seems to be, as it were, preadapted to our judgment" (§23, 83). The unity of the beautiful world matches the unity of the subject; the imagination looks to the world as its mirror. But the ethical requires sacrifice; it is possible only for the traumatized subject, even in Kant, but here let me let Levinas speak first. "Persecution leads the ego back to the self," and it is from "subjectivity understood as a self, from the *excidence* and disposition of contraction, whereby Ego does not appear but immolates itself, that the relationship with the other is possible as communication or transcendence."[11] Kant's analogy of the beautiful and the good works, one could say in Levinas's terms, on behalf of the ego. It is the sublime, in its opposition to the beautiful, that

makes us feel small, that exposes the self as it holds us hostage. The sublime, writes Lyotard, "is none other than the sacrificial announcement of the ethical in the aesthetic field. Sacrificial in that it requires that imaginative nature (inside and outside the mind) must be sacrificed in the interests of practical reason."[12] It is marked and announced by pain, by a falling short of our faculties of perception and presentation in the face of a certain kind of formlessness, boundlessness: "The feeling of the sublime is therefore a feeling of pain arising from the want of accordance between the aesthetical estimation of magnitude formed by the imagination and the estimation of the same formed by reason" (§27, 96). The object of the sublime is not the sensible world or the world of forms, but the mind, and the final object of the sublime, what is figured in our falling short and in sacrifice, is the good itself.

Autonomy

Kant's moral good is absolute; it is the figure of God and what allows at the end of the *Critique of Judgment* for his moral proof of the existence of God. God is a stretch for artists, even artists of genius, and so, too, is the absolute otherness of the work of art that is posited, each in his way, by both Kant and Levinas. "The avant-garde artist or poet tries in effect to imitate God by creating something valid solely on its own terms, in the way nature itself is valid, in the way a landscape—not its picture—is aesthetically valid; something *given*, increate, independent of meanings, similars, or originals." But, as Clement Greenberg continues, "the absolute is absolute, and the poet or artist, being what he is . . . turns out to be imitating, not God—and here I use 'imitate' in its Aristotelian sense—but the disciplines and processes of art and literature themselves."[13] With Greenberg, and particularly in the writings of Michael Fried as they continue and expand Greenberg's arguments, we can return to Lessing's *Laocoön*. Greenberg turns there explicitly in his 1940 essay "Toward a Newer Laocoön," but his is a Lessing not only after Kant but also after Hegel. Greenberg embraces Lessing's link between the beautiful and what is proper to the medium, but he replaces the good that had demanded beauty, and that grew from it, with the history and its necessities. Greenberg's "Newer Laocoön" is, as he put it, a "historical apology" for abstraction, for that painting that imitates (or, in the Aristotelian sense

he refers to, that is determined by and takes as its image) the disciplines and processes of painting itself.[14]

In Michael Fried's "Three American Painters," written in 1965, and in the wake of the history of modernism that Greenberg set in motion in "Avant-Garde and Kitsch" and "Toward a Newer Laocoön," that history will not just be constituted by the artist, but will make moral demands on him: Fried argues for a historical responsibility for the artist that is the equivalent of (and, after Kant, the analogue for) the ethical. He takes the terms for his ethics from the British philosopher Stuart Hampshire; indeed, he uses precisely the terms Hampshire has used to distinguish between artistic choices and ethical demands. Hampshire had argued that "aesthetic judgments are not comparable in purpose with moral judgments, and that there are no problems of aesthetics comparable with the problems of ethics. . . . A work of art is gratuitous. It is not *essentially* the answer to a question or the solution to a presented problem. . . . Action in response to any moral problem is not gratuitous; it is imposed."[15] Fried insists on binding, on an *ought,* if not for aesthetics, then for the painter and the critic; his answer to Hampshire's argument is "yes, but."

> Hampshire's distinction holds good, I think, for all painting except the kind I have been trying to define. Once a painter who accepts the basic premises of modernism becomes aware of a particular problem thrown up by the art of the recent past, his action is no longer gratuitous but imposed. . . . This means that while modernist painting has increasingly divorced itself from the concerns of the society in which it precariously flourishes, the actual dialectic by which it is made has taken on more and more of the denseness, structure, and complexity of moral experience.[16]

In Fried it is not the beautiful that in its proportionality, its fittingness to the world, is the analogue for the good, but rather it is art in both its historical throwness and its historical awareness, in its act in a situation, that is the analogue for the good—and more, a kind of enacted morality.

The separateness of aesthetic after Kant is usually taken, as Greenberg takes it, as historical rather than ontological or categorical. Indeed Greenberg begins "Avant-Garde and Kitsch" by linking the emergence of an avant-garde

and the desire for a work that is "increate, given, whole," to the emergence both of industrial capitalism and its Marxist critique. His mid-nineteenth-century rupture is a double separation; first of the artist from the cultural work of the state, and then of the artist from the state's political adversaries: "Once the avant-garde had succeeded in 'detaching' itself from society, it proceeded to turn around and repudiate revolutionary as well as bourgeois politics. The revolution was left inside society."[17] For any number of writers in the century, the conflation of art with avant-garde practice, and the situation of art on the outside and against society, have been precisely the source of its critical and resistant power, an ethical stance that must remain unannounced. Criticality and resistance are implicit in the work of art that Theodor Adorno posits, a work marked and marred by both its autonomy and its implication in industrial society. For Adorno, the work's precarious criticality hinges precisely on this twofold character; it is both a social fact and . . . an autonomous object: "In its relation to society art finds itself in a dilemma today. If it lets go of autonomy it sells out to the established order, whereas if it tries to stay within its autonomous confines it becomes equally co-optable, living a harmless life in its appointed niche."[18] Thus, "a successful work," that is to say, a critical one, "is not one which resolves objective contradictions in spurious harmony, but one which expresses the idea of harmony negatively by embodying the contradictions, pure and uncompromised, in its innermost structure."[19] Adorno's work of art refers to the beautiful, to "harmony," but here again, as in Kant's sublime, it is a negative presentation; the artwork is constructed by lack, incomplete at its center, but it is just this combination of the promise of cultural or aesthetic unity and the work's discord that forms the criticality of the work of art, and that criticality is inseparable, immanent to the work. Like Fried's work of art bound to its specific history, a work of art that embodies and answers to a historical demand, Adorno's works too suggest what might be called an ethics, a determinate action that sets them against other kinds of actions.

> Works of art are tied up with specific modes of behavior; indeed, they *are* modes of behavior. . . . [Art] gives lie to the notion that production for production's sake is necessary, by opting for a mode of praxis beyond labor. Art's *promesse du bonheur*, then, has an even more emphatically

critical meaning: it not only expresses the idea that current practice de-nies happiness, but also carries the connotation that happiness is some-thing beyond praxis. The chasm between praxis and happiness is surveyed and measured by the power of negativity of the work of art.[20]

Ethics, too, is a mode of behavior, one that runs parallel to, but cannot be conflated with, the autonomy of art, or the autonomous work—here Adorno, like Fried, assumes Kant's aesthetic realm, and has situated it as an analogue not to the moral good as such or in its form, but to behavior, choice, action.

Professionalism

Fried's "Three American Painters" and the essay "Art and Objecthood," which followed it in 1967, have long been seen as marking the end of something. Perhaps one of the things that ended in the 1960s was the functional belief in Kant's analogue, or at least in the efficacy of aesthetic autonomy. What replaces it is the demand for commodity on the one hand, in an increasingly avaricious art world, and for commitment on the other. More and more, the site or the terms of judgment rest not with the specificity of the work of art, and its separate and particularly bound address to its medium, but in a discourse that has increasingly understood art's historical demand literally and translated it as politics. Despite the work he held out for, Adorno had forecast the collapse of its difference and its resistance under the pressures of the "culture industry" on the one hand and of the demands for "commit-ment" on the other. In either case the work of art in its dividedness was solved and surrendered to the world of commodity and exchange: in the for-mer case to the museum's array of "works of art decaying side by side in a pantheon of optimal edification, decaying into cultural commodities"; and in the latter case, "the notion of a 'message' in art, even when politically radical, already contains an accommodation to the world: the stance of the lecturer conceals a clandestine entente with the listeners, who could only be truly rescued from illusions by refusal of it."[21] And again in either case, interestingly, they end up in a kind of classroom, reduced to content, to ed-ification—the "good-for-you" of culture or of political action. The classroom that Adorno and Greenberg scorn—"Picasso's shows still draw crowds, and T. S. Eliot is taught in the universities. . . . Academicism and commercialism

are appearing in the strangest places"[22]—has also been since the 1960s a particularly important site for an increasingly professionalized and institutionalized art world, one that over the past four decades has increasingly recast the separateness of the aesthetic realm as professional specialization, and that has taken the "problems thrown up by the art of the recent past" as professional and institutional in nature.

Allan Kaprow writing in the early 1960s is perhaps the primary theorist of this classroom and its professional demands. Artists now, he wrote in 1964, "do not live very differently from anyone else. Like anyone else, they are concerned with keeping the rooms warm in winter, with the children's education, with the rising cost of insurance. . . . [But] their actual social life is usually elsewhere, with clients, fellow artists, and agents, an increasingly expedient social life for the sake of a career rather than just for pleasure. And in this they resemble the personnel in other specialized disciplines and industries in America."[23] Specialists and experts, these artists are the outcome of Adorno's "Dialectic of Enlightenment," the products of a rationalized and increasingly smooth system of production and consumption. "Artists are called upon to lecture and participate in panel discussions, to appear on radio and TV, where what they say is increasingly attended to as their work is admired. . . . Essentially, the task is an educational one. . . . Their job is to place at the disposal of a receptive audience those new thoughts, new words, new stances even, that will enable their work to be better understood."[24] Here, in these classrooms, in front of these audiences, "resistance," "critique," "beauty," and now "ethics" have become important to art, or rather to young artists, as professional career demands, just some of the necessary new words and new stances. "What kind of work should I be making anyway?" asked a University of Illinois student to a panel composed of Vito Acconci, Suzi Gablik, and Carol Becker on "social responsibility and the role of the artist in society."[25] That question might be an ethical one; its "should" might mark a preexisting responsibility to the other, one that holds the artist hostage, and that comes before freedom. "To be a 'self' is to be responsible before having done anything. It is in this sense to substitute oneself for others."[26] But given where and to whom it was posed—a panel of teachers, of exhibiting artist and published critics—it could also have been a professional question.

"Ethics" now works where politics or critique once did, a displacement that is made clear in the title of an essay by one Tsjalling Swiestra in the journal *Philosophy and Technology*, "From Critique to Responsibility: The Ethical Turn in the Technology Debate." Indeed, ethics might be seen not only as a substitution but also as a sublimation of both terms, and of the term community as well. "The heart of ethics is the desire for community," writes Tobin Siebers in *The Ethics of Criticism*,[27] but what would it mean if that community were not imaginary but the community that Kaprow describes, one in which professional, institutionally mediated engagements are bound up with ethical ones? Ethics, as it is used, is in some sense politics without a target or rift, and community without identity or membership or exclusion; it is a return to the humanist subject not only as he is traumatized and lacerated in Levinas's hostage scenarios but as he enlarges and imagines and identifies, as a subject and a professional. "Ethics has gained new resonance in literary studies during the past dozen years," wrote Lawrence Buell in 1999, "even if it has not—at least yet—become the paradigm-defining concept that textuality was for the 1970s and historicism for the 1980s."[28] Aesthetics in the academy, long a philosophical subdiscipline or a psychological stepchild, has also, as Mary Devereaux writes, "benefited from 'an ethical turn': a revival of long-standing debates about the moral function of narrative and the social impact of the arts. This development has drawn aestheticians into current political debates concerning public funding for the arts, the function of public art, and the cultural value of arts education. Clearly, the 'dreary decades' in aesthetics, so famously lamented by John Passmore, are over. Aesthetics is now, most people acquainted with the field would agree, a lively and attractive discipline."[29] Buell and Devereaux assume the value of art, and of ethics, precisely as they are delivered to the culture industry, as they are good and, maybe, popular.

Refusal

I do not want to end up dismissing the ethical turn, and I'm sure there will be those who find my cynicism too easy. There are ethical questions raised by art practice, both in its public or professional sphere, by its practitioners, and in or in proximity to works of art themselves. What there might not be still are answers to the questions what is to be done, or what should I be

doing—questions to which "politics" answers far more clearly, if often more dangerously and stupidly, than ethics does; like aesthetic judgments, ethical judgments cannot, it seems to me, be made beforehand and outside the specifics and particulars of a situation. In the 2002 exhibition catalog *Painting on the Move*, the critics Thierry de Duve and Douglas Crimp, the former a strong voice for the possibility of painting in the past two decades, and the latter the author of, among other essays, "The End of Painting" in the early 1980s, both invoked the ethical, a turn (or term) that was, until recently, relatively rare in art critical discourse. Here is de Duve: "The best painters don't let their ideas, their ideals, their political or metaphysical beliefs, interfere with their practice. Brush in hand, a good painter wants to be a painter and nothing else, even if he feels flattered in his sense of self-pride by the mission of saving the world that the surrounding culture lends to him. The ethic of the artist resides in respect for his medium, and the decisions he takes are aesthetic and technical."[30] As Fried had done, and as a number of other writers on the ethics of painting have done in recent years, de Duve situates painting's ethical possibility in the medium and its specificity, but he drops out Fried's appeal to history and painting's critical relation to its past. Good paintings—in both senses of the word "good," perhaps—are their own reward, the most, and least, one could want for. De Duve points to Robert Ryman, who wants, he says, to be "a painter and nothing else." Crimp also points to Ryman and suggests a certain kind of humility that is for him the same as, or an emblem for, the ethical. Calling for "a renewed aesthetics of affect and ethics," which he is quick to separate from the nostalgic call for a return to the authentic or original, Crimp comes to find that, after the utopian claims of modernist painting and the nostalgia and bombast of the 1980s "return to painting," modesty might be the most ethical approach. "Beyond [Richter, Ryman, and Warhol], painting's contemporary achievement is modest. But perhaps modesty is itself a significant, even ethical accomplishment under current circumstances. . . . I'm not sure that painting *in and of itself* achieves anything any longer or that there are any tasks specific to it. Maybe this, too, is what I mean by 'modesty.'"[31]

Despite their differences, de Duve and Crimp both align the ethical with a limit or a renunciation. To go through Crimp's list, Richter and Warhol have both used photography, repetition, and genre to renounce the coherence of

style and the singular, demiurgic artist, to refuse his claims to speech, to creativity, to heroism. Ryman, who has painted white paintings since the early 1960s, is clearly an artist who has stuck to his professional last, as it were. He seems the very image of an ethical artist—almost professionally so—one who continues to be honest to the questions he asks of his medium, or of himself, who avoids faddishness or stylistic shortcuts or signatures. The work itself echoes these renunciations; what looks best, or most ethical, one could say, might be just those artists who make tough-minded monochromes over long periods of time—the more denials the better.

Finally, in relation to an art of vision, it seems ethics names a renunciation or limit, a refusal to be seen. That is how it operates and, paradoxically, how it becomes visible. In the midst of my first draft of this essay, the Venezuelan artist Javier Tellez publicly announced his refusal of "the official invitation to represent Venezuela in the national pavilion of the 50th Venice Biennial":

> This decision is a fundamentally ethical one and I have taken it as a Venezuelan and as an artist responsible and aware of our reality. . . . Having been presented in several international exhibitions of this nature (including the last Venice Biennial) I know through my own experience the importance that is put upon any artistic career by being included in these events. But I consider that my main duty is to foreground my ethical responsibility over any personal interest. I must forget myself to have access to the other was for the philosopher Emmanuel Levinas one of the best definitions of an ethical conduct, creating a paradigmatic concept for all artists or cultural producers. This model of commitment can describe the foundations of an ethic based on respect of difference and the intention to incorporate the other within artistic discourse. . . . To participate in the official selection in this situation, under the patronage of the state, would be in some way a betrayal of the principles on which I have built my body of work for over a decade, principles that have always placed me side by side with the excluded ones of our society, those invisible subjects within the social fabric: the mentally ill confined in psychiatric hospitals, prisoners or the populations of shanty towns. I have never believed in the autonomy of the work of art over the social

context and believe that the Venezuelan pavilion today embodies a toxic environment that would inevitably contaminate the reading of any work of art that deals with social inequality. Especially in moments in which the manipulation of information, violence, populism, intolerance, and nationalisms constitute the political discourses shared by the state and the official opposition. The terrible polarization that literally has divided the country in two makes it impossible to articulate a critical position that can operate in-between these irreconcilable dichotomies.[32]

Tellez has refused to participate, and his refusal of art as and in the name of the artist is perhaps the ethical stance art can now take. But ethics here belongs to the artist as practitioner, and as human, rather than to the realm of the aesthetic or the work of art as an analogue for human behavior. It is also, as Tellez makes clear, different from a critical stance, a stance that for him there is no place or room to articulate. While ethics has in some sense come to occupy the place of critique or of politics in the discourse of the art world (and in art-world politics, where these things are worth something, part of what can be forwarded, used, or renounced), critique and politics are ventures or adventures; they posit something. The ethical, Tellez suggests, is primarily a responsibility, a first and binding responsibility that precedes and even precludes freedom, aesthetic or otherwise.

Notes

1. Howard Singerman, "Chris Burden's Pragmatism," in *Chris Burden: A Twenty-Year Survey,* ed. Anne Ayres and Paul Schimmel (Newport Beach, CA: Newport Harbor Art Museum, 1988), 19–29.

2. Robert Horvitz, "Chris Burden," *Artforum,* May 1976, 30, cited in Singerman, "Chris Burden's Pragmatism," 19.

3. Emmanuel Levinas, from "Substitution," cited in Simon Critchley, "The Original Traumatism: Levinas and Psychoanalysis," in *Critical Ethics: Text, Theory and Responsibility,* ed. Dominic Rainsford and Tim Woods (New York: St. Martins, 1999), 90. Burden would perform a more literal hostage taking two months later in the piece *TV Hijack,* in which he held a knife to the throat of Phyllis Lutjeans, a local public television host, and demanded the show they were taping be broadcast live.

4. Chris Burden and Jan Butterfield, "Chris Burden: Through the Night Softly," *Arts Magazine* 49 (March 1975): 69.

5. All forty-four quotations are included in checklist of the catalog *Mike Kelley Three*

Projects: Half a Man, From My Institution to Yours, Pay for Your Pleasure, ed. Suzanne Ghez (Chicago: Renaissance Society of the University of Chicago, 1988), 28–29. See also the discussion of the piece in my essay in the catalog, "Mike Kelley's Line," 5–13.

6. Cliff Eyland, "On Temples, Trials and Taste: Paintings by John Wayne Gacy," *Mix Magazine* 22, no. 3 (1996): 61; available online at http://www.umanitoba.ca/schools/art/content/galleryoneoneone/gacy.html.

7. Gotthold Ephraim Lessing, *Laocoön: An Essay on the Limits of Painting and Poetry,* trans. Edward Allen McCormick (Indianapolis: Bobbs-Merrill Library of the Liberal Arts, 1962), 14–15.

8. Immanuel Kant, *Critique of Judgment,* trans. J. H. Bernard (New York: Hafner, 1951), §59, 199. All further citations will be given in the text.

9. Jean-François Lyotard, *Lessons on the Analytic of the Sublime,* trans. Elizabeth Rottenberg (Stanford: Stanford University Press, 1994), 163, 171. The conclusion Lyotard comes to on the relationship between ethics and aesthetics in Kant is quite different from the one Tobin Siebers draws in his influential *The Ethics of Criticism* (Ithaca: Cornell University Press, 1988), that "Kant worked to resolve the conflict between ethics and aesthetics . . . by giving aesthetics a creative role within the practice of ethics" (23).

10. Emmanuel Levinas, from *Totality and Infinity* and "Reality and Its Shadow," cited in Robert Eaglestone, *Ethical Criticism: Reading after Levinas* (Edinburgh: Edinburgh University Press, 1997), 109, 117.

11. Levinas in Critchley, "The Original Traumatism," 94, 90. In the initial translation of Levinas's "Substitution," a translator's note by Robert Bernasconi defines "exidence" as "'extirpation, destruction.' It is an unusual word, deriving from the Latin *excido* (whose root is *caedo*), which means 'to cut out' or 'to cut off.'" In *Emmanuel Levinas: Basic Philosophical Writings,* ed. Adriaan Perperzak, Simon Critchley, and Robert Bernasconi (Bloomington: Indiana University Press, 1996), 183 n. 38.

12. Jean-François Lyotard, "After the Sublime, the State of Aesthetics," in *The Inhuman: Reflections on Time,* trans. Geoffrey Bennington and Rachel Bowlby (Stanford: Stanford University Press, 1991), 137.

13. Clement Greenberg, "Avant-Garde and Kitsch," in *Perceptions and Judgments,* vol. 1 of *Clement Greenberg: Collected Essays and Criticism,* ed. John O'Brian (Chicago: University of Chicago Press, 1986), 8.

14. Greenberg, "Toward a Newer Laocoön," in *Perceptions and Judgments,* 37.

15. Stuart Hampshire, "Logic and Appreciation," in *Aesthetics and Language,* ed. William Elton (New York: Philosophical Library), 162–63.

16. Michael Fried, "Three American Painters" (1965), in *Art and Objecthood: Essays and Reviews* (Chicago: University of Chicago Press, 1998), 219.

17. Greenberg, "Avant-Garde and Kitsch," 7.

18. Theodor Adorno, *Aesthetic Theory,* ed. Gretel Adorno and Rolf Tiedemann, trans. C. Lenhardt (London: Routledge and Kegan Paul, 1984), 337.

19. Adorno, "Cultural Criticism and Society," in *Prisms*, trans. Samuel Weber and Shierry Weber (Cambridge, MA: MIT Press, 1981), 32.

20. Adorno, *Aesthetic Theory*, 17–18.

21. Adorno, *Aesthetic Theory*, 301, 317.

22. Greenberg, "Avant-Garde and Kitsch," 11.

23. Allan Kaprow, "The Artist as a Man of the World," in *Essays on the Blurring of Art and Life*, ed. Jeff Kelley (Berkeley: University of California Press, 1993), 48.

24. Kaprow, "Artist as a Man of the World," 52, 54–55.

25. Carol Becker, "Speakeasy," *New Art Examiner* 18, no. 6 (February 1991): 15.

26. Levinas, "Substitution," in *Basic Philosophical Writings*, 94.

27. Siebers, *Ethics of Criticism*, 202.

28. Lawrence Buell, "Introduction: In Pursuit of Ethics," *PMLA: Publications of the Modern Language Association of America* 114, no. 1 (January 1999): 7.

29. Mary Devereaux, "The Philosophical Status of Aesthetics," *American Society for Aesthetics Newsletter* online, http://www.aesthetics-online.org/ideas/devereaux.html.

30. "A Century of Contemporary Painting: A Conversation between Bernhard Mendes Bürgi and Thierry de Duve," in *Painting on the Move*, ed. Bernhard Mendes Bürgi and Peter Pakesch (Basel: Schwabe, 2002), 39.

31. "There Is No Final Picture: A Conversation between Philipp Kaiser and Douglas Crimp," in *Painting on the Move*, 178–79.

32. Javier Tellez, "Open Letter," distributed through Electronic Flux Corporation, www.e-flux.com, March 2, 2003.

2 Overlaps
ART AND ARCHITECTURE

Zaha Hadid, Drawing for Peak Competition, 1983

Notes on an Ethical Context for Fragmentation, Continuous and Multiple Grounds, and Other Open Fields of Action

ROBIN DRIPPS

The last two decades have witnessed the emergence of a body of architecture that is difficult to assess within conventional critical frameworks. The overlapping, splintered planes that seem to defy gravity, resist closure, and escape easy description are indeed perplexing when viewed within a formal context where a simple hierarchy of geometrical forms was able to represent a roughly corresponding hierarchy of public institutions and situate these safely within a chaotic natural world. The fragmented, repetitive, and open-ended fields that favor emergence, process, and experience more than a priori conceptual models cannot but produce structures difficult to assimilate into the present landscape of autonomous objects. Finally, the experience of a place through movement reveals such an extended range of viewpoints that the representational and experiential frameworks that have served stable figures at rest are no longer adequate.

The longevity of a figural tradition of architecture has allowed for the development of a framework for its understanding, use, and criticism that unfortunately makes alternatives to this tradition seem oppositional and problematic. This need not be the case. If we could understand that there is an equally long history of thought that has focused on the vast and often unobserved world beyond the figure, a history of thought more cautious about the premature closing of the figure to what is beyond, then we might

Leonardo da Vinci, *Study of*
Human Proportions in the
Manner of Vitruvius, ca. 1492

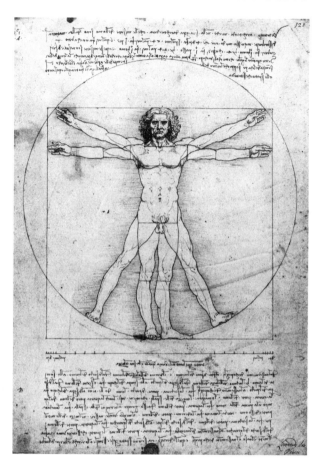

be able to recognize the social, political, and ecological potential of this new architecture.

Architecture is fundamentally a political activity. Whether by intention or accident its artifacts represent possibilities for how people relate to one another and how individuals as well as communities engage the natural world. Leonardo's drawing of the Vitruvian figure circumscribed within circle and square is a perfect example of a world construed from the perspective of a privileged protagonist securing stability within an unstable context. The

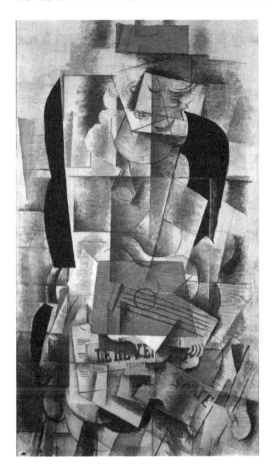

Georges Braque, *Girl with a Guitar*, 1913. Oil on canvas, 130 x 73 cm.

drawing constitutes a basis for the simple hierarchical structure of much premodern architecture, but has even more significance as an analogue for things well beyond the constructed environment. The stability that Leonardo projects is due to the security of an inherently closed system of relationships. The centered human is master of all that is within the safety of its circumscribed world. Human action within this defined territory can be understood with compelling clarity. Within the protection of the circle, human inquiry is free to test the limits of the figure's artificially imposed boundary

and incrementally bring understanding, order, and a degree of control to an ever-increasing domain. The individual human might be replaced by a larger and more complex institution, the enclosed field could become more articulate and varied, and the form of the boundary might take new and even surprising form, and yet the fundamental relationships remain. A bounded and understandable inside has been distinguished from a boundless, chaotic, and possibly hostile outside. In countless manifestations, this oppositional construct has provided the structure for humans to make sense of a world that was not of their own making. As with all reductive paradigms, there are problems. Leonardo's circle exists in a void. There is nothing for this man to engage. The background patterns of everyday life, the forms, processes, and materiality of nature as well as all the messy things that fail to conform to this totalizing schematic have been erased. Must we assume that the vitality, the fluidity, the surprising interconnectivity of things outside human control have no place within the physical and intellectual closure of the figure?

Of course not, as we can see in Georges Braque's 1913 painting *Girl with a Guitar*. Instead of all that empty space both inside and beyond Leonardo's circular figure, Braque renders his canvas overflowing with the energies of a vital ground already engaged in a much larger network of connectivity. His figure and her musical instrument might once have commanded a central position but are now shown to be disassembled, dispersed, and opened up to multiple relationships with this invigorated ground. The hegemony of Leonardo's figure over its missing ground is replaced by a ground so strongly rendered that it now holds as much attention if not more than its nominal figural subjects. This is no singular construct, however. The dense gridding, the faceted surfaces, the palpable materiality, and the contradictory chiaroscuro reveal the presence of a varied background texture the parts of which are actively engaged in configuring and reconfiguring multiple relationships with one another in order to link the guitar player to her surrounding world.

It would be too easy to assume that the differences between these two representations are only the result of an ineluctable historical evolution. This, however, misses the point. Leonardo's *Vitruvian Man* is actually nowhere to be found in Vitruvius's original treatise. Instead Vitruvius himself

describes the impromptu gathering of individuals who, finding it pleasurable to be together after fleeing the heat of the burning forest, invent a rudimentary language as the first step toward establishing political order. This linguistic structure is the enabling construct that allows the assembly to formulate relationships among its individual members and then becomes the means by which they revisit the forest but now on their own terms. Man, per se, was not at the center. Instead the center was reserved for the more ambiguous fire, around which this nascent polity had gathered. Although the fire protected the human from the wild, it was just as much a part of that same wild, a force outside human understanding and control. The edge of the clearing was just as problematic. Seen from inside, the forest edge could be construed as of human intent, but then this same edge was just as obviously a part of the forest's vast, unbounded extent. Both center and edge are plagued or perhaps animated by their oscillating allegiances to human intent and natural force or between figure and ground much the way figure and ground interact in the Braque painting. In other words, already in the first treatise on architecture, where humans make their crucial intellectual rather than instrumental distinction between themselves and the other animals of the forest, Vitruvius hints at a place with the appropriate complexity and ambiguity to also bring these two entities back together.[1]

The same tension can be seen in looking at two of Sebastiano Serlio's stage sets for the classical theater. The world Serlio shows in his ideal Tragic Scene is hierarchically structured around the vanishing point of a single-point perspective and further controlled by its homogenizing grid. It is a circumscribed world of artifice, perfectly and predictably ordered by its human inhabitants. There are numerous examples of just such an ideal city that could have been the basis for Serlio's example. More interesting is his representation of the Satiric Scene. The word *satire* itself describes a medley, a full dish loaded with a great variety of apparently unrelated things. The variant *satyr* refers to a woodland god that is half-human and half-animal. Although the scene is also organized by single-point perspective, it seems as if this device is only barely able to hold things together. The controlling grid that dominates the Tragic set exists in the Satiric only by implication, its abstract lines replaced by actual stones displaying enough particularity and enough freedom for these to have their own voice. As could be anticipated

Sebastiano Serlio,
Tragic Scene, 1611

from its connection to a god existing as both human and animal, the scene
is set in a forest easily inhabited by rustic huts. Human artifice and natu-
ral structure commingle with ease. Idiosyncrasy of all sorts is tolerated and
yet registered against a normative perspectival order. Pictorially, there is the
same fluctuant gridding, the same faceted surfaces, and the same textural
density found in the Braque that reveals a background as compelling as any
figure.

When attention shifts from the closed form of the figure to the nonhi-
erarchical, open structures of the grounds, fields, and webs that are found
in the Satiric Scene, there is more than just a shift in pictorial interest. Fig-
ures achieve their authority through intense focus and exclusion. They are
fixed in our imagination owing to the singular clarity of their meaning. Their
formal gestalt is already complete, so that expansion, extension, and other
forms of connectivity are limited. Grounds, fields, and webs, with their mul-
tiplicity, tend to be fuzzy, directing attention toward the periphery, where
they extend well beyond our understanding and reach to connect to a larger

Sebastiano Serlio,
Satiric Scene, 1611

and more complex world. In contrast to figures, which are exclusive, open
systems are unlimited in what they might include.[2]

 We might suppose that the premise itself of an ideal city would have to
be abstract, reductive, and singularly focused on the willed actions of hu-
man agency. This is certainly borne out by Piero della Francesca's *Ideal City*,
which is little removed typologically from the schematic diagram of Leon-
ardo, or Serlio's Tragic Scene. If, however, we look to the earlier *Allegory of
Good Government* by Ambrogio Lorenzetti, then a very different set of pos-
sibilities is revealed. Presuming that good government falls into the category
of the ideal, we find in Lorenzetti's frescoes compositional strategies closer
to Braque. Instead of the singular view of one-point perspective with its re-
sultant spatial depth moving ineluctably toward a vanishing point, here are a
series of shallow layers slicing through his pictorial space and accommodat-
ing a surprisingly diverse and rich panoply of activity. Lorenzetti has con-
structed an urban field of repetitive window patterns, horizontal and vertical
building edges, roofs and cornices that weave these shallow layers together

while seeming to be oblivious to the facts of the implied spatial depth between them. The same faceted, oscillating surfaces noted in Braque as well as Serlio are the dominant pictorial reading and establish a dense network of connectivity between the animate as well as constructed players.

Evident in these examples are two broadly different ways of representing and, therefore, understanding the world. The first, a preference for closure, finds the inevitable confusion of the immediate present to be problematically chaotic and proposes models that subsume the apparent randomness within a comprehensive whole. A synthetic whole is made through abstraction. The prevalent overabundance of particular, idiosyncratic, or otherwise unique qualities is made intelligible by a process of representation weighted toward finding common qualities and therefore suppressing or veiling much "superficial" detail. Any such editorial process must, obviously, have an author, or some form of authority to be able to make such decisions, creating another filter by means of the necessarily singular perspective directing matters. As a consequence, these models will be hierarchical, reductive, and closed. Attention will go to the outline, since it most effectively defines the model and is the means by which it is distinguished from its context. Surfaces will be solid, smooth, and opaque, so that the inner workings are inscrutable and unavailable to challenge. Closure also establishes an asymmetry across its edges. What is inside and better known is valued differently from the vast, apparently undifferentiated field or ground that is outside, which then leads to the desire to restrict physical as well as metaphorical passage between inside and out.

Piero della Francesca, *The Ideal City*, 1470

The published lessons of J. N. L. Durand, developed while he taught theory at the Ecole Polytechnique, reveal a radical break from the more messy mythical musings on the origins of architecture that had previously been the basis of architecture thinking. As part of the new Enlightenment thinking, Durand demonstrates an unsentimental and almost scientifically rigorous system for assembling parts into larger and larger entities. Notable is the prevalence of a guiding system of underlying axes that controls every decision along the way. Nowhere is there a hint of any preexisting context or of any idiosyncratic particularities of its eventual inhabitants that would interfere with the ineluctable march of this wholly autonomous process. The transformational possibilities shown in Durand's explanatory diagrams are limited to those that maintain the inwardly directed moves that reinforce the center. These have such a compelling internal logic that any external condition that might open this up would only be seen as an unwelcome disturbance to its impressive coherence. Without a place for the rich variety of social, political, and ecological forces at work just outside this compositional window, Durand's figures ultimately became vulnerable to conditions they had never been set up to accept.[3]

The second approach, a preference for openness, is in many ways a reaction to this desire for closure, but when examined more on its own reveals surprising potential. The whole is a given in this approach, but instead of

Ambrogio Lorenzetti, *The Allegory of Good Government,* 1338–39. Fresco on the walls of the Palazzo Publico, Siena, Italy

operating as an accepted conclusion, it is seen as an emergent beginning. There is skepticism toward its opacity and worry that its closure is premature. The desire will be to open up this whole and peer inside in order to understand what makes it hold together. Once open, there will be the inevitable questioning of decisions about relationships and particular choices made regarding what is included or excluded. There will be a studied multiplicity of readings that supplant the hegemony of a singular perspective and the resolved antithesis of oppositional pairings.

When figures or other closed entities are opened, however, they will inevitably be transformed. An open figure establishes a very different relationship with the physical and cultural context that grounds it in the larger world. The fissures, cracks, and other omissions in the once inviolate boundary of the figure, allow its interior life to productively engage the outside world. This world too will alter. In a closed figure, the desire to be on the metaphorical inside is so powerful that the more extensive domain beyond is reduced to the general consideration of just being something out there. Yet when the exterior is permitted to engage the figure on equal terms, the grounds, fields, and other systems that make up the outside reveal an inherent level of differentiation, complexity, and fugitive connective potential that is remarkable. When we understand that these other structures include the myriad processes of nature, the background structures of everyday life, and entire ethnic, gender, racial, and economic constituencies that have been neglected, then the potential coming from their revaluation is enormous, and enormously challenging to any closed form.

The formal response to these conditions will be highly articulate structures whose many parts can be readily identified, separated, and then deliberately displaced, shifted, rotated, or otherwise transformed so they can engage in other continuities. When there is a multiplicity of readings, parts take on deliberately compound identities. Forms, therefore, will be faceted, prickly, transparent, and elusive. There will be a new lexicon of transects, slices, slots, and other fissures or omissions in the continuity of edges that promote more fluid passage among multiple locations. Furthermore, the extensive structure of the ground's repetitive patterns, its seams and gaps, now becomes a constituent part of an emerging hybrid figure that is open, ambiguous, mutable, and continually unfolding.

These two fundamentally different ways of seeing things have coexisted with varying degrees of harmony or hostility for long enough that we can now understand the complex interchanges and dependencies that continue to keep their necessary pairing operative. However, theories of representation as well as theories of making seem to be underdeveloped when having to deal with processes that are open, changeable, and whose formal outcome lacks the immediately legible gestalt of the closed figure. The aims of figuration are mostly inherent in the form itself and readily deduced by simple examination of its external aspect. The geometrical elegance of pure form, for instance, has served to order as well as to act as metaphor for countless human aspirations. Compared to this, the deliberate fluctuations of appearance of open form, where readings are not immediate but emergent and unfolding, can be initially disconcerting. With a shift in focus from object to relationship and from closed to open form, process of all sorts becomes more important and yet again more difficult to grasp without more inventive ways to represent the vital forces of life that remain hidden.

This was exactly what Etienne-Jules Marey set out to do in the mid-nineteenth century. A self-proclaimed biologist-mechanist, Marey spent his life experimenting with devices designed to reveal a structure of animate life that he believed was beyond the grasp of human vision. Notational devices linked to sensors capable of detecting the slightest tremor automatically recorded these vital traces, and thus eliminated the human intermediary, whose complications and distortions he thought prevented access to reality. By capturing and analyzing the most hidden and turbulent forces, he put forward the thesis that life was movement and nothing else. His mechanisms revealed an articulate structure for motion that was at odds with the conventional understanding of its being a homogeneously continuous and gradual change. Instead, Marey's graphic traces of the provocative rhythms, rustlings, muffled pulses, surges, and ruptures of the inner world that he discovered could be seen as ciphers for the inner workings of life itself, or perhaps nature's own expression, without filter, echo, or interference: it was faithful, clear, and, above all, universal. By peering into the closed forms of life, Marey made it possible to imagine continuity among different forms of life that had previously been considered separate.[4]

Although this was work at the defining edge of modern scientific research,

Etienne-Jules Marey, *Motion Study.* Chrono-photograph, ca. 1886

Marey's desire to understand the workings of a world beyond immediate sensual apprehension and its evocative graphic traces has also proven to be catalytic for research in art, film, and architecture at various moments when these disciplines also desired to open up form and look into the inner workings of things that had remained in the shadows.

Much the way Marey's hypotheses were a direct challenge to the vivisectionists, who drained the life from their subject in a failed attempt to locate its vitality, the Italian Futurist artists challenged the still life or nature morte by celebrating just those qualities that resisted the stabilizing closure of classical composition. These artists, poets, musicians, and architects looked at human and mechanical motion as well as the dynamic pulse of the emerging modern city and proposed this to be the essence of a new modern human condition. Although the subject of movement had long fascinated artists, the Futurists wanted to go well beyond the surface appearances of things in motion in order to reveal the workings of an internal structure hidden by previously closed surfaces. The movement they discovered and then represented was not smoothly continuous but a frenetic pattern of overlapping lines and discontinuous intersecting arcs moving increasingly outward. Although figures are clearly present, their gestalt must be deduced from the many separate pieces tending to go their own way. Even more present than these figural fragments, however, is a very different form of background. The

silent, empty, and inarticulate background of the still life now has a life of its own. Space is no longer understood to be an abstract void without the requisite substance needed to engage its figures but a substantial and extensive entity with a discernible, articulate structure just as valued as the figure. In other words, by revealing the inner structure of movement, these artists made visible a world beyond the figure and gave the figure itself a means to engage this medium.

The explorations of Futurist artists are typically presented as an inevitable outcome of unprecedented changes taking place at the beginning of the twentieth century. While mostly true, this assessment should not blind us to the work of artists operating much earlier whose work showed an equally strong desire to open up and expand the figure's capacity to engage the rest of the world.

Uccello's 1456 painting *The Battle of San Romano* bears a striking resemblance to Boccioni's 1915 *Charge of the Lancers*. Uccello portrays a wild proliferation of intertwined lances extending the reach of the battling human figures into a surrounding field of trees, such that figure and ground are enmeshed and almost indistinguishable from one another. The lances attenuate the human figure, drawing attention away from its solid, contained center and toward a defuse periphery shared by other lancers as well as the similarly rendered forest. Instead of representing the figure through outline and therefore emphasizing its opacity, Uccello's fragmented, discontinuous edges show how even within the stasis of a painted canvas, the inner life of his figures can move outside and be part of this larger external world. By elevating the representation of a complex field of action over that of a lone heroic figure, both painters open up and expand the heroic theme of battle to portray the chaotic interplay of human and natural forces.

At the same time that Futurist painters were revealing the charged nature of space, their musician colleagues were finding it possible to fill this space with sounds rarely considered the subject of music. In 1913 Luigi Russolo, a painter turned composer, wrote *The Art of Noise,* a manifesto determined to break the "limited circle of pure sounds." His starting point was the infinite variety of noises produced within the modern industrial city. Russolo argued that sound, a product of human artifice, was so limited by its hierarchical tonal structure and the inherently narrow acoustic range of its traditional

Umberto Boccioni, *The Charge of the Lancers,* 1915

instruments, that it was unable to be a compelling part of this new city filled with noises never imagined by the ancients. "We find far more enjoyment in mentally combining the noises of trams, backfiring motors, carriages and bawling crowds than in re-hearing, for example, the 'Eroica' or the 'Pastoral.'" Noise, argued Russolo, had become the ubiquitous background of the modern city. Noises of all kinds were now so familiar that they would be more compelling in drawing people into the dynamic vitality of life itself than would be possible with the sounds of classical orchestration that Russolo found extraneous to the modern city. Unfortunately, the only surviving records of the few performances that he gave with his fantastic noise organs are the newspaper accounts of the mayhem they caused. What he had invented was an assortment of devices, controlled by various cranks and levers, that could reproduce, modify, and even create *ex novo* a cacophony of rumbles, hisses, crackles, buzzes, murmurs, and explosions that combined with more traditional instruments in a memorable demonstration of his

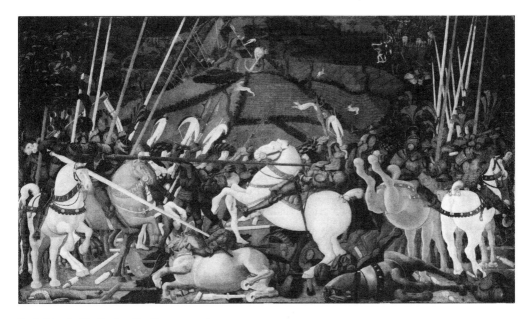

Paolo Uccello, *The Battle of San Romano*, 1456

musical ideas. These musical happenings, however, were only the merest hint of what Russolo had in mind. Ultimately he envisioned that the motors and machines of a city would be "deliberately attuned, and every factory transformed into an intoxicating orchestra of noises."[5]

Russolo wanted to open the closed form of the concert to include the multitude of overlapping, juxtaposed, and incomplete acoustic fields that make up a city. Music, which had typically been removed physically and intellectually from everyday life, could now be seen arising from this life. By revealing the musical potential of the newly mechanized city, might it be possible to see the competing and cacophonous noises of a more wildly varied urban structure as fragments capable of entering into multiple and constantly shifting relationships more responsive to the increasingly open and democratic political and social structures that were becoming common?

What is apparent in these examples is the degree to which different formal structures, and different strategies of composition, open our eyes to

Zaha Hadid, Lois and
Richard Rosenthal Center
for Contemporary Art,
Cincinnati, 1997–2003.
Digital montage

phenomena and relationships previously unimagined. Once the singular fig-
ure becomes open, we can shift attention to the large number of fields that
are its context. We now become aware of the significant variety of competing
physical, social, ecological, and aesthetic systems that were just too contrary
and too messy to be part of the ordered world of figures. What must also be
apparent is that we are not seeing as much of a progression from one vision
of the world to another as many would believe, but instead are aware that
a profound tension has always existed between the need for order and the
anxious recognition that this same order will ultimately become a constraint
to free inquiry. Holding the center is necessary when needing to bring order
to the world. But at the same time it is crucial to engage the rich vitality of
competing forces at the edges and give these just as strong a voice.

It is within this longer view of a compositional history that has remained

Zaha Hadid, MAXII National
Centre of Contemporary
Arts, Rome, 1997–2009
Digital montage

obscure that contemporary work such as recent projects by Zaha Hadid can be seen as consistent with the same intentions to reduce the hierarchical hold that the figure has over the internal structure of its content to allow far more open relationships among things inside and between them and the surrounding world. Two projects for museums are instructive, since this institution has historically taken on an almost unquestioned authority in portraying carefully scripted cultural narratives supporting prevailing social, political, and aesthetic agendas. The dominant central figure with its flanking galleries, along with the singular and controlling entry portico, is the inevitable formal manifestation of this role. In Hadid's museum in Cincinnati and to a greater degree the Center for Contemporary Art in Rome, the eighteenth-century model for the museum is almost entirely absent, re-placed by a network of path/galleries that allow visitors to make their own

way physically and intellectually through the cultural terrain within, and then to find constant opportunities to compare their revelations to a surrounding context that would previously have been withheld.

In Cincinnati there is still a vestige of the central figure, yet this is so pushed to the urban edge that any sense of completion requires the local surroundings to be included as part of this fragment of a figure. The inclusion of the city within the life of the museum and the transparency of its contents back to the city through unexpected openings throughout the building continue the sense of the art within being a critical part of a vital urban existence. Customary understanding of the ground as a singular location on which things rise and lose connection to this important datum is also confounded as the reconstituted ground of the city now rises in a series of ramps, curved floor planes, and other suggestive devices, so that it can be part of a three-dimensional spatial matrix that engages the entire place. However, it is the system of overlapping and interlocking galleries with their spatial cuts making a field of literal and physical connectivity that gives its visitors a sense of intellectual ownership over what they discover that distinguishes this museum from what has gone before.

The Center for Contemporary Art in Rome carries these themes further. Situated within a complex military and industrial area outside Rome's historic center, the project has given up the premise of its own center to favor a three-dimensional field of twisting and intersecting gallery/paths that extend and contrast with the multiple systems of movement already existing on the site. These sinuous ribbons of space become the open site for the display of contemporary art. Walls are few, and when they do appear, they are not the massive enclosing walls that give art a solid position but instead are mostly ephemeral screens that do house the art but also have images projected on them, have openings cut so that other images are included and then are aligned so that they frame views of the city. The result is a complex overlap and intersection of art and urban life that allows an open-ended interpretation of both by its visitors. To a large degree it could well be the spatial analogy to the orchestrated sounds of the city that Russolo proposed almost a century earlier.

The great potential of architecture is its capacity not merely to provide effective settings for human action but to use its impressive array of spatial

strategies to reveal ever more productive relationships among the pieces of the world. In this regard architecture transcends its role as service provider to the status quo and becomes a means to move beyond what is already known. The inherent relational structures intrinsic to architecture are a powerful means to physically and metaphorically catalyze critical thought and action with respect to the social, ecological, and political entities that are now capable of being included within a more complex and articulate whole. While this sounds obvious and mostly benign, the ethical implications are profound and often disturbing. Although these ideas have a long history, it is only recently that the technology has existed to make them more than a static representation of openness. As architecture becomes ever more open, it will be ever more apparent all that has been excluded. As a field of relationships becomes understood as a means for radical inclusion, then arguments for exclusion of all sorts become all the more suspect.

Notes

1. For a more complete account of the Vitruvian myth of origins, see R. D. Dripps, *The First House: Myth, Paradigm, and the Task of Architecture* (Cambridge, MA: MIT Press, 1997).

2. A more extensive theoretical discussion of the ground can be found in Robin Dripps, "Groundwork," in *Site Matters,* ed. Carol Burns and Andrea Kahn (New York: Routledge, 2004).

3. J. N. L. Durand, *Précis des leçons d'architecture* (Paris, 1819).

4. François Dagognet, *Etienne-Jules Marey: A Passion for the Trace* (New York: Zone Books, 1992).

5. Luigi Russolo, *The Art of Noises,* trans. Barclay Brown (New York: Pendragon Press, 1986).

Extraordinarily Real: Ethics, Aesthetics, and the Promise of Modern Architecture

NATHANIEL COLEMAN

The question of how to create a more meaningful architecture came to the forefront of architectural discourse in the years after World War II. Orthodox modern architecture, reacting against the late nineteenth century's obsession with style, had failed in its attempt to re-create the authority and capacity for meaning of classical architecture. Instead, by the 1950s the most radical qualities of modern architecture had been institutionalized as appropriate representations of the power and reach of capitalism. Today, in the current epoch of extreme free market capitalism with its emphasis on branding, it is tempting to say that perhaps architecture can only ever be meaningless. Yet every building *does* communicate something about the way of life—good, bad, ugly, or indifferent—it attempts to confirm; and this, in essence, is its meaning. Architecture gives physical shape to the political aspirations, social needs, and religious rituals of a society. Just as literature has meaning, every building or complex, from the lowest to the highest order, harbors a pregnant content. Every building speaks to us, like a story, about a way of life.

It was during the years after World War II, when this question of meaning was so prominent in architectural discourse, that three of the modern period's most intriguing and what I will call "humane" architectural works were built: Le Corbusier's La Tourette (1953–60), Louis I. Kahn's Salk Institute (1959–65), and Aldo van Eyck's Amsterdam Orphanage (1955–60).[1] If

modernism's transformation into an "international style" severed twentieth-century architecture from its radical social and artistic roots, these three structures should be seen as attempts to recuperate the ethical promise of early modern architecture. Their poetics depend upon an ability to view the ordinary elements of building, and of everyday life, *imaginatively,* thus avoiding the limitations of a prosaic outlook conditioned by the economic imperative of the construction industry and marketplace. As I will argue, they represented *another* modern architecture, one capable of exceptional richness, and one that remains a real possibility only tentatively entered upon.

All three were indebted to early twentieth-century art movements, especially the Surrealist theories of André Breton and Mondrian's project for revealing mutual relations through abstraction. While orthodox modern architecture had concerned itself primarily with problems of quantity, planning, economy, and especially prefabrication,[2] this focus had resulted in a reduced environment increasingly incomprehensible to the actual inhabitants of buildings. The best architects of the 1950s appealed to dreams, fantasies, fairy tales, the past, other cultures, and to an alternative, maybe authentic, modernity, represented less by technology or science than by the achievements of earlier twentieth-century artists, especially the Surrealists. With such influences in mind, Le Corbusier, Louis I. Kahn, and Aldo Van Eyck brought forth an architecture charged with a level of meaning and emotion absent from other buildings of the day, an architecture that satisfied the demand for functionality even as it sought to cultivate a deeper level of *felt* experience, one that would transcend the mere *look* of a building. All three, I will argue, depended as well upon an aesthetic enriched by connections with ethics, not one of narrow stylistic appeal or of some presumed aesthetic autonomy.

From Arbitrary Beauty to the Decorated Shed

As early as the seventeenth century, theorists such as the French architect, scientist, and physician Claude Perrault (1613–88) had questioned the authority of the language of classical architecture. Perrault argued that there were two kinds of architectural beauty, one positive, and the other arbitrary. Positive beauty concerns those aspects of buildings that are measurable in terms of quality and technique. This includes, for example, materials and

construction, which permit evaluation according to an absolute standard. Arbitrary beauty is changeable; more precisely, its character is situational, dependent on time and place. It is a matter of habit and custom. Perrault's positive/arbitrary dyad has haunted Western architecture since his time, finding its most extravagant manifestation in what the postmodern architect Robert Venturi proposed as ordinary (positive) constructions made into architecture through the application of supposedly immediately recognizable decorative (arbitrary) signs as the surface of a building.[3]

Although Perrault had the greatest confidence in the enduring, socially determined, value of the classical language of architecture, his argument that the column orders derived from ancient Greek and Roman architecture were not the result of divinely ordained law but rather a matter of custom set in motion an inevitable loosening of allegiance to ancient tradition. Caprice, however, unleashed from the controlling reason of taste has, ever since Perrault, challenged architects' abilities to render the human realm comprehensible. Style battles, inherited from the latter half of the nineteenth century, often appear to provide the only avenue of creativity. But this rarely results in architectural comprehensibility or buildings capable of touching emotion. Nevertheless, architects continue to dream of places that stir the passions of the individuals and groups inhabiting them, even if they are hard-pressed to imagine how to create such places. The problem of a meaningful architecture resists the ability of genius alone to resolve it, especially when solutions are attempted outside the certainties that universal values of beauty or taste once ensured. When genius fails, method must prevail, and method is ever dependent on theory for elaboration of rules for conduct. Such a theory, however, is impossible without a companion aesthetic that welcomes such considerations—without an aesthetic open to ethical matters, in other words.

Such an aesthetic might seem alien to us today, when aesthetic questions are more commonly associated with such questions as the form, structure, material, and surface appearance of a building. Yet a building can also be beautiful because it carries out a particular social function well, or because it appeals to consumers, or effectively expresses the values of its producer. Social function as a concern of aesthetics is not as strange as it might at first seem, especially if beauty is understood as "that reasoned harmony of all the

parts within a body [such as architecture], so that nothing may be added, taken away, or altered, but for the worse."[4] The wholeness, or comprehensiveness, that Alberti's definition of beauty presumes, identifies the artifact as a body and goes on to suggest that social bodies are made up of individual bodies: therefore the most *beautiful* society is that society in which all the individuals and institutions that form it are embraced as necessary to form the whole. Furthermore, a work of architecture will be complete only when it is comprehensive—that is, when it achieves all those aspects that are properly its job, including the emotional as well as the technical, the theoretical as well as the practical. A work will be more beautiful the more it responds to the multiplicity of problems, from the social and aesthetic to the technical, material, and conceptual, that make up the creative work of architecture.

Ethics, in its most basic sense, concerns the nature of *right* judgment. It is the art of making appropriate choices. Aesthetics therefore has an ethical dimension: because it is an evaluative process, it depends upon a set of rules and principles, of carefully considered choices made to ensure that buildings are pleasing to sensory perception and imagination. Right judgment and appropriate choices are required in every instance where the objective is to make rules and principles operative, whether for good government or good architecture. In its fullest sense, aesthetics therefore concerns the making of things as much as their beauty. A healthy correspondence between ethics and aesthetics, and the prospect of a meaningful architecture, are endangered when aesthetics is reduced to a concern for visual appearance alone; the correspondence gets even more difficult when the viewer's perspective so dominates that the producer's drama in creation recedes from view.

By renouncing, or simply forgetting, their pre-Enlightenment responsibilities as the key workers in providing forms to accommodate social conduct, architects have impoverished their efforts, even as many imagine they have inscribed a supposedly freer role for themselves in the shaping of the world. No matter how much lighter the problem of architecture might seem when unburdened of its former task of establishing settings carefully attuned to the variations of social life, the worth of a building ultimately rests upon its relative appropriateness to the job it is charged with doing in a particular situation. Uncompromising aesthetic autonomy, with its promise of liberating architecture from the messy reality of its social dimension, leads

only to a diminished architecture. "Freeing" architecture from the burden of use and material does not produce a more meaningful architecture; it is a recipe only for a purposeless, dematerialized architecture that is also socially meaningless. No matter how much reductive formalism, or aesthetics of the image, might be called upon to justify the serious social inadequacies of a piece of architecture, art for its own sake can never erase the many ethical dilemmas of creation which must be faced.

Abstract Reality and Surrealism

It could be argued that painting, freed from naturalistic representation by photography, took the lead in breaking with the past of academic painting and bourgeois mores and bringing abstraction to modernity. This step was not simply self-indulgence for Dada artists, though, even less so for Surrealists. Extreme expressions of machine brutality and valuation of the unconscious were indictments of an originally promising modern reality now coming up short. By attempting to show how it might be possible to shatter the world as it was, both groups of artists began to formulate the pathways to a fuller existence, if not exactly prescribing its values in operation.

Breton's conception of Surrealism and Mondrian's idea of abstract reality share an early twentieth-century preoccupation with reconciliation.[5] For Breton it would be a reconciliation of waking reality with dreams; for Mondrian it would be a reconciliation of the mind-matter dualism. The bringing together of apparent opposites was expressed differently by Surrealism and abstract reality, but both revealed a mutual desire for an augmented reality (and consciousness) that could redeem individuals from the reductive excesses of nineteenth-century materialism. If Breton sought the roots of creative invention in the access dreams give to unconsciousness, Mondrian wanted to unveil primordial relationships, which he argued form the basis of all meaning. Both conceptions of reconciliation harbor great consequences for architecture, already provisionally explored in the strongest modern work. In a way, Mondrian's project for abstraction as a form of revelation helps to release the Surrealist project from interpretations stuck on its most provocative (dream) imagery. For abstract reality to be comprehensible, access to unconscious perception at the moment of experience must be at least entertained as a real possibility. Precisely because it is communally

comprehensible, when effective, work of this sort offers itself to individuals as a common ground for social interaction.

For Mondrian, abstraction was an unveiling of relationships that carry a charge, which naturalism (representation) either veils or confuses. Repose, for example, is the outcome of such relationships; it can be expressed by a flat land, a broad horizon in the distance, with the disk of the moon high above—all abstracted by the fall of night. Expression of repose purged of all its representational (naturalistic) appearances can still convey the outcome of repose, which is a condition of peacefulness and tranquillity. If this is correct, the beauty, or sense of balanced calm, of a beach with the ocean beyond and a bright big moon above is as much the outcome of charms specific to a particular beach under unique circumstances as it is a direct apprehension of meaning at the moment when the relationship between the flat swath, broad horizon, and illuminated disk above, which emphasizes the counterpoint of the first two, is experienced. In abstraction, the trick is to purge the assemblage of its representational naturalism without losing its referential content. Ultimately, it is not what it *looks* like but rather what it *feels* like that matters. If such a statement sounds woolly, it is because rationality overvalues what is seen, and thus documentable and ultimately countable. But that does not make emotion any less real than its quantifiable counterpart. The *realness* of felt experience suggests that the barely conscious intangible, which resists explicit expression, is more fully the architect's occupation than simply the measurable, or representable, especially if touching emotion is a sensible aim.

Mondrian's consideration of repose offers a convenient way to nudge abstract reality toward architecture. For example, the architectural correlate of repose is horizontality. The very word *repose* carries with it the idea of horizontality: "to lie or lay something at rest." Consequently, a setting of (or for) rest—that is, a place evocative of rest—might emphasize horizontality over other arrangements, especially verticality. But horizontality in relationship with verticality, depending on the proportion of each to the other, actually increases the experience of repose through counterpoint. Horizontal also carries with it horizon, the implication of which is a limit where earth and sky meet, but also the sky dome itself, defined at its lower limit by an apparent plane—the ground or earth. Building also participates in this drama by

constantly attempting to reconcile the horizontal and vertical in terms of an upward thrust carrying a potentially crushing load, or through the preparation of a horizontal building platform ready to receive and support vertical elements of construction. Kenneth Frampton suggests that this is the drama of the tectonic, which is ultimately a poem of construction revolving around the downward pull of earth and the upward thrust of sky.[6]

In all their forms, gravity and resistance to it can be seen to evoke bodily experiences of rest, play, work, and even death. With this in mind, it is possible to argue that emotional states are traceable to bodily states. For example, a body at rest on a bed (or on some correlate to a bed, such as a rug or a beach) appears to best communicate the condition of repose, which expresses the peacefulness or tranquillity that horizontality conveys. Repose is comprehensible at the moment of its perception precisely because rest (or sleep) is so crucial for emotional and physical well-being. Rest is always in mind, sleep is when the day is shaken off and dreams intrude upon consciousness. To summarize: Abstraction reveals the relationships naturalism conceals. It also reveals the outcome of those relationships. In doing this, abstraction can overcome representation without a loss of content. A content that communicates through reference rather than representation is *experienced* rather than *read*. If Mondrian's theory of *abstract reality* overcomes representation, Surrealist theory offers a pathway to reclaiming awareness of the content that abstraction can harbor, especially by validating the reason of dreams, which is associative.

Because decisions are never made on rational grounds alone, concern with emotional criteria, the qualitative and the intangible (such as Mondrian's and Surrealist theory give access to), should be the *real* preoccupation of architects. Broadly rendered, individuals really do desire two things: something that locates them in their own time, and something that binds them to a distant, even primitive, past. Things that harbor both—the modern and the ancient—are most capable of carrying a charge to which emotion and desire respond, even as more rationalist function is met. Coexistence of apparent opposites, such as the primitive and the modern, is the logic of dreams. Architecture responsive to the actual richness of the multivaried needs of individuals is possible only when rational functionalism is intermingled with extended emotional functionalism. Such architecture is not so much

representational, in the sense of resemblance to something familiar, such as a past architecture, as it is capable of evoking states of being both archetypal and contemporary. The architectural theorist and historian Joseph Rykwert pinpointed the link between Mondrian and an enriched architecture, and in so doing he implied a role for Surrealism:

> In [the strongest] pictures [by Mondrian] abstraction has been left behind—they are images constructed out of autonomous and artificial elements. In these pictures figuration is not resemblance but analogy. Mondrian is the key. Here all the threads I have toyed with: psychology and anthropology, perception study and ergonomics, come together at last to be given a form. What that form shall be can only be worked out in time. But I believe we have come to the end of a non-figurative architecture and that we must now look to the scattered material which psychologists and anthropologists have been gathering. Not only myth and poetry, but the fantasies of psychopaths await our investigation. All the elements of our work: pavement, threshold, door, window, wall, roof, house, factory, school—all these have their poetry; and it is a poetry we must learn to draw from the programmes our clients hand us, not to impose it by a cheap melodramatisation, but to spell it from the commonplace elements which we fit together.[7]

A figurative architecture—informed by Surrealism and abstraction—is an articulation of figures arranged into a particular form; it is nonliteral and does not embody or convey meaning by way of melodramatization; it uses neither stereotyped characters nor exaggerated emotions; it is not simplistic, and the conflicts it purports to resolve are not reductive. A figurative architecture operates with metaphor and analogy—the building *is* a body, and the building *is like* a body. The figures of figurative architecture are all the elements of architecture, including the parts, or materials, of a building fitted together through construction, the spatial themes of a building experienced through sentient occupation, and the institutions that make up and house society. The difference between an architecture of technical functionalism and one of emotional functionalism is that the first simply attempts to get the job done with a minimum of effort as it appeals to reason alone; the second is technically functional in *addition* to establishing a place for dreams,

desires, and the intangible. The first is best suited to accommodating operations, the second to sheltering an ethos.

Surrealism assists architects by suggesting how it is possible to look at building assembly not simply as a combinative process guided by economy and efficiency but *also* as a method to defamiliarize construction, occupation, and institutions so that the wonder hidden by such commonplaces is revealed as an ever-present immanence, which overconfident rationality conceals. Surrealism and "abstract reality" get at the apparently hidden marvelous dimension of the commonplace by appealing to faculties beyond waking reason alone: dreams, unconscious thought, and even madness can reveal the wonder that seemingly firmly established banality conceals, informing an architecture of enriched meaning.

Early modern explorations of Surrealism and abstract reality had much to offer modern architecture. In practice, however, it was another strain of modernity that perhaps proved more influential. This was the modernism that was associated with progress as an end in itself, the modernism of economy and efficiency driven by an extreme rationalism that often came at the expense of cultural life. Modernity of this sort arose alongside modern technology and science.[8] To some extent, these two conceptions of *modernity* continue their struggle for dominance: the reductive economies of efficiency motivated by desires for total organization square off against dedication to a rich synthesis capable of domesticating the modern world and its trappings by bringing them within the domain of humanism. The three architectural works that I will now discuss exemplify this latter modernist spirit: that of a more humane modernity in which the machine, machine production, and scientific reason are embraced as human creations (to the extent even of revealing their wonder). All three works draw powerfully on the insights of Surrealism and abstraction discussed above.

An Ethos Takes Flesh: Three Examples

Le Corbusier's Dominican House, La Tourette, is notable for its roughness, partial enclosure, and play of Corbusian forms within the courtyard as well as throughout the complex. It is worth noting at the outset that although La Tourette is often called a monastery, it is not one; it is actually a convent. The significance of this distinction is inscribed throughout the structure.

If thought of as monastery, Le Corbusier will appear to have intentionally defied monastic enclosure with a series of cruel jokes that render it meaningless, especially in the cloister. But this is not the case. Different kinds of religious communities require different sorts of structures to house their practices. As commonly understood, monasteries house fully enclosed communities; convents do not. Monastic life is generally identified with the very specific form of the cloister and the quiet introspection it suggests. A cloister is an enclosed space usually in the form of a quadrangle surrounded by covered passages opening into the court on one side and facing a nearly solid wall with openings on the other.

In monasteries, the cloister is the most interior space; it is the spatial correlate of retreat from the outside world toward inner reflection, which is the purpose and obligation of the community. Monastic rules are clear: there is an inside and outside; the world beyond is a temptation; the rigorous enclosure of monasteries offers a protected other world while focusing the attention of monks on contemplative work. If La Tourette were a monastery, Le Corbusier's placement of cluttering rectangles, cylinders, pyramids, and other forms (housing a passageway, stairs, a chapel, and other functions) in the interior of the court would have successfully destroyed the integrity of what is arguably the most important "room" for the pursuit of monastic life. Worse still, because he deferred to the topography of the site—in fact he chose the most difficult part of it to build on, precisely to emphasize the slope La Tourette inhabits—Le Corbusier's convent does not permit a level open court surrounded by a fully enclosing perimeter, a feature commonly associated with cloisters and the solitude they provide. Moreover, nowhere is the court fully enclosed; it "leaks" in nearly every direction, permitting movement from within the tentative precinct the structure defines out into the natural (and human) world outside, beyond its half-heartedly enclosing walls.

By defamiliarizing monastic forms through displacement resulting in surprise, Le Corbusier made La Tourette an appropriate setting for an order of preachers who traditionally lived in university towns, took no vows of silence or enclosure, and who ate in community. For preachers ministering to society at large who also choose to live in community, a setting simultaneously open and closed, as well as cosmopolitan and insular, provided a

Closed and Open, view across court toward church wall, Convent of La Tourette, Eveux-sur-l'Abresle, 1953–60. Architect: Le Corbusier

uniquely appropriate material expression and platform for the practices of its Dominican inhabitants. La Tourette becomes a setting uniquely suited to the Dominicans' struggle to negotiate a balance between the certainty of enclosure and monastic order and the temptations of the world.

While partial enclosure is here comprehensible as an opening up of monasticism toward cosmopolitanism, the roughness of La Tourette is also immediately understandable as an architectural correlate to vows of poverty. The Corbusian forms that clutter the non-cloister, and the overall arrangement of the complex, quickly disclose that things are not exactly as they appear (convents are not monasteries). And especially in its most recent reconceptualization as a cultural center, La Tourette reveals how religious orders, with their commitment to faith, hope, and charity, might still have something to share with *rootless* cosmopolitans, even if this particular convent sits on a hill in the countryside beyond the city.

If La Tourette embodies an ethos of virtuous poverty nurtured by passion, optimism, and generosity, the Salk Institute presents itself as a democratic setting: the town center or public square of an ideal city. The central court, for which the complex is most famous, provides a level platform upon which diverse constituencies and individuals can meet. In this instance, the varied population includes junior and senior researchers as well as staff and visitors. Most importantly for architect Louis I. Kahn and his patron, Jonas Salk, inventor of the first safe and effective polio vaccine, the platform they devised was meant to become a common ground upon which scientists and artists could meet.

Kahn's convictions that "architecture comes from the making of a room," that the "street is a room by agreement," and that "the City [beginning] from a simple settlement became a place of assembled institutions" underpinned his powerful conception of the nature of individual, neighborhood, and civic life.[9] What there is of the Salk Institute is but a fragment of a larger whole that, if the residential and community components had been built, would have become a demonstration of how modern architecture could effectively house and facilitate communities. Nevertheless, the as-built matching laboratory buildings, which face off across the plaza divided by a watercourse running westward down its middle, establish a democratic temenos devoted to open inquiry, individual reflection, and social encounter.

The refinement of concrete at the Salk Institute is notable, particularly in contrast to the roughness of La Tourette, but smoothness is not so much an expression of affluence or technique as it is an attempt to offer the West Coast of the United States a building it has no business having—an "ancient" ruin suspended in time and filled with wonder. Like Kahn's, Salk's objective was one of transcendence. Both found motivation in a spirit of inquiry, the objective of which was to collapse the divide between scientific and poetic reason. Architects and scientists are both preoccupied with invention: in this light the Salk Institute is suggestive of the spirit of scientific invention.

As a center for biological research, it is not surprising then that the Salk is as preoccupied with discovery as it is with birth. In an effort to house contemplation of both, the Institute looks backward, as does La Tourette, toward monastic enclosure. In this instance, it looks for clues to how a place of inquiry—on the edge of a continent—can be open in one direction and closed in the other: open to researchers and the spirit of scientific discovery contained by ethical restraint, closed to too much worldly distraction and the piercing sun. These are practical as much as ethical concerns, the negotiation of which found a compelling aesthetic expression that effectively communicates the values held dear by client and architect alike. If the Salk Institute continues to resonate for the researchers it houses and for architects and other admiring visitors, it is because the building embodies a comprehensible set of beliefs that are supported by compelling practical and technical solutions subsumed to a partial whole that is immediately recognizable as an enduring work of art. What is more, the Salk is set, with aching sensitivity, along an east-west trajectory defined by the Institute's deference to the canyon that opens up before it along the sun's path from its rising in the east to its setting into the western horizon hovering over the Pacific Ocean.

More often than not, an honorific quiet descends upon the Salk. But if the water channel bisecting the plaza is followed westward, toward the setting sun and the ocean (womb of all life), to the point where it drops to the lower plaza, one is struck by the noise of the water as it falls and the chatter of lunching researchers who cheerfully occupy a deck facing outward toward the sea and the horizon—toward wonder. And where Western science falls, nearly undiscernibly, into a meeting with the infiniteness of dreams.

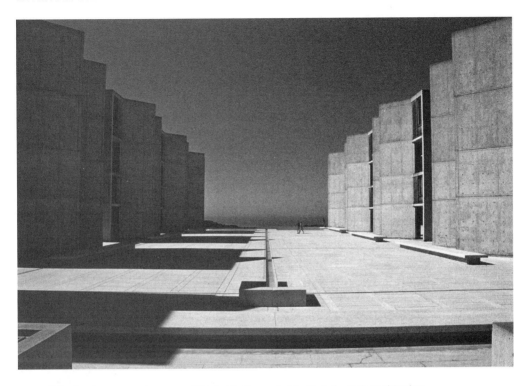

Toward Wonder, view across plaza toward the Pacific Ocean, Salk Institute for Biological Studies, La Jolla, California, 1959–65. Architect: Louis I. Kahn

The method for attaining forward-looking recuperative results at La Tourette and the Salk included making use of a critical historical perspective that backward glances can provide. Achievement of these striking structures depended on dreamlike defamiliarizations of ordinary program types that were abstracted to a point where representation was replaced by reference. As a result, the familiar (as well as the somewhat stranger) architectural elements that form both buildings (not to mention the way of life embodied by them) are comprehensible at the moment of perception as bodily experience. Much of what applies to La Tourette and the Salk also obtains in Aldo van Eyck's Amsterdam Municipal Orphanage, though here defamiliarization and displacement are more overtly employed to break open an institutional

Comprehensible Complexity, basic structural unit, Amsterdam Municipal Orphanage, Amstelveenseweg, Amsterdam, 1955–60. Architect: Aldo van Eyck

Opposite page: Children's Gateway, passage framed with light pink glass, Amsterdam Municipal Orphanage, Amstelveenseweg, Amsterdam, 1955–60. Architect: Aldo van Eyck

form so as to redeem it. Van Eyck achieved this by establishing an exceptionally strong initial element depicting the drama of load and support. This figure refers as much to the body as to a primordial past of original construction, which binds the orphanage to Stonehenge, Laugier's Primitive Hut, and Le Corbusier's constructive system (which draws from both). The persistence of this figure derives, no doubt, from its reference to the body's defiance of gravity and to the thresholds humans pass through—physically and psychologically—throughout their lives.

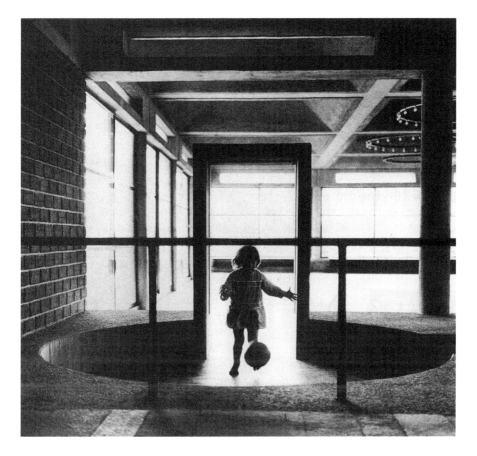

Not only does the Amsterdam Orphanage look backward to go forward, it looks elsewhere as well. For van Eyck, who eschewed anything reductively schematic, reform in the present demanded a gathering of parallel traditions, one as equally valid as the other. He believed that only through a commingling of "the immutability and rest" of classical culture (and civilization), the "change and movement" of modernity, and "the vernacular of the heart" of traditional societies could a fuller, richer, architecture flourish. The richness van Eyck aspired to is only achievable when any one worldview is

acknowledged as partial; a more complete perspective on reality demands
that a multiplicity of relative outlooks—often distant from one another in
time and space—be allowed to operate in a dynamic imagination.

Although the Orphanage is an apparently humble building, it embodies
the iron will of its architect to establish an inclusive setting capable of hold-
ing human ambivalence in all its complexity. An assemblage of parts, the
structure is animated by a comprehensible complexity throughout: from the
arrangement of spaces, especially courtyards, thresholds, interior walkways,
and common areas, to the choice of common materials, predominantly
brick, concrete, metal, and glass. The spatial complexity of the building—
making a unity out of diversity—achieves a kind of labyrinthine clarity that
originally organized the Orphanage's occupants according to age, gender,
and function. Rather than confound orientation, this sort of arrangement
was intended to invite inhabitants to make bits of the whole their own.

Although the influence of Mondrian and Surrealism on architecture is
often at best only an implicit trace, in the case of Aldo van Eyck it was ex-
plicit. He fortified his recuperation of modernity's primary values from the
stultifying pall of technocratic reason by returning to the liberating potential
of abstraction. Mondrian's model for overcoming representation with pure
abstraction in painting provided van Eyck with a method for doing the same
in architecture. Borrowing Mondrian's conception of abstraction made it
possible for van Eyck to reveal mutual relations across time and cultures that
obsession with outward appearance conceals. Moreover, the dynamic mutu-
ality disclosed by abstraction suggested a way to redeem the potential of in-
stitutions as places for human occasions. Informed by Surrealism's tolerance
for the real value of the unconscious, for imagination and experience, van
Eyck imagined that buildings such as the Orphanage could convey respect
for the role of subjectivity in the making of the world.

If the ethical function of La Tourette was to provide its Dominican in-
habitants with a setting for negotiating the tensions between the clarity of
monastic enclosure and the pitfalls of urban preaching, and that of the Salk
Institute was to establish a democratic platform where artistic invention and
scientific inquiry could have equal footing, in the Amsterdam Orphanage
van Eyck attempted to weave content through form and matter into a com-
plex whole dedicated to children who would experience human aspiration,

dread, and boredom in the same space differently. What makes these three buildings even more worthy of attention is that each embodies a carefully elaborated ethos that draws its poetry from the common elements fit together by the architects to form an eloquent expression of individual artistic value in the service of an important social or communal endeavor. What is more, La Tourette, the Salk Institute, and the Amsterdam Orphanage each extended modern architecture by making it more fully modern. In bridging the illusory divide between *waking reality* and the *reality of dreams,* they demonstrate what van Eyck called an "authentic modernity." It is a modernity infused with the unconscious that can redeem wonder as it surpasses the limitations of the nineteenth century's grasp at certainty—the shadow of which we continue to inhabit. Representation and the *styles* are left behind, but modern building materials and methods of construction are softened by abstraction, which, in these examples, reveals meaning directly to the body.

Notes

1. For an extended discussion on these three buildings and their architects, and on architecture's social dimension and the problem of meaning in architecture, see Nathaniel Coleman, *Utopias and Architecture* (London: Routledge, 2005).

2. See, e.g., Joseph Rykwert, "Meaning and Building" (1957), reprinted in *The Necessity of Artifice* (New York: Rizzoli, 1982), 9.

3. Claude Perrault, *Ordonnance for the Five Kinds of Columns after the Method of the Ancients,* trans. Indra Kagis McEwen, introduction by Alberto Pérez-Gómez (Santa Monica, CA: Getty Center for the History of Art and the Humanities, distributed by the University of Chicago Press, 1993).

4. Leon Battista Alberti, *On the Art of Building in Ten Books* (ca. 1486), trans. Joseph Rykwert, Neil Leach, and Robert Tavernor (Cambridge, MA: MIT Press, 1988), book 6, chap. 2, p. 156.

5. For a concise discussion of Surrealism, see André Breton, "What Is Surrealism?" (1934), available from http://pers-www.wlv.ac.uk/~fa1871/whatsurr.html (accessed June 15, 2005); Breton, "Limits Not Frontiers of Surrealism" (1937), in *Surrealism,* ed. Herbert Read (New York: Praeger, 1971), 93–116; and Breton, "Surrealism and Painting" (1928), reprinted in *Theories of Modern Art,* ed. Herschel B. Chipp (Berkeley: University of California Press, 1968), 402–49. For a concise discussion of abstract reality, see Piet Mondrian, *Natural Reality and Abstract Reality* (1919–20), trans. Martin S. James (New York: George Braziller, 1995); Mondrian, "Plastic Art and Pure Plastic Art" (1937), in *Modern Artists on Art,* ed. Robert L. Herbert (New Jersey: Prentice-Hall, 1964), 114–30; and Mondrian, "Statement" (ca. 1943), reprinted in Chipp, *Theories of Modern Art,* 362–64.

6. Kenneth Frampton, *Studies in Tectonic Culture* (Cambridge, MA: MIT Press, 1995).

7. Rykwert, "Meaning and Building," 15, 16.

8. For an introduction to this idea of the modern, see Jürgen Habermas, "Modern and Postmodern Architecture," reprinted in *Rethinking Architecture: A Reader in Cultural Theory*, ed. Neil Leach (London: Routledge, 1997), 227–35; Alberto Pérez-Gómez, *Architecture and the Crisis of Modern Science* (Cambridge, MA: MIT Press, 1983); Gianni Vattimo, *The End of Modernity*, trans. Jon R. Snyder (Baltimore: Johns Hopkins University Press, 1988).

9. These three quotations come from Kahn's handwritten notes on three drawings in the collection of the Philadelphia Museum of Art. See Coleman, *Utopias and Architecture*, 184.

You can tell the difference in essays between someone with a strong historical or theoretical awareness and someone who is primarily a practitioner/educator. Coleman's essay comes off as speculative, perhaps a side effect of its being condensed from his book *Architecture and Utopia*.

Robin Dripps' "Notes... builds a case for the moral work of resisting easy unity and pursuing instead, work that reflects (and reflects back) the simultaneity, diversity, plurality, and fragmentation of contemporary life. Yet surely, this is not the first time a moral role has been claimed for art — that it reflect us back on ourselves.

Sigerman's "Ethics, Autonomy and Refusal" reaches higher theoretical plateaus by relating the ethics of denial, or refusal (Adorno's negative dialectic) to more contemporary issues of artistic denial of the easy alternative — of self-promotion & ingratiation into society, of its specialization and academicization — with refusal to participate in status-quo cooption as well as of aloofness. — and the hazards of both promoting norms of behaviour

Ockman gives a historical runthrough of moral impulse in modernity in architecture and after. Always readable, but lacking any new ground.

The Sense of the Senses and the Ethos of an Aesthetic Pursuit

THOMAS BERDING

While the recurrent question of modernism, in its sense of anticipation, discovery, and even exhaustion, may be embodied in the traveling, youthful refrain of "are we there yet?," postmodernism, not so much in its origins, but in what it largely became, strips the concept of destination altogether with the disenchanted cry of "been there, done that." From a pursuit of the essence of the medium to the critique of the very idea of essence, from the existential self to the alienated other, it has been a historically driven, invaluable, and clarifying ride. It has also by and large increasingly reflected the disassociation of the theoretical from the sensory, and the realm of action from the realm of thought—slowly nudging us away from the world of engagement.

Surely the *scriptocentric*,[1] hermetic, and hyperrationalized character of much contemporary theory has not aided engagement. In its self-reflexive qualities and linearity, theory can obfuscate the holistic character of experience, the realm in which art is not only known but made. At the same time, the disassociation of sensate awareness from aesthetic recognition is chronicled by analytic philosophers like Arthur Danto. Danto actually cites by date the end of the historical phase of art, assigning 1964 as the year of momentous occasion, with Andy Warhol's Brillo boxes being the culprit. "He brought the history to an end by demonstrating that no visual criterion could serve the purpose of defining art, and hence that art, confined

to visual criteria, could not solve his personal problem through art making alone"; and furthermore that "the question of whether something is art is less and less a question of what manifest properties an object has, and more and more a question of how it fits a theory that it has to be compatible with all possible sets of manifest properties."[2] While philosophically sound, institutionally validating, and beautifully alert, in such narratives the self-scrutinizing character of art has increasingly led to a distancing of what is evident to the senses.

Concurrently, advances in science and the climate of technological innovation have added to the distrust of one's own sensate experience, while providing the model of progress for modern experiments in other disciplines. Advances in "seeing," ranging from the photograph to the MRI and from electron microscopes to telescopes and remote viewing, make the scale of our senses seem woefully inept relative to the infinite universe. In fact, much new knowledge seems to lie beyond the grasp of the experiential. As Buckminster Fuller wrote prophetically in the middle part of last century, "In World War I industry suddenly went from the visible to the invisible base, from the track to the trackless, from the wire to the wireless, from the visible structuring to the invisible structuring in alloys . . . man went off the sensorial spectrum forever as the prime criterion of accrediting innovations."[3] It may at first seem that science and technology have shamed the naked eye, the human senses, and even human consciousness itself. The expulsion from our quite imperfect sensory experience is nearly intellectually perfect, save for the assumption, which is at the core of the faster, better, stronger world provided by technology, that more information leads to more meaning, and, as such, normative sensory experience and by implication the judgments used in making are flawed. This distancing of our experiential sense of the world from what we know to be true in the physical world as learned from science may appear to leave art in the ditch, disillusioned and even delusional.

Despite this apparent alienation of our senses from our epistemic yearnings, and beyond the rhetorical and metaphoric manifestos that run through the twentieth century, it is clear that artists continually source the world. Looking at artistic practice as framed by the paradigms of the sense of the senses and the ethos of an aesthetic pursuit may enable a resituating of the

practice of making beyond a rigid, mechanistic view where the relationship between ideas and execution, text and image, and even maker and viewer are too narrowly conceived. Newly defined, enlarged, and considered, the dialogue between ethics, which has been defined largely by its immersive life-bound context, and aesthetics, which has pervasively been articulated as a removal from life, both in its high-modernist autonomous stage and in its postmodernist incarnation as critique, may be possible.

While the orbits that aesthetics and ethics travel in are specific to each, they do reflect and shadow the treatment of each other. As for an aesthetics and ethics linkage, the sensitivity, empathy, projective qualities, and receptive sensibilities at work in viewing and making art certainly appeal to an identification capacity and reveal our longing to resituate, or at least expand, ourselves in the world. These are all qualities, in whole or in part, that carry an ethical resonance. At the intersection between the experiential and the theoretical, the aesthetic and the ethical stand as processes of ongoing assessment, as actions in a continually unfolding context which mutually reject the formulaic and a priori determined approaches that a mechanistic view puts forth. It is critical that any examination advances the conversation beyond didacticism and denial, so that aesthetics is neither placed in a subservient position nor put back into the hyperbolic rhetoric of much of the century recently past which had art's proverbial back turned to the world.

As the aesthetic turns to face the world, there is a tacit acknowledgment of sensing as a way of knowing. Though this knowing or sense of the senses has many aspects and histories, it is most associated with mimesis. While it is aligned with ethical judgment in Plato's views of the corruptive power of the mimetic arts in *The Republic*, there is also the populist and rather superficial identification of the ethical with the subject or narrative component of art, a morality play gone freeze-frame. Aside from these moral overlays, that mimesis is writ so large in the artistic enterprise is not without its reasons. While visual works of art have linguistic qualities, they also have a much deeper and less arbitrary connection to the sensory world than other semantic structures. That an image rising out of a series of marks on a piece of paper bears a likeness to a three-dimensional spherical object that we know as a ball is not such an accidental occurrence; whereas the linguistic representation provided by the letters "b-a-l-l" and the image of a spherical form

correspond because of a much more encoded and less essentialist reason. While it is true that both modes of communication require cultivation and education, the judgment of the senses comes into play more directly in the visual representation than in a written account of a phenomenon.

Though perceptual experience may be the primary reserve we seem to draw upon in the act of recognition, it is quite another thing to say a work of art is just a facsimile of the "real" thing. To engage a work of art is neither to encounter it as a mere copy or imitation nor to decipher it as simply a linguistic event that counts on our collective if not arbitrary agreement that letters arranged in a certain sequence can signify something else. To engage the aesthetic components of a work is to engage our own awareness of the contingencies, analogies, and groupings that are found in the very act of perception. Indeed, to engage a work of art is to remake the world, and even ourselves, in accordance with its offerings. Ultimately, the picture that mimesis presents divulges an ethos about our relationship, not only to the sensory, but to the realms of the imaginary, the idealized, and the cultural.

Beyond mimesis, the studio practice offers a valuable way into the discussion of aesthetic decision making and its ethical implications because it illuminates them as fields of human engagement requiring the exercise of deliberate and intuitive choice. The character of aesthetic decision making with its accompanying questions regarding intentionality, responsiveness, and hierarchical sequencing allows an understanding of the artist's decisions, not as simple projections into an unbounded space of action, but as a specific testing of sensations and configurations as they rub up against a host of values. Often agitated and friction-filled, this process of testing the various values has itself become the subject of many an artist's work.

In even a brief look at two painters, we can see that the discipline of working from sensory perception can reveal as much about the maker as the subject. Even as the seen structures the painting, the painting structures the seen. While Cezanne's arrangements of apples and onions, both hardy fruits and vegetables capable of holding their shape a long time, allowed for a prolonged study, they also served, as near as a still life could, to approximate a mountain. The rather commonplace subjects he chose to paint—still lifes, portraits, the mountain in Aix-en-Provence—far from limiting his quest in their known, ordinary character, anchored the true aim of his grand and

Lucian Freud, *Still Life with Book*, 1991–92. Oil on canvas, 19 x 24.2 cm.

lofty inquiry, the scrutiny of the sea of vision itself. In the contemporary painter Lucian Freud's vision, however, the accent is on a decidedly different kind of awareness: life is splayed before us, as unblinking, nude, clammy, iridescent, and gnarled. As their gray and neutral tones are divided and subdivided, again and again, an undressing takes place, exposing the very artifice of ideality in the process. Countless revisions and hatchings of color embody not just the figurative subject but also the stare of a slowly accrued, nearly catatonic, yet hardly monumental sense of time. Of course, the fleeting and transitory experience can also be the subject for working from life. Keen observation, or rather deep immersion in a situation that is rapidly changing, can be telling of how selective perception is. Any attempt to hold still the complex and fully dimensional nature of experience, including that which lies beyond sight, into the still and flat plane of painting, offers compelling, shorthand evidence that all making is a translation—at once a compressing of sensation and an extending of thought through contact with the world. And while one's sensate experience tests one's conception of the ideal, it also quietly and clandestinely provides the building blocks for one's imaginary construct of the world over time.

When working from observation, there is an opening up to the world that occurs. Seeing and creating implicit and explicit relationships that go

beyond the preconceived, the artist confronts his or her own inherited expectations, associations, and notions of rightness. The simple and humble exercise of raising and lowering one's physical position relative to an object in space enhances our awareness of being of this world, not just bodies who project on it. As we kinesthetically move through the world, our cognition is moved by the world. With the alignment of one's eye level with the horizontal edge of a table, a certain infinity of space is suggested, for no back edge is known, no space is bound. Upon lowering oneself relative to the edge, we further find access to the underside, the relatively unknown section of the table, the shadowed plane that is largely intended not to be seen. It is, as it registers in our mind, not only a view of the table but a glimpse of our own unrecognized and hidden selves. Innocence, mischievousness, and even adoration are alternately evoked as one gazes up to the larger world above. While such an account may seem to describe the activity of looking, it is essentially about finding the comparative and the contingent part of identity and existence. Such local repositioning stands as a reminder of our placement on a global sphere that is continually moving, not in a trajectory, but in a revolution with recurrent conditions like birth, death, and the change of seasons that get cultured and mythologized again and again, individually and collectively.

In our encounter with the world, both viewing and making require empathy—the capacity to soften the boundaries of self, to move beyond a fixed notion of identity, and to take on as one's plight that which lies outside narrowly defined contours of self-interest. It is a leaving of self, a recognition of one's own grouping with other forms in the world, which entails seeing likeness and acknowledging difference. It is this process of extracting cocommittedly from both self and the world that produces the expression and experience of art. In an inescapable paradox, the artist's actions reveal both the perceiver and the perceived, for making is not only the opening up of a view but the putting up of a mirror. A double identity or a double awareness is formed that has a highly reflective quality to it. In many ways, the artist studies sense perception to study both how he/she sees and how he/she is seen. For even if the artist claims not to be working directly from a perceptual source, he/she speaks through the visual. As such, it may be said that the visual world is continually sourced when making, so that corporeality

inescapably exists as both a reference and a tool of expression in any artist's studio.

Though this may appear, on the surface, to be a turn to the nostalgic, it is actually far from it, for the sensate experience need not be answerable to mimetic criteria, and indeed never was. The sensibility I am alluding to is more about building a profound awareness of the dialectic that exists between mind and body and individuals and their environment, and that is essential to any ethical or aesthetic perspective. As Merleau-Ponty offers, "It is not a question of reducing human knowledge to sensation, but of assisting at the birth of this knowledge, to make it as sensible as the sensible, to recover the consciousness of rationality."[4] The sensate experience is not an absolute that slowly slips into subjectivity as other catalysts, conceptual or personal, are introduced but an exposure to a way of seeing/thinking that is all about concurrency and interdependency. In fact, far from being an indoctrination into absolutes, it is quite the contrary.

Whether working from direct observation, the memory of an object, or other sources, visual thinking and, in general, creating with the senses are not just about otherness but about opening up one's own decision making to oneself, affording a view that may lie outside the scope of other disciplines. As the artist Mel Bochner states, "Painting, because it is in and of the material world, offers an access to the processes of the mind, to the indecisions and uncertainties philosophy can't cope with."[5] Object to object, image to format, object to maker, maker to viewer, the continuity with the world and cognition may be established, lost, and retested with every selection and every deletion. Moreover, intentionality, desire, the bounds of self, and the very constructs of culture get put to the test.

No matter if it is internal to the work or a source for it, the quality of the reply to any phenomenon is largely dependent on one's ability to imagine— that is, to see beyond the visible, to reconfigure the situation in new terms and to model a new problem from it. It is one thing to sense; it is quite another thing to make sense, that is, to put forth in new terms an experience that is comprehensible. To make sense of the world is to make an idea palpable and the sensate intelligible, closing the gap between our being in the world and our imaging of it. In this shortening of distance, when we look at something, we must in part look away. This is not a call for the denial of

sensory perception, but rather for the combining of experiences—the aesthetic memory, personal recollection, and the present corporeal condition—into the creation of a new, more memorable image.

When either making an emphatic and indelible mark on-site or conjuring up one's past experience of studio work, covertly or overtly, memory is a guest in perception. Even within the parameters of a drawing or painting, memory is at work. As each color, shape, and line is established on a surface, each move also suggests a way of seeing and a treatment of a neighboring area's form. While such awareness aims to alternately engage and be blind to a priori experience, a resonant dialogue occurs within and across the bounds of the work. Shared characteristics between forms are revealed that may lie dormant to a literal or utilitarian viewing. To work in the realm of the senses and aesthetics is to construct resemblances within the visible field and to invite comparisons beyond it that hold import larger than the descriptive. It is to go to the source of metaphor, revealing our desire to connect experience and, as such, re-place ourselves in the world, elevating our view of certain moments above others, that we have brought or go on to find in the act of making. The very inclination to the poetic may in fact reveal the embedded aesthetic desire at work in how we cognitively engage the world, making possible the rendering of an awareness that heretofore was not enabled by existing, regulated, classifying systems and social orders. As the philosopher Susanne Langer states, "Every new experience, or new idea about things, evokes first of all some metaphorical expression,"[6] and while metaphor most assuredly draws on the sensual world for its carefully crafted resemblances, it also draws on the hope that there is more than the known and the denotative to be found in experience. It is a process of wandering, comparing, remembering, and ultimately listening to our desire to belong.

To uncover the aesthetic in our experience is really to find a new quality of experience in our senses, a new consciousness. It is a reconciliation of expectations, hopes, and dreams with the world's materiality, as represented by the medium itself and the sensations of life. While various social, personal, and cultural numerators accompany aesthetic desire, these qualifiers unfold within the spectrum of the senses and in a clearing of the aesthetic's creation. From a physio-biologically based perspective like that of scholar Ellen Dissanayake, art is born from an inner proclivity that is rooted

in our very origins. At the same time, it is an intensification, exaggeration, and essential part of the definition of what it is to be human. As Dissanayake writes, "There is this germ in human behavior that wants to make special things that you care about, to show your regard for them. You want to do something special to show that investment and concern."[7]

In the artistic process, the ethos of aesthetics also reveals itself. The act of making exists not just as a means of realizing an intention or a way of representing what one already knows but as an act of thinking and formulating in its own right. The result is that experience is not just referenced but created. As each decision leads to the next, the finish line is constantly reestablished, sometimes welcomed closer and in other artists' studios continually pushed back. In either case, the work becomes a record of the event of seeing and possessing, trailing its own ethos as it pursues the aesthetic. Like a long-division problem playing out before us, a work of art is a testimony to how it came to be. It is a compression of decision making open to critical analysis. Directly or indirectly, by its doing or undoing, a work often holds the evidence of the method through which its maker *sees* conceptually and perceptually. A palpability of choice, a contesting of values, a sequencing of appraisals, adjustments, criticisms, and doubts make up what the viewer senses, whether visible or not. For the painter and printmaker, Terry Winters says, "the work is really about contingencies and the pragmatics of making things, and making do with things that are in the world. The application is towards a very practical, pragmatic daily thinking. . . . [To] make things and become." With their latticing forms and multivalent references, Winters's paintings possess a networking character. In their dense web of visual choices they chart how he, and ultimately we the viewers, map or configure the conceptual world through sensual terms. In this way, the paintings and the experiences they create can be seen as examples of a process Winters refers to as "manual imagination."[8]

The contemporary artist Jessica Stockholder also works in a space that lies between visuality and materiality, using painterly and sculptural forms to both animate the mundane and court the unforeseen. Exquisitely concrete in their quotidian poetry, Stockholder's hand-hewn geometric slabs of flamboyant color play off domestic items that hardly betray their origins. As Frances Colpitt has written, "Stockholder's unexpected juxtapositions of

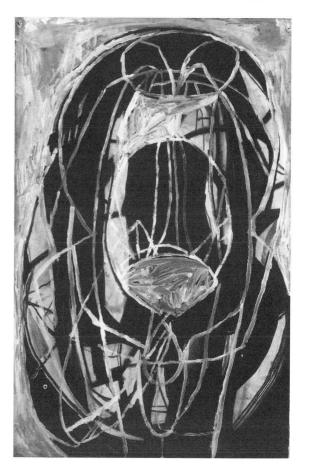

Terry Winters, *Tenon's Capsule 1,*
1994. Charcoal, graphite, ink, and
acrylic on paper, 40 x 26⅟₁₆ in.

such a variety of unrelated objects encourage discovery and elicit surprise, not only in their color and form but with respect to their original function and newfound context."[9] While architecture, domesticity, and color exist in a certain proportion in Stockholder's hands, these same elements were sequenced in a decidedly different way by the consummate aesthetician of the twentieth century, Henri Matisse, of whose work it has been said that "even the inanimate objects are invested with a sense of self-awareness that seems to border on consciousness."[10] Both the rhythmic syntax of Matisse and the

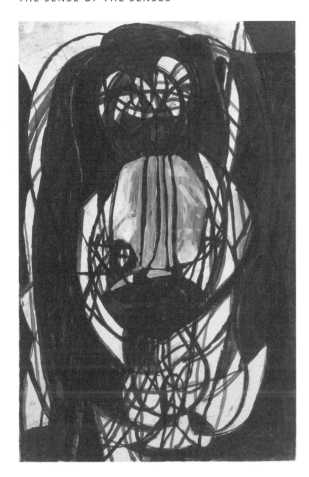

Terry Winters, *Tenon's Capsule 2,*
1994. Charcoal, graphite, ink, and
acrylic on paper, 40³⁄₁₆ x 26¼ in.

right-before-your-eyes recombining of the world of Stockholder reveal that
the customs and practice of aesthetics do not simply take the world as it is,
or conform to the status quo, but reformulate it from the cues the artist finds
in the community of things and artists past and present.

Aesthetic sensibility, like the scanning of vision itself, is a wandering and
wondering impulse. While purposeful, the knowledge the aesthetic typically
imparts is not narrowly functional or instrumentally defined, nor does it
point toward an end product. Instead, the aesthetic needs to be evaluated

Jessica Stockholder, 2003. Chair, radio, purple quartz light, wood, steel bowls, photographs, carpet, hardware, paper mache with plaster, plastic elements, wire mesh, PowerBBS, 68 x 40 x 45 in.

with regard to how it enriches and enlivens the imagination of all of us as creators of value and meaning, how it aids our ability to dwell more deeply in the world through forming new ways of seeing and thus conceiving of the world. As the American philosopher John Dewey wrote, "While perception of the union of the possible with the actual in a work of art is itself a great good, the good does not terminate with the immediate and particular occasion in which it is had. The union that is presented in perception persists in the remaking of impulse and thought. The first intimations of wide and

Henri Matisse, *The Piano Lesson*, 1916. Oil on canvas, 8 ft. ½ in. x 6 ft. 11¾ in.

Philip Guston, *Moon*, 1979. Oil on canvas, 69 x 80 in.

large redirections of desire and purpose are of necessity imaginative."[11] In the hands of individual artists, this imagination takes countless forms, including contemplation, communion with a form, a celebration of a social construct, or a critique thereof. Whatever its tone, the aesthetic experience seems to present us with ways of seeing the world anew that are deeply memorable. Indeed, the sense of contingency between our imaging of the world and our standing in it that the aesthetic experience evokes can be quite liberating and even metaphorically instructive if we apply its lessons to the ordering of self and cultural paradigms.

The pursuit of aesthetics through the sense of the senses helps reinvigorate the space between knowledge and experience, providing a continuous reservoir of possibilities, an endless re-informing of self, a scaling of the world to experience, a bridging of the rational to the sensory, and a linking of the societal to the individual. Art making and viewing, when examined through the lens of the sense of the senses and the ethos of an aesthetic pursuit, exist as inherently hopeful and communal acts, revealing the terra incognita where one may find a more difficult definition of wholeness, a territory where the construction of self is tied to engagement with the world and where choices are colored ethically, not by way of the a priori direction of their aim, but by way of their ability to illuminate an aesthetic attitude toward life.

With no preordained grammatical rules, the visual language is always grappling with itself as it grapples with the world. The *impurities* and multiple desires that come into its domain constantly reanimate and challenge the language and premise of previously established designs. While art serves the refining of ourselves, in its unifying character it also serves the refinding of ourselves. Through its compelling invitations to reposition our psyche, art often asks us to weigh belief systems and understandings in radically new ways. For makers and viewers alike, it is a grooming of the sensibility of making choices that "feel right" within a shifting context of contested, even ethical, values.

The aesthetic pursuit may be understood as an act of faith, for even if it is not a vertically oriented conduit to some higher existence, it is a declaration that connectivity is still possible, that the hand can meet the mind, and that difference may be able to be gathered in multiple, unforetold notions of unity. It is, in fact, a celebration of the distinction of continually participating in the world's creation, and a resituating of that into experiential terms for others to see. While it is ecological in that it continually regenerates itself, the aesthetic pursuit is also an essential honoring and re-informing of the environment that birthed it, of consciousness itself, and of previous makers that preceded in this venture of assigning order in ourselves.

The aesthetic impulse as an act of reformulating. It is essentially progressive & optimistic here,

Notes

1. Term used by Ellen Dissanayake to describe the hyperliterary character of much postmodern theory and Western philosophy in general. For an in-depth explanation, see her "Does Writing Erase Art?" in *Homo Aestheticus: Where Art Comes From and Why* (New York: Free Press, 1992), 203.

2. Arthur C. Danto, *Encounters and Reflections* (Berkeley: University of California Press, 1990), 287, 344–45.

3. Buckminster Fuller, quoted in Susan Sontag, *Against Interpretation* (New York: Doubleday, 1990), 301.

4. Maurice Merleau-Ponty, *The Primacy of Perception* (Evanston: Northwestern University Press, 1964), 167.

5. Mel Bochner, quoted in Charles Stuckey, "Interview with Mel Bochner," *Mel Bochner, 1973–1985: Exhibition* (Pittsburgh: Carnegie-Mellon University Press, 1985), 19.

6. Susanne Langer, *Philosophy in a New Key* (Cambridge, MA: Harvard University Press, 1951), 141.

7. Ellen Dissanayake, "What Is Art For," quoted in Suzi Gablik, *Conversations before the End of Time* (New York: Thames & Hudson, 1995), 43.

9. Terry Winters, quoted in Richard Shiff, "Manual Imagination," in the exhibition catalog *Terry Winters: Paintings, Drawings, Prints, 1994–2004*, ed. Adam D. Weinberg (New Haven: Yale University Press; Andover, MA: In association with the Addison Gallery of American Art, 2004), 29.

9. Frances Colpitt, "Jessica Stockholder: A Merging of Mediums," *Art in America*, February 2005, 95.

10. Jack Flam, "Driving Us to Distraction," *Art News*, April 2001, 106.

11. John Dewey, *Art as Experience* (New York: Putnam, 1980), 349.

3 Overlaps

ECOLOGY AND AESTHETICS

Architecture, Aesthetics, and the Public Health

STEVEN A. MOORE

The modern professions as we know them today trace their lineage back to codes of ethics drawn up by guildsmen in the Middle Ages. These guildsmen thought that a class of specially trained practitioners—today's doctors and lawyers—could check the power that the moneyed elites wielded over them in a way that individuals could not. In other words, the appearance of the professions was not a natural but a politically negotiated event. The case of architecture is typical. In 1897 legislators in the state of Illinois recognized that the interests of citizens were being put at risk by the interests of capital. Simply put, those who developed and owned buildings were putting pressure upon those who designed and constructed them to cut corners and thus minimize cost and maximize short-term investor profits. The result was a series of construction failures that increased in proportion to the size of capital's dreams.

In 1897, therefore, Illinois architects went beyond the stage of informal gentlemen's agreements and entered into the formal and legal contract of professional registration in exchange for receiving a limited monopoly to engage in the design of public buildings—a practice denied to engineers or contractors.

We architects, then, are thrown into a historical agreement that has serious ethical import. This agreement stipulates that our legal authority to practice architecture is contingent upon, and balanced by, a fiduciary

responsibility, or public trust. We have achieved a degree of autonomy from the pressures of the marketplace only in exchange for our oath to guard the public health.[1]

At about the same time that professional licensure laws for architects appeared, a new set of ideas about belief, truth, and action that has come to be known as *pragmatism* was developed by philosophers including Charles Peirce and William James. In the pragmatist tradition, ethics is understood to be situational, not absolute. In philosophical terms, pragmatists operate from *pluralist* rather than *monist* assumptions, meaning that they are skeptical of those who claim that a single principle can be applied to all situations. Historians tell us that the skepticism of pragmatists Peirce and James toward moral absolutism was a reaction, at least in part, to the devastation produced by the diametrically opposed, yet ethically certain assumptions that fueled the Civil War.[2]

Our own time is not so different. The ethical certainty of the Taliban, Al Qaeda, and the religious Right of North America has left most of us more skeptical of certain types of monism than ever before. It is important, however, to distinguish philosophical pragmatism from another school of contemporary thought, postmodern relativism. Where relativists argue that competing truth claims can be equally valid, pragmatists hold that there is just no such thing as *Truth*. Rather than an immutable principle—Truth with a capital *T*—there are only provisional truths with a small *t*. In this sense, truth for a pragmatist is something closer to an *event* than a fixed principle. For James, "Truth happens to an idea. It becomes true, is made true by events."[3] In traditional epistemology, things hold together when they are true. In pragmatist epistemology, things become true when they hold together. In this sense the epistemology of pragmatism is developmental, relational, and historical rather than immutable, autonomous, and ahistorical.

For example, in the *Sand County Almanac* the naturalist Aldo Leopold argues that man's definition of "our community" is naturally evolving to include nonhuman species. In this view, our ethical relation to nature can be characterized as progressively Darwinian because such development is necessary for our own survival.[4] The poet Frederick Turner makes a similar Darwinian, or developmental, argument with regard to the concept of beauty, but from an entirely different tradition. Unlike contemporary postmoderns,

who argue that "progress" is an ideological myth, Turner argues that real progress is not only possible but historically and scientifically demonstrable. In his view, beauty is an objective reality in the universe that is experienced as a pancultural neurobiological phenomenon. His point is that evolution is a self-organizing process in which the experience of beauty is our reward for participation.[5] Both of these arguments, one ethical and one aesthetic, are consistent with pragmatism because they are developmental.

Here I intend to assess the ethical content of architecture's aesthetic predispositions from a pragmatist perspective. Since such a view understands ethics and aesthetics to be pluralist, developmental, and situational, as opposed to fixed or immutable, it is incumbent upon us to try to understand the situation into which we are all thrown.

For many citizens, the current situation is full of risk. Three years after the twin hurricanes, Katrina and Rita, ravaged the Gulf Coast, housing is grossly inadequate, residents still worry about the adequacy of the levees, and the lingering environmental hazards unleashed by the storms pose significant health risks, especially to the poor and most vulnerable. Far away from the Gulf Coast, New Englanders of all classes, who are mostly dependent for winter heat on fossil fuels appropriated from the oligarchic regimes of the Middle East, worry not only about escalating fuel costs and political instability but about the growing inability to insure coastal properties. Architecture, they are told, accounts for nearly half of the greenhouse gases that contribute to climate change and rising oceans. And in the distant Southwest, citizens are beginning to face the real possibility that cities like San Antonio and Las Vegas will run out of water. The question is, then, *what do we do in response to the situation in which we find ourselves?*

Three possible responses to this question guide the balance of this essay. First, we could argue that we should renegotiate upward the degree and condition of our autonomy from market forces on the grounds that aesthetic exploration and social critique are as valuable to society as is the public health. Second, we could argue, in the manner of engineers, that it is necessary to construct a theory and science of sustainable architecture before our actions would be of much use. Or third, we could simply act as best we can to strike a balance, and thus avoid the excesses that threaten the public health, but avoid, too, a soulless, superefficient, if clean environment.

The First Response: The Pursuit of Aesthetic Autonomy

Art turns into knowing as it grasps the essence of reality, forcing itself to reveal itself in appearance and at the same time putting itself into opposition to appearance. Art must not talk about reality's essence directly, nor must it depict or in any way imitate it. —Theodor Adorno, *Aesthetic Theory*, 1970

Modern appeals to formal aesthetic autonomy tend to rest upon the broad shoulders of Theodor Adorno, a founder of the Frankfurt School for Social Research. Adorno argues that by revealing to society the alternately sublime and terrifying "essence of reality," art produces a critique that is more potent than those to be found in the banal, and easily manipulated, conditions of everyday life. In concrete terms, Adorno and architects who follow him, such as Peter Eisenman, would turn architecture away from the material risks endured by the citizens of the Gulf Coast, New England, the Southwest, and elsewhere, so that we might turn "indirectly," through abstraction, toward the "essence of life."

From a pragmatist perspective, though, Adorno gets it backward. In his view, the interpretation of art informs subsequent action, disabusing it of false consciousness. In other words, deduction produces action. For the pragmatist, however, interpretations of the world emerge from action itself. As Louis Menand put it, "First we decide, then we deduce."[6] Our ideas about the nature of the world are constructed through our engagement with the lifeworld, not through our removal or abstraction from it. To argue that aesthetic abstraction subverts the commodification of market forces—what Adorno called the "culture industry"—is to invert the relation between knowledge and action. In the pragmatist view, abstraction from the lifeworld only anesthetizes us to the material conditions in which others live.

Adorno has argued that "'The dialectic critique of culture' has no alternative but to 'participate in culture and not participate.'"[7] Yet it is the necessity of such selective nonparticipation, or of formal abstraction, that in the hands of some tends to reproduce the very conditions critical theory wishes to subvert. For the pragmatist there is no singular metaphysical "essence of reality"—to again evoke Adorno's phrase—to be revealed a priori by artists. Rather, there are only the plural realities for artists to construct out of the material conditions into which they have been thrown.

This logic does not suggest that the world of appearances (to which Adorno refers above) can legitimate itself only through direct social or political action. Nor does it suggest that aesthetic production and social action are somehow opposed to each other. Nor do I intend to diminish the very significant social contribution made by artists. The issue is rather one of immediate necessity. Like my colleague Michael Benedikt, I believe that the production of beauty is a necessary social practice because its existence makes human life worth living. And like critical theorists, I also believe that the production of aesthetic critique is a necessary social practice because it helps us to recognize unexpected possibilities for living in the world. Art is, in this sense, a future-oriented practice.[8] My argument is that aesthetic production does not trump the relief of suffering in the community. I make this claim not just because we owe solidarity to our fellow beings, but because it is through such direct engagement in the lifeworld that we construct human knowledge. As the pragmatist philosopher Richard Rorty has argued, we can distinguish "questions about pain from questions about the point of human life," but, he implies, we are under no obligation to choose between them.[9] The point is that in our current situation there is no reason, save our disinclination and the shortage of time, why we can't choose to do both.[10]

More than a decade ago, Kenneth Frampton argued that "behind our preoccupation with the autonomy of architecture lies an anxiety that derives in large measure from the fact that nothing could be less autonomous than architecture."[11] He based this bold statement on the assessment that "architecture is both a cultural discourse and a frame for life."[12] He meant by this, I think, that architecture is a unique cultural practice. Like art, architecture is a discourse that produces cultural value in proportion to its isolation from everyday consumer choice. But, unlike art, architecture is primarily responsible for the production of the "lifeworld"—the setting that both frames everyday social relations and gives place to the sacred. So, while architectural discourse strives toward autonomy in the manner of art, architectural production is always already embedded in the messy political, economic, and environmental conditions of everyday life.[13] It is through such direct engagement with everyday conditions that we idealize the world—it is how we imagine how life might be better.

Frampton's critique suggests that we architects have generally appealed to the wrong principles to legitimate our operations. Specifically, we have alternately relied upon the authority of science or art to keep the philistine demands of utilitarians and populists from our door. For instance, Peter Eisenman's early work was based upon the quasi-scientific principles of semiotics, and his later work has been based upon the postmodern artistic discourse concerning uncertainty. Frampton's complaint, however, is that architects in general, and Eisenman in particular, have failed to legitimate their practices on the basis of unique architectural knowledge.

The type of architectural knowledge to which Frampton refers has always been bound to social conditions and to the desire to ennoble and change them. The Greeks had a word, *praxis,* that has come into common use in North America; we generally understand it to mean those institutional practices upon which the lifeworld depends—agriculture, business, health care, and so on. For Aristotle, however, one cannot consider the institutional practices, or *praxis,* of a society without also considering *phroenesis*—the concept of intellectual virtue. *Praxis* and *phroenesis,* taken together, refer to the "aptitude of each and every person to pass judgment in public matters as in private ones."[14] In this sense, all citizens engaged in the production of the lifeworld share a responsibility to pass judgment about how their practices, as well as those of others, affect the community as a whole. For the Greeks, then, as for contemporary pragmatists, the argument for absolute aesthetic autonomy is a hollow one based upon a false dichotomy between two equally compelling desires. On the one hand is the desire to realize aesthetic sublimity and social critique. On the other hand is the desire to minimize suffering. Not only does this false dichotomy tend to justify the inaction of some citizens, but it obscures our understanding that direct action in the lifeworld is itself the source of human knowledge.

A Second Response: Theory Development

Action without good scientific foundation, however, is a recipe for disaster. Consider the countless times when modern technology was so hopefully applied and yet so dismally received: atomic power, the damming of wild rivers, and the introduction of genetically modified species to agriculture, to name only a few. From this standpoint, it seems, we need to get our science

right before we act. But what kind of science and what kind of architecture do we need?

In my view the discourse concerning sustainable development provides the most potent possibility through which the broad concern for public health can be related to the environment, to economics, to social equity, and to the aesthetic dimension of culture. Yet the complexity and breadth of the concept makes sustainability a difficult idea to pin down. Is it possible to develop an a priori definition of sustainability—a definition that we can use to direct all subsequent action?

While some understand the concept of sustainable architecture to mean the romantic recuperation of premodern conditions, the historic conditions that give rise to the concept of sustainable development are essentially modern. Furthermore, the origins of the concept of sustainability did not emerge within architectural discourse, but are inherently transdisciplinary.[15] The figure "The transdisciplinary origins and ethical dilemmas of sustainable development" illustrates how contemporary architectural discourse is indebted to no fewer than six related modern disciplines: philosophy, physics, biology, politics, economics, and public health. A brief review of how the idea of sustainability evolved in these six related disciplines will, I think, help architects frame the dilemmas they face today.

There is a widely held view that since the time of René Descartes (1596–1650) Europeans have increasingly seen themselves as existing outside of nature and that this mind-set has allowed humans to exploit nature without concern for its well-being. Although this simple characterization has some merit, we must also recognize that other early modern thinkers attempted to construct a vision of human life as inherently related to natural conditions. For example, consider John Evelyn's *Sylva: A Discourse of Forest, Trees and the Propagation of Timber*, a scholarly book on sustainable practices published in 1664. In 1713 Hans Carl von Carlowsky used the term *Nachhaltigkeit*, translated from the German as "sustainability" in *Silvacultura Oeconomica: The Directive for Wild Tree-Breeding in Accordance with Nature.*[16] Both examples document that, within the discourse of natural philosophers, the concept of a sustained yield realized through the human management of natural resources was well understood if not universally practiced. We might, then, credit the natural philosophers of seventeenth-century Britain

The transdisciplinary origins and ethical dilemmas of sustainable development

	Philosophy	Physics	Biology	Politics	Economics	Public health
Primary concepts	Sylva culture (1664) Deep ecology (1980s)	Entropy (1865) Energy economics (1920s)	Evolution (1859) Ecology (1866)	Enlightenment project of rights extension	"Throughput"— nature is conceived as resources and sinks that are external to human economy	The sanitary idea Civic economy (1850) Germ theory (1880) New ecology (1945)
Major figures	John Evelyn (1620–1706) Ame Naess (1925–)	Rudolph Claussius (1822 –88)	Charles Darwin (1809–1882) Ernst Haekel (1834–1919)	John Locke (1632– 1704) Karl Marx (1818– 1883)	Adam Smith (1723–90) Herman Daly (1935–)	Jeremy Bentham (1748–1832) Edwin Chadwick (1800–1890) Michel Foucault (1926–84)
Ethical dilemmas	What is the human relation to nature and who has moral responsibility?	Given an emergent state of chaos, what is our moral obligation to future generations?	Does an anthropo-genic world diminish evolutionary prospects?	Shall individual rights be preferred to the health of the ecosys-tem as a whole? How shall ever more scarce natural resources be justly distributed?	How do we account for, or internalize, the real costs of natural production and waste filtration?	Shall we prefer the suppression of environmental risk to the experience of otherness?
Objective indicators	The instrumental degradation of nature	Global warming	Species loss and loss of reproductive choices	Relative rates of resource consumption and environmental risk	Environmental pollu-tion and unsustainable rates of consumption	Environmental and technological threats to public health

and eighteenth-century Germany with initiating the modern discourse on sustainable practices. That discourse traveled to North America with Gifford Pinchot (1865–1946), who was named chief forester of the U.S. Forest Ser-vice by President Theodore Roosevelt. Since the mid-1960s a few architects, landscape architects, and planners have contributed to this philosophical discourse. It has not, however, become an essential part of architectural education.

In the discipline of physics, Rudolph Claussius (1822–88) is generally credited with the development, in 1865, of the Second Law of Thermody-namics, commonly referred to as *entropy*. Based upon his observation of

thermal transfer, Claussius argued that one couldn't finish any real physical process with the same amount of energy as one started with. Once energy is expended, changing it from a usable to an unusable form, it cannot be replaced. In any closed system—like our own solar system—entropy measures the amount of energy not available to do work. By the 1920s this modern understanding of basic physics prompted natural scientists to develop the doctrines of *energy economics*. These doctrines express various ethical and economic imperatives to expend energy as efficiently as possible thus delaying the inevitable chaos associated with advanced states of entropy. In the 1960s the architects Victor and Aladar Olgyay applied the implications of entropy to architecture in their seminal book, *Design with Climate*.[17] However, it was not until the energy crisis of the 1970s that most architects began to appreciate the salience of Claussius's research to the design of buildings and cities.

With regard to the discipline of biology, we are accustomed to saying that the 1859 publication of Charles Darwin's *On the Origin of Species* introduced the concept of evolution. This is not exactly correct. Although there were highly respected scientists of the time who tenaciously argued that nature was unchanging, there were other contemporaries of Darwin, the English philosopher Herbert Spencer and the French naturalist Jean-Baptiste Lamarck, for example, who had advanced the idea that nature evolves over time. What was so radical about Darwin's book was not the idea of evolution itself but the idea that changes in nature were not guided by supernatural intelligence. The idea that evolution was determined, not by God, but by random chance, introduced the possibility of *anthropogenesis*, or human-created conditions that would subsume natural order. With the intellectual possibility of an anthropogenic world came an ethical and pragmatic crisis that was not confronted until the mid-twentieth century.[18] Without Darwin (1809–82) we could not have the contemporary discipline of environmental design.

Only a few years after the publication of Darwin's book, the term *ecology* was coined by the German zoologist Ernst Haekel (1834–1919). In his *Generelle Morphologie der Organismus* of 1866, Haekel did not fully develop the scientific concept as it is understood today, but he did help to popularize the notion that biological entities cannot be understood outside their natural environment. Haekel reasoned from a philosophically monist position that

is opposed to the Cartesian dualist assumptions of Western science. It is not surprising, then, that the latter-day supporters of ecology, awakened by the 1962 publication of Rachel Carson's *Silent Spring,* would reject a purely quantitative approach to the conservation of nature. It is this holistic approach to design that was adopted in the 1960s by pioneers such as the landscape architect and planner Ian McHarg.

In the discipline of politics, the linked concepts of ecologism and sustainability can be partly understood as a continuation of the Enlightenment project of *rights extension.* The Scottish Enlightenment in particular, under the influence of John Locke (1632–1704), introduced the notion that all men, not just the landed aristocracy, possess natural rights. Since that time, Western societies have extended rights to men of color and to women; today, organizations such as Earth First! and PETA (People for the Ethical Treatment of Animals) argue for the natural rights of various plants and animals.[19] The field of environmental ethics is, however, divided over the granting of such rights. While some, like PETA, argue for the rights of individual animals, others, like the "deep ecologist" Arne Naess, argue for the superior rights of the ecosystem as a whole. It is this latter view that has had much influence upon the late twentieth-century projects of architects such as Brenda and Robert Vale in England and New Zealand.

From economics, architecture has inherited not only the "bottom line" but the neoclassical model of economy that derives from Adam Smith (1723–90). In this tenacious doctrine, nature was viewed as little more than the source of free raw materials and a place to dump wastes. The ecological consequences of the neoclassical, or "throughput," economic model has, however, been challenged by contemporary economists such as Herman Daly. Daly argues that the human economy exists within a larger natural economy. To fail to account for the ecological costs of "sources" (natural resources), or the costs of disposing of "waste" in natural "sinks," is only to delude oneself that such costs are "external" to the economic system. The implications of such emerging economic theory for architecture are enormous.[20] In Daly's view, we should be responsible, not just for the initial cost of construction, but for the cost of building operation, building decommissioning, and the impacts upon all those other sites from which materials and energy were mined or where they will be buried.

The last dilemma, which derives from the modern discipline of public health, requires a bit more consideration. On the right hand of this dilemma is the tradition of the utilitarian philosophers, principally Jeremy Bentham, who argued that the aim of life, ethically speaking, is "the greatest good for the greatest number."[21] From this logical precept Bentham constructed an attitude toward social order that we now regard as authoritarian and technocratic. It seems that Bentham and followers like Edwin Chadwick, progenitor of "the sanitary idea," were not predisposed to trust in the ability of common citizens to make sensible choices concerning much of anything. Rather, their idea of "civic economy" relied upon an educated elite to efficiently manage the interests of society, which they conceived to be essentially economic in nature. Such an efficiently managed, or sanitized, society was, of course, the nightmare of the left hand of this dilemma, articulated so powerfully by Michel Foucault.[22] In Foucault's view, the institutions of public health constructed by nineteenth-century utilitarians were little more than the illegitimate mechanisms of the modern bureaucratic state through which social deviancy, or *otherness,* might be eradicated. The ethical dilemma posed by the doctrines of public health, then, is characterized by a confrontation between two desires: first, the desire of those who, like Chadwick, wish to minimize environmental health risks; and second, the desire of those who, like Foucault, see the management of private, existential risks by the state to be a totalitarian scheme intent upon the production of monoculture.[23] In my view this ethical dilemma can be resolved only by getting beyond the anthropological assumptions of both sides.

The point to be derived from all six disciplines characterized in this diagram is twofold. First, architects should acknowledge that they face substantive ethical dilemmas created by the modern situation. The discourses of philosophy, physics, biology, politics, economics, and public health now demand a response from those responsible for architectural production. Second, a universally accepted definition of sustainable development, or of sustainable architecture, will not be reached simply, or quickly, if at all. However, if we can agree that the modern situation is socially constructed, then we should be able to agree that its resolution must also be socially constructed by those with an interest in the lifeworld—meaning virtually everyone. In this view, sustainable science and sustainable architecture cannot be

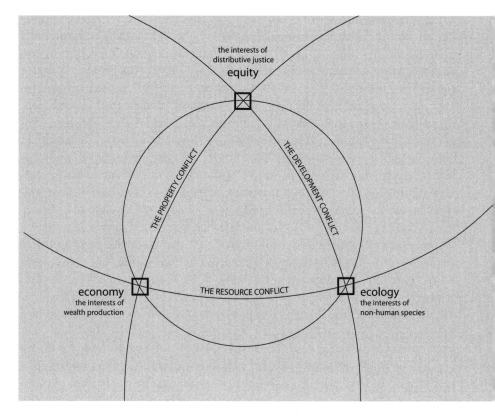

defined a priori by scientists in the laboratory, or by architects in the studio. Rather, they must be constructed over time by the actions and discussions of citizens.

I am not, however, suggesting that we should avoid constructing provisional definitions. In fact, I want to briefly offer two diagrams that speculate about what variables are at play within "sustainable development." The first ("The planner's triangle") is derived from one crafted by the planner Scott Campbell, and the second ("The four points of design") is one I constructed myself in collaboration with colleagues at the University of Texas, Center for Sustainable Development.

Campbell's diagram is, in my view, the most elegant definition of

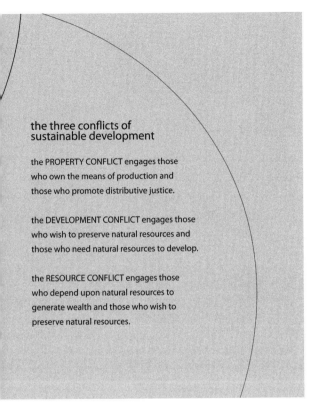

The planner's triangle: Sustainable development—green, profitable, and just

the three conflicts of sustainable development

the PROPERTY CONFLICT engages those who own the means of production and those who promote distributive justice.

the DEVELOPMENT CONFLICT engages those who wish to preserve natural resources and those who need natural resources to develop.

the RESOURCE CONFLICT engages those who depend upon natural resources to generate wealth and those who wish to preserve natural resources.

sustainable development yet to appear. It argues that sustainable development is necessarily a discursive practice. I would like to go one step further, however, and argue that the concept is *democratic* because it involves the resolution of private conflicts in the public space. But as much as I admire this diagram, I find that it lacks at least one dimension—the aesthetic. The planner's triangle, I believe, should expand to a broader configuration.

One benefit of adding the fourth element to the structure of sustainable development is that we are less likely to reduce architecture to some quantitative formula or list of best practices enforced by well-intended but dull technocrats. To erase the aesthetic from our criteria of the good would hardly enhance our situation—it would only keep us from ever wanting to

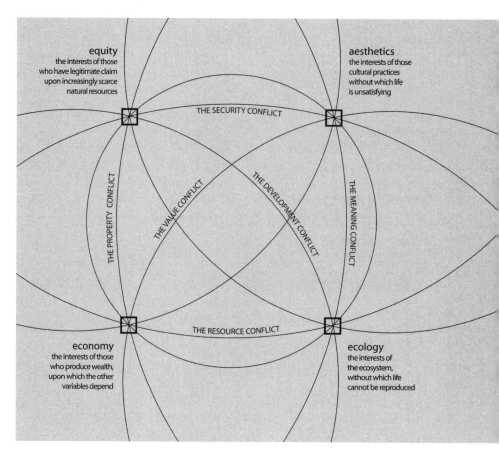

equity
the interests of those
who have legitimate claim
upon increasingly scarce
natural resources

aesthetics
the interests of those
cultural practices
without which life
is unsatisfying

THE SECURITY CONFLICT

THE PROPERTY CONFLICT

THE VALUE CONFLICT

THE DEVELOPMENT CONFLICT

THE MEANING CONFLICT

THE RESOURCE CONFLICT

economy
the interests of those
who produce wealth,
upon which the other
variables depend

ecology
the interests of
the ecosystem,
without which life
cannot be reproduced

get out of bed. On the other hand, the problem with adding aesthetics to the definition of sustainable development is that we are less likely to measure, and thus satisfactorily manage, the elusive variables at play. Expanding the number and nature of the variables to be considered only makes empirical data harder to gather and interpret. In the end, any abstract or a priori model of sustainable development will tend to suppress local opportunities for action in favor of universal principles.[24]

To sum up, I believe it would be unwise for architects to wait for scientists to define, on the basis of the above six discourses, what it means to be

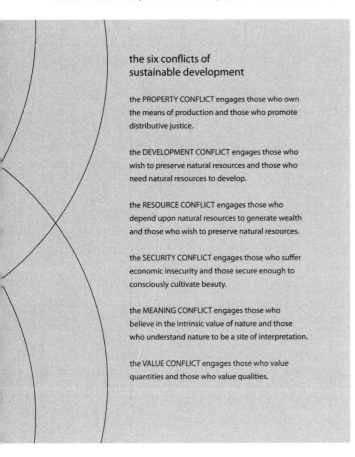

the six conflicts of
sustainable development

the PROPERTY CONFLICT engages those who own
the means of production and those who promote
distributive justice.

the DEVELOPMENT CONFLICT engages those who
wish to preserve natural resources and those who
need natural resources to develop.

the RESOURCE CONFLICT engages those who
depend upon natural resources to generate wealth
and those who wish to preserve natural resources.

the SECURITY CONFLICT engages those who suffer
economic insecurity and those secure enough to
consciously cultivate beauty.

the MEANING CONFLICT engages those who
believe in the intrinsic value of nature and those
who understand nature to be a site of interpretation.

the VALUE CONFLICT engages those who value
quantities and those who value qualities.

The four points of design: Sustainable
development—green, profitable, just,
and beautiful

sustainable. Waiting for pronouncements from a higher authority is coun-terproductive because it shuts down democratic discourse. Second, while constructing provisional theories and definitions of sustainability may not produce the empirical knowledge necessary for effective action, such specu-lations are helpful because they stimulate the public discourse upon which sustainable practices will ultimately depend. In my view, then, the construc-tion and constant renovation of humble theories is a necessary but insuf-ficient practice required to resolve the ethical dilemmas into which we are thrown.

A Third Response: Action

My third and final response to the question of what architects should do in the present situation is simple—we should act.

It is clear from a cursory historical examination that the emerging discourse of sustainability, rather than developing from within the discipline of architecture, has been imposed upon the field. Modern architecture, however, is not inherently unsustainable or antinature. The early works of Richard Neutra brilliantly embody the environmental and social concerns that the contemporary advocates of sustainable architecture now promote.[25] However, one must face the fact that some strains of contemporary architecture largely ignore the questions of environmental sustainability and the public health in favor of an internal discourse devoted to formal aesthetic concerns. Though they may hold other merits, such concerns are irrelevant to the most pressing conditions that characterize our situation.

If architects are to honor our responsibility to guard the public health, safety, and welfare, we have to engage in public discourses, like that of sustainable development. If we are to act as citizens, rather than as autonomous agents of self-realization, we have to exercise our ethical responsibility to pass judgment on how our projects, and those of our fellow citizens, affect the community.

What should architects do in response to the situation in which we find ourselves? We should do the best we can to close the divide between aesthetic production and citizenship. In serving the public's health, in the most expansive sense of that term, we will serve an always unfolding beauty.

Notes

1. Section 4 of state of Illinois statute An Act to Provide for the Licensing of Architects and Regulating the Practice of Architecture as a Profession (June 3, 1897) provides for the examination of architects by the State Board of Examiners. That section states in part, "The examination shall have special reference to the construction of buildings . . . the strength of materials, and . . . the laws of sanitation as applied to buildings" (83).

2. This is the position argued by Louis Menand in *The Metaphysical Club* (New York: Farrar, Straus, and Giroux, 2001).

3. I first made this argument in "Critical and Sustainable Regions in Architecture" (PhD diss., Texas A&M University, 1993), 30, before I was aware that William James had made the

same argument eighty-six years before. He argued in 1907: "Truth *happens* to an idea. It *becomes* true, is *made* true by events. Its verity *is* in fact an event, a process: the process namely of its verifying itself." See "Pragmatism," in William James, *Writings, 1902–1910: The Varieties of Religious Experience, Pragmatism, A Pluralistic Universe, The Meaning of Truth, Some Problems of Philosophy, Essays,* Library of America (New York: Literary Classics of the United States, 1987), 574.

4. Aldo Leopold, "The Land Ethic," in *A Sand County Almanac: With Essays on Conservation from Round River* (1966; New York: Ballantine, 1970).

5. Frederick Turner, *Beauty: The Value of Values* (Charlottesville: University Press of Virginia, 1991), 31, 116–40.

6. Menand, *The Metaphysical Club,* 353.

7. Adorno quoted in *The Essential Frankfurt School Reader,* ed. Andrew Arato and Eike Gebhardt (New York: Continuum, 1994), 204.

8. Arato and Gebhardt, *The Essential Frankfurt School Reader,* 222.

9. Richard Rorty, *Contingency, Irony, and Solidarity* (Cambridge: Cambridge University Press, 1989), 198.

10. The art/citizenship opposition that I construct here is related to, but not synonymous with, two of the "dialectical dualities" found by Dana Cuff: the individual vs. the collective nature of architectural practice, and the "design against business" opposition. See Cuff, *Architecture: The Story of Practice* (Cambridge, MA: MIT Press, 1991), 11. Magali Larson also recognizes that "in America, aesthetic and social purpose remain divorced." This divorce was best illustrated by the 1932 exhibition at the Museum of Modern Art curated by Philip Johnson and Henry Russell Hitchcock in which European modern architecture was introduced to the United States. See Magali Sarfatti Larson, *Behind the Postmodern Façade: Architectural Change in Late Twentieth-Century America* (Berkeley: University of California Press, 1993), 74. For both of these authors, the separation of aesthetics and social action is ideological.

11. Kenneth Frampton, "Reflections on the Autonomy of Architecture: A Critique of Contemporary Production," in *Out of Site: A Social Criticism of Architecture,* ed. Diane Ghirardo (Seattle: Bay Press, 1991), 26.

12. Frampton, "Reflections on the Autonomy of Architecture," 18.

13. Magali Larson makes a similar point in *Behind the Postmodern Façade,* 12: "The ideological autonomy that our society accords to professionals and, even more so, to artists cannot hide the fundamental heteronomy of architectural work."

14. Richard J. Bernstein, "Heidegger's Silence: Ethos and Technology," in *The New Constellation: The Ethical-Political Horizon of Modernity/Postmodernity* (Cambridge, MA: MIT Press, 1992), 79–141.

15. To distinguish between these terms, I'll define *interdisciplinary* as a discourse between professionals who recognize the autonomy of the respective disciplines engaged. *Transdisciplinarity,* however, refuses to recognize the boundaries between disciplines as anything other than a social convention that is based upon power relations.

16. This literary discovery was made by Ralf Brand, a PhD student in the Community

and Regional Planning program at the University of Texas. Brand is investigating alternative, nontechnological models of sustainable development.

17. Victor Olgyay and Aladar Olgyay, *Design with Climate: Bioclimatic Approach to Architectural Regionalism* (Princeton: Princeton University Press, 1963).

18. Menand, *The Metaphysical Club*, 117–21.

19. The relationship of Enlightenment rights extension and contemporary ecologism has been studied by Timothy Beatley. See his *Ethical Land Use: Principles of Policy and Planning* (Baltimore: Johns Hopkins University Press, 1994).

20. Daly has written extensively on this topic. His most recent contribution to the redefinition of economics is Herman E. Daly, *Ecological Economics and the Ecology of Economics: Essays in Criticism* (Cheltenham, UK; Northampton, MA: E. Elgar, 1999). On the early economic analysis of "sources" and "sinks," see Kenneth Ewart Boulding, *Beyond Economics: Essays on Society, Religion, and Ethics* (Ann Arbor: University of Michigan Press, 1968).

21. W. L. Reese, *The Dictionary of Philosophy and Religion: Eastern and Western Thought* (Atlantic Highlands, NJ: Humanities Press, 1980), 53.

22. Michel Foucault, *Discipline and Punish: The Birth of the Prison* (Harmondsworth: Pelican Press, 1975).

23. The same dilemma continues to be articulated between contemporary authors like Ulrich Beck and Peter Marsh. Beck argues that it is unjust that those who control the means of production generally escape the health risks associated with environmental pollution while those of modest means suffer such risks disproportionately. See *The Risk Society and Beyond: Critical Issues for Social Theory*, ed. Barbara Adam, Ulrich Beck, and Joost van Loon (London: Sage, 2000). In contrast, Marsh, who describes himself as a left-wing libertarian, objects to "the level of concern (some might say 'obsession') with dietary, health and lifestyle correctness that characterises contemporary Western societies, and the UK and the United States in particular. This pursuit of novel, narrow concepts of so-called 'health' and 'fitness' has led us to create new outcasts—those who fail to conform to the increasing catalogue of prescriptions for what is 'best for us'—those who, contrary to the advice of self-appointed arbiters of modern rectitude, persist with 'bad habits.'" Peter Marsh, "In Praise of Bad Habits," lecture to the Institute for Cultural Research at the King's Fund, London, November 17, 2001.

24. This logic is expanded considerably in Steven A. Moore, *Alternative Routes to the Sustainable City: Austin, Curitiba, and Frankfurt* (Lanham, MD: Rowman & Littlefield, 2007). There I argue that while models and lists of "best practices" may have heuristic value, in the end they are more dangerous than helpful.

25. See Richard Neutra, *Architecture of Social Concern in Regions of Mild Climate* (São Paulo: Gerth Todtmann, 1948). A similar argument is made by James Steele in *Ecological Architecture: A Critical History* (London: Thames & Hudson, 2005).

Tries to diagram the overlaps and tensions and conflicts, dilemmas, in contemporary planning where ecology is an objective

Fire Wall: A Meditation on Architectural Boundaries

WILLIAM SHERMAN

> *The thermal space of the bonfire is no less architectural than the visual space of the*
> *hut. Only an obstinate fetishism for icons or an object oriented, hieratic conception*
> *of architecture can deny the bonfire the status of ab ovo architecture so easily*
> *assigned to the hut. What is a house but a hearth? ... hut and fire, construction and*
> *combustion, are inextricably linked in the history of habitation, a unique combina-*
> *tion of constructed order and combustible disorder.*
> —LUIS FERNANDEZ-GALIANO, *FIRE AND MEMORY*

The first wall was ephemeral and invisible, the boundary of the thermal and linguistic circle at the original bonfire, a space woven by warmth and words before it found architectural form. As it became material, it acquired additional meaning and weight, registered the dimensions of human habitation and construction, and provided temporary shelter from a sometimes hostile climate.

In his *Ten Books on Architecture,* Vitruvius wrote:

> Therefore it was the discovery of fire that originally gave rise to the coming together of men, to the deliberative assembly, and to social intercourse. And so, as they kept coming together in greater numbers into one place, finding themselves naturally gifted beyond the other animals in not being obliged to walk with faces to the ground, but upright and gazing upon the splendor of the starry firmament, and also in being able to do with ease whatever they chose with their hands and fingers, they began in that first assembly to construct shelters.[1]

The provision of shelter by means of fire or enclosing walls was defined by Vitruvius as both a private and a public act, simultaneously the product of bodily necessity and the origin of social intercourse. The wall's dual functions of shelter and communication are inextricable from the start, a measure of both the limit of human need and the necessary connection between

people, a built language that is the basis of political and social relationships. From the original infusion of energy in the flames of the bonfire, physical and social structures arise to articulate a set of civilizing principles, simultaneously consuming, conserving, and concentrating the preexisting flows of energy.

To construct a wall is to define one's place in the world, to establish a boundary mediating between a dynamic environment and a place of contingent stasis. It stabilizes the inherent dynamism of the natural environment sufficiently to allow the activities of everyday life to become the foundation for invention rather than mere survival. The fabrication of an interior space distinct from the environment is the founding act of civilization. The construction of this distinct inside simultaneously constructs an outside; the wall renders material the intended relationships between inside and outside.

From these individual acts of construction, a collective realm emerges, amplifying and intensifying energy flows for human purposes through the reordering of material relationships. At a certain moment of urban density and technological proficiency, the stabilizing function of the wall was displaced by a centralized infrastructure, liberating the wall while creating a fragile new dependence on the centralized flow of energy. The stabilizing function of the wall, woven into the fabric of daily life, was replaced by a system that linked near and far, distancing consumption from combustion. In the liberated wall, routine choices like the design of a window became acts with far-reaching but unseen consequences. The setting of a thermostat is multiplied by thousands of similar choices into the demand that fills the tankers and railcars from distant coal mines and oil fields. If, on the other hand, the wall itself performed the infrastructural function, consumption and combustion would be reordered in consciousness with the immediacy of the bonfire.

The design of this revitalized wall requires a profound acknowledgment of our understanding of the processes of nature, whose flows it inevitably alters as well as those of the human body and mind. Yet, as Vitruvius implied, though these understandings are essential, they are insufficient: the construction of a wall is also a cultural act. A wall is never neutral. Every mark, every opening, recalls and redefines a cultural history, scaling our individual

and collective identities in relation to the city and the world. Personal, environmental, and societal principles become implicit in the choice of the wall's form, its functions, and its materials; the design process is inescapably a process of ethical inquiry.

In the design context, it is possible to use the term *ethics* in a way that is not bounded by antiquated hierarchies validated by external authority, but rather accounts for and explicitly articulates two aspects of ethical inquiry. The first is an acknowledgment that ethics deals with intent and action rather than the interpretation of works. "Is this an ethical building?" is an absurd question because ethical values are not immanent in a work, but exist in the intentions (cultural or individual, conscious or unconscious) that brought a work into being. The second is the consideration of the principles that govern ethical judgment. These principles are not preexisting; they are constructed through individual or cultural experience and are necessarily conditional and unstable. The moment these dynamic characteristics are frozen or universalized, the discourse shifts to the terrain of a moral code.

Ethical inquiry is useful in exposing and challenging the assumptions and values that underlie the decision-making process in design. Although often used interchangeably, *ethics* and *morals* are not synonymous, and the distinction must be maintained if we intend to reveal and construct value systems rather than affirming those that are presumed to exist with eternal authority. Ethical inquiry is a discipline of critical self-consciousness in the present, expanding the momentary present into a space that allows the act of decision making to coexist with the recognition of the values that inform a choice. Ethical inquiry is active in the present moment as the simultaneous construction and evaluation of dynamic and conditional values. Does this definition imply a state of ethical relativism in which the question of responsibility evaporates? Only if one interprets "dynamic and conditional" as implying that they are entirely untethered. Without the assumption of an absolute preexisting ethical baseline, an implied one must be recognized in the ongoing construction of a cultural consensus.

There are then two obligations of those engaged in serious ethical inquiry who desire to build an expanded community with a shared sense of collective responsibility. The first is to bring one's ethical values to public consciousness in the form of arguments to be made, refuted, and engaged in

a vital intellectual discourse, to join the conversation at the bonfire. This is essential to the formation, development, and sharing of values to construct the evolving consensus that links individual action to a higher responsibility. The second is the obligation to expand the dimensions of the group engaged in this discourse. As the group expands, the opportunity for a shared sense of self-interest is broadened, the cultural foundation for ethical inquiry is strengthened, and the necessity for collective responsibility as a guide to individual action becomes inescapable. The fire, when constructed and kept by a larger body of invested individuals, produces more for the common good than simply heat.

The equation of architectural acts—the construction of walls—and community building as a self-conscious act of expanding the circle of shared interest is predicated in Vitruvius's text and echoed in Richard Rorty's *Contingency, Irony, and Solidarity:* "The right way to take the slogan 'We have obligations to human beings simply as such' is as a means of reminding ourselves to keep trying to expand our sense of 'us' as far as we can. . . . The right way to construe the slogan is as urging us to create a more expansive sense of solidarity than we presently have. The wrong way is to think of it as urging us to recognize such a solidarity as something that exists antecedently to our recognition of it."[2]

At the heart of this argument is the understanding that we are bound as a culture not by the buildings that we make but by the act of building—by architecture as an act of bridging. The solidarity between people that makes cultural formation possible does not exist independently of the act of constructing solidarity. Cities are far more than physical constructs—as sites of intercourse and exchange, their concentration is essential to the construction of solidarity. Density necessitates increasingly elaborate and far-flung supporting infrastructures that are bound regionally and globally in an increasingly interdependent community. If those ties are based, however, on the model of a one-way flow of consumption divorced from the consciousness of combustion, the community being constructed is one not of solidarity but of exploitation. The ethical and design challenge is to imagine a construct that reorganizes the unidirectional flow from combustion to consumption into a multidirectional network in which material and energy are recalibrated. This new multidirectional network engages the productive energy of natural

processes and the transformative properties of architectural boundaries to redefine the modern infrastructure.

In this new role, the architectural wall has the potential to become the critical agent in modulating the direction of the infrastructural flows. By contrast, the contemporary wall in common practice has become a place of emptiness, a site for meaningless pattern making and vacant reflection. Liberated from its function as a representational field by the ascendance of text, from its weight-bearing function by the structural frame, its environmental function by abundant energy, its human dimension by industrial manufacturing, the wall has been simultaneously freed from constraint and drained of purpose. It is now fertile ground for the most profound reinvention. As Le Corbusier systematically inverted the plinth, the bearing wall, the aedicular window, the pediment, and the room with his five points of architecture, there is the opportunity now for a new inversion that leads to a new place.

The first industrial age freed us from the classical relationship of mass and geometry through the construction of an extensive energy infrastructure, allowing the invention and transportation of new materials, greater ease and rapidity of communication, and the liberation of the thermal envelope and the cycle of day and night. A new paradigm was formed, supplanting the dynamic, intersubjective relationship between humans and their environment with static definitions of human function in relation to a comprehensibly ordered visual environment. Despite forty years of postmodern criticism of the functionalist narrative, the paradigm still rules design and experience at the building scale in the codified mechanical engineering standards that assume a static ideal. Such standards are translated at the urban scale in the formulas of civil and traffic engineers that structure the flows of water and cars and, at the global scale, in the continued application of modern Western values to distinct local cultures in the form of outdated master planning strategies.

This positivist, technological narrative is predicated on the taming of the Promethean flames into a stable portable heat, freeing culture from the hearth and people from the language that grew from their coming together. The eyes were liberated to organize the world to their liking; the processes, needs, and functions of the body accommodated by the infrastructure of portable fire. The wall, once laden with the memory of the thermal limit of

Diagram of porch airflows

the fire's warmth and the human dimensions of its conception and material realization, was reduced to an unblinking visual shutter.

The binding forces of society that a wall can provide—space for social interaction, warmth, and the registration of human interaction—cease to exist unless continually renewed in ongoing engagement over time. This engagement transcends the visual, constructing a space of interdependence between human habitation and the world beyond.

The term *wall* may be generalized to refer to the entire building enclosure

or envelope, which is not merely a line of separation but a space of interaction between the interior and exterior. In shaping a place or building a wall to achieve a meaningful stability, the architect composes with four fundamental elements of architecture: mass (or material), geometry, energy, and time. The structure of the relationship between them is contingent on a theory of the human relationship to nature. Distinct theories regarding this relationship have emerged through history.

The Judeo-Christian heritage that has animated the last millennium of Western building conceives the human as separate from nature, endowed by god as its steward. The polytheistic religions of Asia and indigenous cultures worldwide are often cited as positive alternatives to the anthropocentric notion of stewardship. It is sometimes argued that monotheism, as a departure from the traditions of nature worship at the core of Judeo-Christian theology, implicitly subjects nature to the geometry of human need and desire.[3]

At a further extreme, ideologies based on the exploitation of nature without even the concept of stewardship subordinate nature's processes to the demand for energy and the geometries implicit in its extraction and distribution. This approach has enabled the engine of industrialized urbanization to define the world we now inhabit. The metropolitan city of the twentieth century is inconceivable without the infrastructural apparatus necessitated by the extraction and consumption of nature's resources.

An attractive alternative lies in the preindustrial vernacular relationship with nature, a partnership only possible in the case of a density of inhabitation that does not challenge the limits of the productive capacity of the land. Circumscribed by local material and energy supplies, subordinate to the daily and seasonal cycles of time, the geometries of this partnership describe an interdependent relationship. It is, however, a state to which the scale of contemporary functions, economies, and production techniques cannot return without cataclysmic social upheaval.

From Fire to Infrastructure

In the premodern condition, materials and energy were limited and time was a given. The solution to the construction of a wall that worked to serve the role of fire—providing a meaningful place of human gathering in sufficient

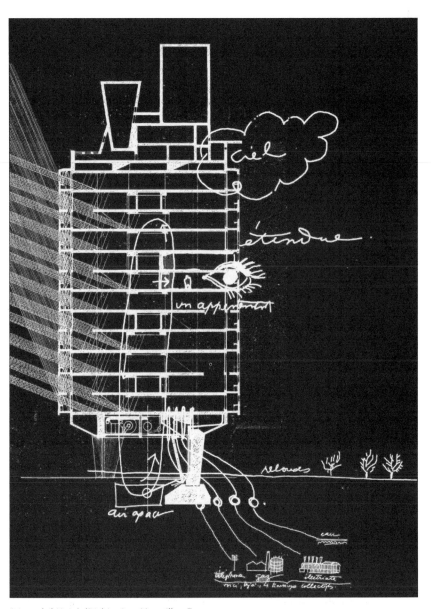

Brise-soleil, Unité d'Habitation, Marseilles, France

thermal comfort to transcend mere survival—lay in its geometry, or design. Its orientation, thickness, apertures, and stability negotiated the physical and cultural needs of the individual and the tribe, village, or settlement. Design could not be construed entirely independently of these purposes, even if this was posited as an ideal at times. With the advent of the modern infrastructure, materials were invented to eliminate the role of mass in favor of lightness, energy became abundantly portable, and time was tamed. Geometry (or design) was reduced to a visual poetic divorced from explicit purpose or agency—an aesthetic realm freed from other responsibilities. This concept is embodied in Le Corbusier's diagram for the Unité d'Habitation in which the energy, communications, water, and sewer are handled by the pipes and wires, so that the remaining relationship to the world is the act of viewing from a disengaged room in the sky. The wall is a visual framing device, its environmental function reduced to the *brise-soleil* that is breaking rather than engaging the energy of the sun.

Parallel with this narrowing of architecture's capacity to deepen the relationship between a multisensory, multidimensional human experience and the world, humanity's tools approached the scale and power of natural forces. The application of our potential to construct a parallel nature—the infrastructural precondition for the modern city—carries with it a great responsibility to make ethical choices with respect to the larger human community, the environment, and the individual's experience of daily life. The Hoover Dam and the diversion of the Colorado River did not, as some have argued, make Los Angeles possible; it was the assumed design preconditions and ethical choices on which Los Angeles based its form that necessitated the Hoover Dam. The infrastructure begins at home.

From Fire to Wall

Human understanding of the world must precede the application of infrastructural tools that operate at the scale of nature. The construction of that understanding is the new program of the architectural wall. When the centralized infrastructure is decentralized from the pipe to the wall, the design flow is inverted from dependence to agency. Rather than being conceived as contingent on the precondition of a stable infrastructure, the boundary condition of architectural space defines where the necessity of infrastructure

begins. The geometry of material relationships, in the form of the wall, becomes the infrastructure, capturing, storing, and distributing the necessities of shelter independently of the piped and wired connections.

As the wall—or building envelope—becomes the new fire, the finite resources of centralized supplies are replaced by the infinite resources of natural dynamics, which are continually renewed by the sun. This inexhaustible source confounds the process of entropy by infusing the system with its energy. As the wall engages this energy in all its forms, from solar radiation and natural ventilation to light and rain, the human connection to these forces is renewed. The result is neither a cult of energy efficiency nor the anticivic imperative of grid-free self-sufficiency, but an inversion of the hierarchy of our relationship to infrastructure, making our processes of construction and our daily rituals of inhabitation all part of the building of a shared community.

If the wall is to be reconsidered in these terms, what does it mean specifically? Nick Baker, an environmental engineer, offers a clue to this productive engagement with natural processes through a new type of wall or building envelope:

> Although we spend most of our time indoors, we are really outdoor animals. The forces which have selected the genes of contemporary man are found outdoors in the plains, forests and mountains, not in the centrally heated bedrooms and at ergonomically designed workstations. Fifteen generations ago, a period of little consequence in evolutionary terms, most of our ancestors would spend the majority of their waking hours outdoors, and buildings would primarily provide only shelter and security during the hours of darkness. . . . One of the characteristics of the natural world is its variety (in space) and variability (in time) and the opportunity and need to make adaptive responses. Should we be providing this in our buildings by a closer coupling of the interior with the outside? Or is it possible for the built environment to provide an equivalent richness, together with the challenge and opportunity to respond, without the engagement of nature—a kind of "virtual nature"? . . . These are the questions, which are going to become increasingly relevant as urbanization continues and the pressure to build bigger and deeper buildings grows.[4]

Double-Envelope Ventilating Wall, GSW Head-
quarters, Berlin, Germany. Architects: Sauerbruch
+ Hutton

Without resorting to a nostalgic denial of the contemporary cultural con-
dition, Baker poses the challenge of reconciling our present needs with our
genetic makeup, a relationship at times severed by our current privileging
of infrastructural stability. An emphasis on the engagement with nature's
processes in the constructed realm may operate functionally to provide and
conserve the energy, air-, and water flows while accomplishing something
more profound: connecting us to the world and each other in a way that re-
flects our common genetic makeup. In the GSW building in Berlin, Matthias
Sauerbruch and Louisa Hutton have inverted Le Corbusier's Unité diagram,

Inhabited Wall, Campbell Hall South Addition, University of Virginia at Charlottesville, William Sherman and SMBW Architects

using a similar dimension of wall to translate the energy of the sun into a source of heat and a mechanism for ventilation by engaging the dynamic forces of nature. The wall has become the infrastructure, dramatically reducing the inhabitant's dependence on the presumed stability of remote energy sources. At the same time, the inhabitant is connected viscerally and visually to the dynamism of the light, air, and thermal energy engaged in the boundary layer.

In this way of thinking, the building envelope is not a line but a zone of interaction linking the interior to the adjacent exterior conditions and finally to the terrain of nature's processes. The visual function of the wall as a framing device is complemented by the workings of the wall as an infrastructural device. A wall may capture and store energy, provide a thermal boundary, transmit and modify natural light, create airflows for natural ventilation, and equalize air pressures to resist unwanted water infiltration while capturing it for subsequent use.

The wall's interaction with these dynamic natural forces is complemented by a subjective interaction with the human psyche and physiology. A wall can construct an environment in constant flux rather than the artifice of fixed conditions; engage the response of the retina, the lungs, the skin, and all sensory organs; provide for individual rather than centralized control in adjusting the local environment; accommodate the unpredictability of human behavior; and further a cultural understanding of architecture.

A body of work is emerging globally that recognizes these opportunities. By necessity, a new aesthetic is emerging with it, a multisensory rather than purely visual aesthetic. Often couched in the language of sustainability and energy efficiency, elements of this idea are taking form in work operating under many guises: explorations of alternative construction paradigms, such as intelligent skins and pressure-equalizing rain-screen walls, as well as investigations into human physiology and its spatial/temporal responses. A critical issue to recognize is that, given the pace of global urbanization and the scale of contemporary building programs, historically defined vernacular paradigms have limits of applicability. The richest of the new work overlays this approach to the wall as decentralized infrastructure with parallel complementary investigations into contemporary urban strategies. It is in this arena that architecture will locate its fire function as the catalyst

for cultural invention, building a binding network of connections between people and the dynamic forces of the environment.

Breathing this new life into the modern wall involves the reversal of the dependency between architecture and the apparatus of the modern infrastructure. The infrastructure that liberated architecture from nature is also the terror at the heart of modernity: the inhuman scale of industrial and corporate power, the potential reach of the omnipotent modern state, our dependence on the immensely fragile network distributing fundamental human needs. We assert our civil humanity when we reverse the flow: when the infrastructure becomes dependent on individuals, when our actions extend our collective reach rather than presume an existing common ground. As the physical manifestation of our connectedness is transformed from an invisible, unidirectional infrastructure to a spatial, multidirectional network, the fire is created anew in the construction of each new wall.

Notes

1. Vitruvius Pollio, *Ten Books on Architecture*, trans. Morris Hickey Morgan (New York: Dover, 1960), book 2, chap. 1, p. 38.

2. Richard Rorty, *Contingency, Irony, and Solidarity* (Cambridge: Cambridge University Press, 1969), 19.

3. Ian McHarg makes this argument in near virulent terms:

> The emergence of monotheism had as its corollary the rejection of nature; the affirmation of Jehovah, the God in whose image man was made, was also a declaration of war on nature. The great western religions born of monotheism have been the major source of our moral attitudes. It is from them that we have developed the preoccupation with the uniqueness of man, with justice and compassion. On the subject of man-nature, however, the Biblical creation story of the first chapter of Genesis, the source of the most generally accepted description of man's role and powers, not only fails to correspond to reality as we observe it, but in its insistence upon dominion and subjugation of nature, encourages the most exploitative and destructive instincts in man rather than those that are deferential and creative.
>
> McHarg, *Design with Nature* (Garden City, NY: Doubleday, 1971), 26.

4. Nick Baker, "We Are All Outdoor Animals," in *Architecture City Environment, Proceedings of PLEA 2000*, ed. Koen Steemers and Simos Yannas (London: James & James, 2000), 553–55.

A GOOD ESSAY THAT CONSIDERS THE HUMAN WALL or WALL SECTION - IN A PHILOSOPHIC light - as the primitive replacement for fire - to the contemporary working wall or inhabited wall, or energy-producing wall.

Re-earthing Cities: Aesthetics, Ethics, and Ecology in City Building

TIMOTHY BEATLEY

Each year I begin a class on sustainability that I teach at the University of Virginia by asking students to tell me the qualities they find most desirable in a community. Not surprisingly, many of these enthusiastic planners-to-be cite things like personal safety, clean air, access to parks and recreation, good housing, and safe neighborhoods. These are understandably important qualities and not trivial concerns.

Yet, typically absent from their thoughts, and the discussion that ensues, are some remarkable omissions. Beauty is frequently left out. Ethical concerns are also typically absent. Few new students express a desire to live in a delightful or aesthetically satisfying place, just as few say they wish to live in a fair, just, or ethical place. What they think of first is the physical dimension of home, streets, sidewalks, and parks, not the ethical and aesthetic values and value structures that these physical qualities reflect. Absent, as well, is a sense of the connections between different facets of a place. Students tend to see cities as collections of discrete, unrelated components. They rarely demonstrate an integrated view of how cities and communities work. The ecological context of cities, if it comes up at all, is usually couched in the narrow terms of parks, ball fields, and greenbelts. Once I point them out, these omissions become obvious to my students, but it often takes some prodding before they can see how vital aesthetic and ethical considerations are to the life of cities.

The City as an Ethical, Sustainable, and Aesthetic Ecosystem

This chapter is an attempt to summon a much different vision of cities, one in which considerations of beauty and justice are not ignored or overlooked but embraced and vividly dramatized. I call this vision "re-earthing," for it depends upon an effort to recapture a connection to the natural world that is all but lost in modern cities. Cities, I argue, and we ourselves, have become so cut off from the earth and the underlying ecosystems and resource flows that sustain us that we use resources like energy, water, and food without knowing where they come from and without understanding (or assuming responsibility for) the environmental and social impacts associated with their production. Our cities also deprive us of the variety of rich and profoundly satisfying aesthetic experiences that a feeling of connection to the natural world brings. The "re-earthing" that I believe we need in cities amounts to a radical reconnection and reawakening to the world around us, one that fosters a greater awareness of place, environment, and of each other. Implicitly, "re-earthing" involves an awakening of both our ethical and aesthetic sensibilities.

Cities are more than architectural abstractions and engineered structures of concrete, brick, and mortar; they are inherently natural, and embedded in complex climatic, hydrological, and biological systems. Like all complex living systems, cities possess intricate metabolic streams and material flows that are required to support the lives and lifestyles of their inhabitants. Food, lumber, energy, and other substances flow in, while outputs in the form of solid wastes, carbon emissions, and air and water pollutants flow out. We all appreciate our place in the natural world on some level (such as when the wind hits our face on a cold winter day), but rarely does our mental template of cities reflect the extent of our ties to nature.

Increasingly, however, an alternate way of looking at cities is taking root. The practice of "sustainable" cities holds that we view cities holistically—that we strive to achieve a balanced or circular metabolism in them wherein efforts are made to reduce the size and extent of the inputs needed in the first place.[1] Proponents of sustainability believe that we can "design with nature," as Ian McHarg argues, and even more profoundly, that we can design all city features to be organic and natural.

This is certainly a new way for most designers to view cities, and one full of potential for shaping a healthier world. But just as true, it is vitally important that the city be reconceptualized as an artistic palate, as a grand canvas for individual and collective expressions, and not just in the traditional form of public art in public spaces. Every space, every venue, every pole, every park and parking deck, represents the possibility of injecting exhilaration and invoking contemplation. Every crack in a façade or sidewalk can express and celebrate the wildness and beauty all around. Today there are many compelling examples of how sustainability and beauty may reinforce, and even inspire, one another. This new understanding of the city as a complex natural system has fostered a new aesthetic—a new way of relating visually and sensorially to our living environment.

Rethinking the City's Simple Building Blocks

If cities are inherently embedded in natural systems, how then can we go about nurturing and highlighting this connection in our planning and urban design? Cities can do this in many large and small ways, but it requires a profound change in perspective. It means seeing the place of the natural world in cities and urban environments as just as legitimate and valuable as it is perceived to be in more pristine places, such as national parks. Such a perspective allows for a vision of cities, not as hopelessly gray, concrete, or devoid of the beauty and complexity of nature, but rather as green canvases of many textured possibilities.

It means reimagining every basic building block of our urban form. Reconceptualizing roadways, for instance, may offer some of our most promising possibilities for rethinking traditional function and utility, and at the same time advance a more nuanced aesthetic of nature. Streets can be fundamentally and profoundly natural, even as they convey traffic. "Green streets" have been endorsed by cities in Europe and the United States, and variously translated into planting trees and grass, narrowing roadways, and extending sidewalk and pedestrian spaces to serve at once to calm and slow auto traffic and to create new community spaces.[2] Some cities are going even further, conceiving of green streets as spaces where storm water is conveyed and treated, ecological and hydrologic systems and cycles are visible, food is grown, and habitat is found (or restored).

Cistern Steps Drawing (detail), Donald Carlson, FAIA, 1998. Study for The Vine Street Project, Seattle, Washington (with Carolyn Geise, architect, and Buster Simpson, artist). Graphite and colored pencils on paper, 12 x 12 in.

One notable example of this vision can be seen in the "Growing to Vine Street" initiative in Seattle. Spearheaded by the architect Carolyn Geise, the concept for Vine Street, in a former working-class neighborhood near downtown Seattle, is one of a street that grows nature in the form of trees, vegetation, and community gardens. The street collects water from rooftops, sends it down to cisterns and through vertical gardens to a street-length bio-filtration swale, then eventually to Puget Sound. The project draws a picture of what sustains the city: it makes transparent and visible the natural processes on which its inhabitants depend, provides opportunities for direct aesthetic experiences of nature, and enhances the beauty and humanity of public spaces. An especially interesting element of the street is a series of "cistern steps," designed by Carlson Architects. Here, water is collected, in a series of sidewalk terraces as it meanders down the streets through connecting tunnels that remove impurities. Such efforts also serve to recapture the "public" realm of streets, far too long given over to the narrow interests of auto mobility. As one commentator has noted, the streets become a kind of public stage: "New and old streets are being conceived as changeable, programmable public spaces that must and can do many things at the same time."[3]

The Green Bridge in London is another creative example of rethinking the urban realm, reconceiving functional elements of the city as ecological systems, contributing to sustainability, and adding new forms of beauty. Designed to carry bicycles and pedestrians, the bridge, designed by the British architect Piers Gough (of CZWG Architects), connects two separated pieces of Mile End Park, in the Borough of Tower Hamlets. Some twenty-five meters wide, the bridge contains mature trees, soil, and grass and spans five lanes of roadway below. From the ground, it appears as if a tree branch is reaching over to embrace the land on the other side. It lays a literal "green carpet" over the road ramp, in one journalist's words.[4]

There are many other creative re-earthing possibilities. The side yards of buildings might be reenvisioned as places for meadows of native floral exuberance, and building façades as living walls of plants, bird habitat, and edible landscaping. The paved surfaces of schoolyards might be taken up and reimagined as rain gardens, and rooftops seen as opportunities for delightful new ecological spaces. Vacant urban sites could be viewed as opportunities

for regeneration of patches of urban forests and native habitats, where exposure to native flora and fauna might occur alongside sustainable harvesting. The result would be an environment that was aesthetically exciting and interesting, ecologically and emotionally restorative, and one that reflected a new, more ethically responsible set of urban-nature relationships.

The City as a Field of Ecological Flows

Contemporary city builders must begin to understand cities and region in a more integrated way. They must see, in particular, that every project, no matter how large or small, has ecological implications, both on the local environment and on the natural world at large. Certainly these are connections that are sometimes difficult to see, as my students exhibit in their tendency to divide the world into discrete, tangible policy slices. It is nevertheless vital that we begin to see the intimate role that nature plays in our cities.

An initiative in Chicago known as Chicago Wilderness is one example of city builders attempting to reimagine cities in the light of ecology. A collaboration of more than 160 different organizations, it has resulted in developing a regional ecological vision for the Chicago area, placing on a single map some 200,000 acres of significant ecological and protected lands. Noteworthy accomplishments include the preparation of perhaps the nation's first urban biodiversity plan. Though the plan is far from perfect, it represents a promising attempt to see the city and region as one connected ecological system in which actions in one place affect the integrity of the system as a whole.

Efforts in a number of cities to restore and rehabilitate urban watersheds offer some hope, as well, of providing a unified framework for understanding cities as ecological wholes. Many things can be done. The natural hydrology of the city can be restored by bringing streams long since buried in underground pipes and channels back to the surface, a practice known as "daylighting." A proposal to daylight a segment of the Strawberry Creek through downtown Berkeley, California, is perhaps the boldest proposal of this kind yet. Here, in one proposal, a busy street would be replaced with a largely free-flowing stream, allowing nature back into the hard surfaces and gray spaces of this city. Stream daylighting is a promising practice. While still not widespread, some spectacular segments of stream daylighting have

been completed in European cities like Zurich, and other ambitious proposals have been tendered in American cities.[5]

The trend toward naturalizing the built environment is also part of a new ethical perspective that is beginning to recast the relationship between humans and nature. Especially in the United States, people have tended to see nature as located far from residential and commercial areas. In the past, visiting real "nature" always required considerable travel to special places explicitly labeled "parks." In contrast, the new paradigm of ecological cities develops an urban environmental ethic that views natural forces, and systems of ecology, not as abstract and distant, but as close, familiar, and ubiquitous. We come to the ethical recognition that how we treat one piece or part of the urban fabric affects others. We are all "downstream" in some significant way, with incumbent duties to protect, restore, and consciously avoid harming the ecology and its inhabitants, human or otherwise, of this interconnected whole.

Unexpected Opportunities: Infrastructure as Aesthetic Presence in the City

It has been customary in the past for cities to reserve their finest buildings for those pursuits, whether they be the arts, education, or commerce, that are valued most by the culture, and to seek to hide vital public infrastructure such as power stations and sewage treatment plants. Integration of beauty and ecology in these messier forms of city service and infrastructure is one area where much progress has been made in recent decades.

In the work of the late Austrian architect, artist, and activist Friedensreich Hundertwasser, every rooftop, courtyard, and window represents an opportunity for nature to take hold and reassert itself. Hundertwasser believed that human design and construction takes something away from nature. Society's obligation, in his view, is to design and build in ways that restore, replace, or otherwise compensate for these subtractions from the ecological balance sheet. The incorporation of rooftop gardens, trees, and hanging plants represents a fundamental way of naturalizing the built environment of cities. At the same time, Hundertwasser's use of colorful tiles, reflective materials, and playful cones and other shapes puts into practice the belief that art can complement a green ethic.

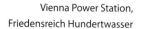

Vienna Power Station,
Friedensreich Hundertwasser

Hundertwasser's famous Vienna power plant demonstrates convincingly that a public structure providing electricity and heat can be seen as a chance to expand civic architecture. Danish designs for combined heat and power plants reflect a similar sensibility—that such uses need not be camouflaged or isolated, but celebrated.

Such a philosophy can do much to enliven urban settings, make them fundamentally stimulating and interesting, while at the same time understanding the ethical need to provide a service or public infrastructure in the most ecologically sustainable manner. Hundertwasser's Vienna power plant is whimsical and entertaining, but also part of an extremely efficient, decentralized, urban energy production and distribution system.

Urbanscapes That Teach

In a similar spirit, the artist Michael Singer challenges our view of how a city's utilities and infrastructure might look and operate. His solid

waste–management facility in Phoenix, which he designed with fellow artist Lennea Glatt in collaboration with the engineering company Black and Veatch, includes a visitor's center and an amphitheater where visitors can view the waste sorting and recycling process. Instead of hiding the gritty waste and material processes upon which we all depend, Singer's building brings it front and center. The Phoenix community appears to have welcomed this new kind of civic venture; some 10,000 schoolchildren visit the facility each year. It is at once a facility for servicing and sustaining the city, an expression of the civic realm, and an embodiment of artistic expression.

Teaching through city building is really not a matter of choice, though: it happens whether intended or not. What we build typically conveys de-earthing lessons: that energy and resources are abundant and that we need not worry about squandering them, that we can and should design in ways that place us above and separate from the environment, that our cities and built form are in a sense floating in some ethereal plain, elevated far above nature, watershed, bioregion.

The Waterworks Gardens in Renton, Washington, takes a uniquely different path. An important case study of, of all things, a waste-water treatment plant, this collaboration between the artist Lorna Jordan and Jones and Jones landscape architects is organized as a series of gardens, or rooms, connected by pathways. From the first garden room, the knoll, where polluted water summons the visitor, to the "Release," a wetlands where the final cleansing of the water takes place before it is returned to the Springbrook Creek, the process of cleansing is told.

The waste-water plant has become a community attraction, a place where even weddings are now held. What was undesirable and nasty has become a celebratory space. In Jordan's words: "I wanted waste treatment to be an opportunity rather than a problem. This is a chance to connect people to the cycles and mysteries of life."[6]

The design of parking lots (as much as I'd like to see fewer of them) also represents an opportunity to teach about watersheds, the draining of water off hard surfaces, the pollutants that come off our cars, and their impact on bays and estuaries and other aquatic ecosystems. The parking area of the Tampa Aquarium is an example. The lot was designed to collect and naturally treat storm water while simultaneously educating visitors. In addition

to seeing display placards, people driving into the aquarium are handed a brochure explaining the design and its importance in protecting the water quality of Tampa Bay, into which the lot drains. "Have You Ever Parked in an Exhibit?" is the eye-catching title of the brochure.

The Aesthetics and Ethics of Urban Food

One result of the globalization of food markets is that the produce we buy at stores—already heavily packaged and sanitized of any semblance of its natural or grown state—has traveled great distances (1,500 miles on average, by some estimates). We no longer have any clear connection to or understanding of the people and landscapes that produce it, and no appreciation for

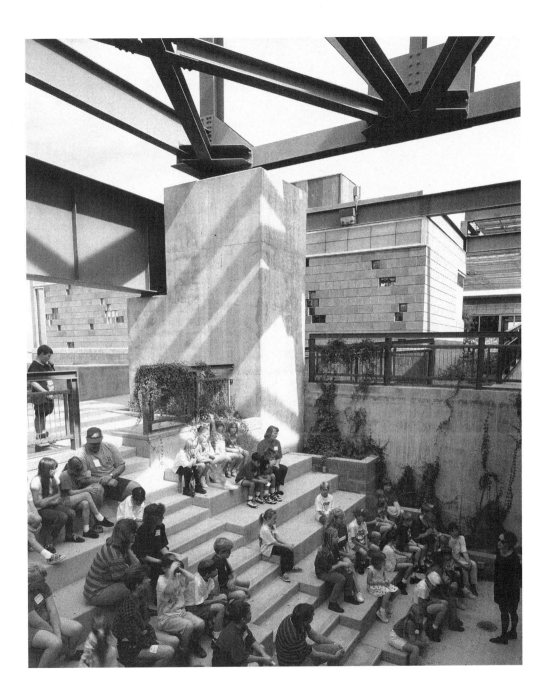

the seasons and natural rhythms from which it comes. Moreover, we little understand, nor take responsibility for, the environmental and social costs associated with its production: the pesticides and herbicides that farm workers are exposed to, for example, and the energy needed to transport it to our dinner tables. This is consumption without connection and without responsibility.

It robs us of an appreciation of place, too. We eat as if we are placeless: bananas from Central America, kiwis from New Zealand, greenhouse tomatoes from Holland in the dead of winter. We have lost our seasonal senses that connect us to our specific places, our personal geographies, and our natural homes.

One way to develop a healthier relationship to food is to be directly involved in growing it. We know now the many therapeutic rewards gained from actually putting one's hands in soil. For many in developed countries, gardening is an important counterbalance to otherwise indoor jobs and lives. Many city governments now make unused land available for community gardens, as well as providing plants, clearing abandoned lots, and offering technical advice.

Many urban housing designs today incorporate room for food growth and other garden spaces. In Amsterdam, a new 600-unit car-limited neighborhood in the Westerpark district, GWL-Terrein, has designed-in garden plots. Much of the interior courtyard space of this project, with an innovative landscape plan by WEST-8 landscape architects, is given over to small community garden plots. These are made available to residents to grow their own food or flowers, with preference given to those without individual garden spaces behind their flats. On a typical summer day the gardens are a flowing, flowering collective amenity and are bustling with committed residents tending the plots. It is as close to living in a garden as one can imagine.

Gardens and spaces to grow food in cities can be sensitively included even where space is very limited. The architect Bill Dunster's design of the Beddington Zero-Energy project in the London Borough of Sutton includes the interesting notion of "sky-gardens"—second-story gardens accessible from one's flat by an elevated walkway. The gardens lie directly across from the flats' main living spaces and, though without a direct physical connection, they are always within loving sight.

Farmers' markets are another way to reconnect to the farmers and farms producing the food we eat. Motivations for shopping at farmers' markets vary, of course, but to many they represent a special aesthetic experience. The sights and sounds of markets, and especially the smells, are glorious. There is a diversity and rich visual and sensory texture to what one finds. Every vendor at a farmers' market seems to bring tangible pieces of the farm where the food is grown; produce is often sold out of the back of a truck, and the crates, boxes, and even the mud on the tires provide a kind of visceral connection to where the food comes from. Farmers' markets are also significant public and community events where one can talk to a neighbor or friend; in this way they reinvigorate the social life of cities.

The growth of Community Supported Agriculture, or CSA, programs, which have been called "partnerships of mutual commitment," is another positive trend in cities.[7] Participating urban residents buy shares in a CSA

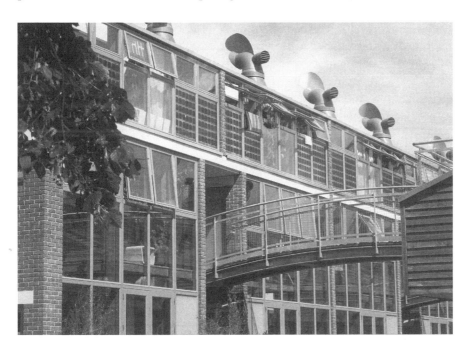

Beddington Zero-Energy Development, London, Bill Dunster

farm, which entitles them to a basket or box full of produce (and often flowers) each week during the growing season. In the process, members and farmers often get to know each other quite well, and farm visits and volunteer workdays are common features. The social and civic benefits are considerable, and again represent a new and important way of understanding (and making visible) the ethical dimensions of food and food production. CSAs, then, represent "economic exchanges conditioned by pleasure, friendship, aesthetics, affection, loyalty, justice, and reciprocity in addition to the factors of cost (not price) and quality."[8]

Cities could pursue other ways to reconnect people with the land. Small commercial farms and greenhouses might be viewed as legitimate and desirable uses within cities, an important form of local economic development. School districts could be growing their own food (and are in some places), urban landscaping standards might emphasize edible landscaping that imagines a different kind of fruit orchard (an urban orchard), or cities might demand a food impact statement to accompany any major new development, essentially requiring some conscious thought about where food will come from for the new residents living there. Establishing community kitchens (and community ovens in some places), where locally grown foods, special recipes, and local dishes can be prepared and enjoyed, might serve to strengthen the bonds of place.

The Aesthetics and Ethics of Water

There is something primordial about water. People want to be near it; they enjoy seeing it, hearing it, jumping through it, and feeling its rejuvenating coolness. Lacking our inhibitions, children can't resist the urge to splash and play in water whenever they are near it.

Few individuals have built as impressive and creative a body of work celebrating water in cities as the German artist and designer Herbert Dreiseitl. Town squares in German villages like Gummersbach and Hattersheim have been transformed by his projects, which incorporate waterways and water flows in city center plazas, courtyards, and buildings.[9] The results are often spectacular. On the steps of Hattersheim town hall there is now a flow form with water pulsating downward. Purified and aerated along the way, the water meanders through the town hall plaza and a town park, ending in

Watercourse meandering
through plaza: Hatters-
heim town center, Ger-
many, Herbert Dreiseitl,
designer

a retention pond and wetland. Water has become a new presence, a creative
way of linking the town hall and nearby park, and a "way of taking people to
the water."[10]

Water finds a more expansive presence in Freiburg, Germany, where a
network of water channels extends in the streets throughout the old city. A
light rain brings downspouts to life. Everywhere water can be seen flowing.

Water systems as urban design, such as those designed by Dreiseitl, have
a strange power to draw us out of ourselves, to bring us back to the here and

now and to the world around us. Such places arouse in us a watchfulness, a new awareness of place. We are forced to step over or to the side to avoid a channel of water or a slippery step. Occasionally, one ends up with a wet shoe, reminded that the natural is all around, and perhaps should be experienced with full senses, not only vision.

These aesthetic elements reinforce a sustainable city ethic because they encourage our participation in the city. It is not just that we want to be together with others in a delightful space, but that these urban features break us out of our passivity and isolation. In such places, we climb, touch, listen *together*. The aesthetic qualities of water are a marvelous way of calling attention as well to our present unsustainable relationships to water: our overconsumption and water shortages, the flooding and disruptions of natural hydrological systems, and the contamination of water from urban runoff and non–point source pollutants. Water, in these beautiful projects, brings instead the possibility of hope and renewal.

Making Ecological Cycles Tangible in the City

It is now not uncommon for new housing projects in cities to put waste and water management in key, highly visible settings. This key green, living element reminds residents that a natural treatment cycle is part of their community. If the treatment cycle fails or malfunctions, and the reed bed dies, residents are the first to notice. The Bioworks in the Fredensgade neighborhood in Kolding, Denmark—a living machine in the form of a glass pyramid—treats wastewater naturally and makes the process a prominent, visually dramatic part of the neighborhood and living environment. The final stage in the treatment process sends nutrient-rich wastewater to the top of the pyramid, from where it trickles down, feeding plants on several interior levels.

In making essential natural processes visible and transparent, the Fredensgade Bioworks is a crucial antidote to what the ecological architects Sim Van der Ryn and Stuart Cowart call the "flush and forget" technology. In modern communities our lives are supported and sustained in mostly invisible ways. The energy that runs our lights, our washing machines, and our air conditioners comes from somewhere, we realize, though for most people, exactly where it comes from and how it is generated are unclear. Food

arrives mysteriously at the grocery, and waste is whisked away from our curb, to be processed by others. We drive cars, day in and day out spewing carbon dioxide and other pollutants into the atmosphere and spoiling the habitats of animals and people many thousands of miles away from where we live. There is, it seems, a growing disconnect between our lifestyle choices and ethos and their physical and ecological implications.

Yet, several attempts to reverse this disconnect are now being made. Here we return to Dreiseitl's visionary work. The water concept of the Potsdamer Platz, a bold reurbanization scheme for this district in Berlin, symbolizes this more organic, circular, and metabolic view of cities. Water from rooftops is collected and stored in underground cisterns, then used for toilet flushing and plant watering. The water collection system also provides water to a piazza, where it becomes a prominent feature of the city's public life.

The biodynamic farm at Kronsberg is another example of a circular metabolic system. Here the farm is organized as a closed-loop ecological system.

Farmers' market on boats, Campo St. Barnaba, Venice, 1995. A common sight in Venice, the small produce vendor is a typical place for Venetians to buy their fruits and vegetables. Vendors commonly display where the produce comes from, important information for Venetian consumers.

Methane is recaptured from farm waste and used to heat buildings; organic waste and livestock manure is recycled on farm fields. As in nature itself, nothing is wasted.

Other metabolic flows, other inputs essential to support urban life, can be made more visible and transparent. In many Italian cities, this happens in a natural way with respect to agricultural goods. In cities like Venice, residents purchase fruits and vegetables from small market vendors whose signs showing where the food was grown are as important as those showing the price. One knows and pays attention in an important sense that, for example, the avocado about to be purchased was grown on the island of St. Erasmo. These scenes certainly constitute a special aesthetic, an ambiance of place.

At the heart of this visibility is an assumption of responsibility; an ethical owning up to the repercussions of our behaviors and lifestyles. As "re-earthing" designers, we hope that seeing firsthand the garbage stream our communities generate may instill a new civic willingness to take responsibility—to resolve to recycle, to use less, to live lives on a reduced material flow.

Re-earthing Ethics in Design and Planning: Our Energy Impact on Place and Planet

It is increasingly acknowledged that the design of buildings and the planning of landscapes requiring wasteful amounts of fossil fuels are profoundly un-ethical. Any contemporary urban aesthetic should, therefore, seek to build understanding of the energy embodied in our built environment, how that energy affects the environment, and how our buildings, land-use patterns, and transport systems foster energy dependence. Owning up to these impacts could bring a city-building ethos that seeks to exert a light footprint, and nurtures living patterns, development, and technology that reduce energy consumption and dependence, especially on fossil fuels. The importance of solar, wind, biomass, and other renewable energies in city building has never been greater, and there are increasingly compelling design and development models that show the way.

Designed with principles of sustainability, the recent redevelopment of

the Western Harbor in Sweden established the ambitious goal of providing 100 percent of its energy from local, renewable sources. Through a combination of very efficient district heating—that is, with homes and businesses connected to a central hot-water heating system, roof-mounted photovoltaic panels, solar hot-water heating systems, and a wind turbine, among other ecological features—the community has met these goals. The ecological model district of Kronsberg, in Hanover, already mentioned, represents yet another similarly compelling model of city building. With many similar energy features like photovoltaics, solar hot-water heating, and three large wind turbines close to homes, more energy is produced than is needed by the neighborhood.[11]

Renewable energy projects in cities also have a promising aesthetic dimension. It is exciting to see how energy is produced and to know where our energy is coming from. And there is the sheer beauty of seeing the technology used to produce energy. Well-designed and -placed wind turbines are a marvel to see, watch, and hear. They add an element of interest and fascination to urbanscapes, bringing dynamism and movement to an often static built form. A recent project in London—a Sainsbury's grocery store in the new Greenwich Millennium Village—boasts two twelve-meter-high wind turbines that transform an otherwise dull entrance and parking area into a visually dramatic site and, at the same time, produce a considerable amount of the energy needed to run the facility. While wind turbines are controversial when placed in rural locations, where they are felt to interrupt the visual lines of a more bucolic landscape, they represent an aesthetic enhancement and beautiful addition to urban and suburban settings. Integrated in rooftop designs, photovoltaics hold the same promise.

The design of such projects raises a number of other interesting aesthetic questions. Some may argue, for example, that features such as photovoltaic panels ought not to be apparent or obvious and that the best energy technology is one that is hidden from view. This thinking holds that it is best to "normalize" homes and buildings, not make them appear too outside the mainstream, and wherever possible to integrate renewable energy systems into existing tastes, materials, and methods. As a planner, I seriously question this view. I believe that new forms of beauty can in fact emerge as we

make visible and boldly manifest on a rooftop or building façade energy-saving and sustainable designs and processes. Making beauty and respecting the planet ought not be incompatible activities.

Urban Ecological Solutions

As we enter the twenty-first century, it is clear that we are now, globally, in an epoch of cities. Already about half the world's population lives in cities. By 2050 the number is expected to rise to 75 percent. In the more affluent nations of the North, such as the United States, already the majority live in cities. While these urban trends bring much potential in the way of improvements in living conditions and economic prosperity, they also carry grave threats. If they continue, these trends threaten to deprive us of any contact with nature, which we need profoundly, and of any connection to the sources of the energy, food, and water that we use. The importance of cities in addressing our present environmental predicaments has never been clearer: the most energy is consumed, the most waste is generated, and the most carbon is emitted in cities. Without doubt, the path toward global sustainability runs through our urban areas.

On a practical level, as a planner, I am especially concerned with how we reform the planning and design process to support a re-earthing strategy. There are many creative ways to do this. Requiring new buildings and projects to calculate and be accountable for their ecological footprints, and seeking out new opportunities for incorporating nature and natural systems at every stage, are important. We must acknowledge that our design and planning decisions affect the environment in profound ways, and that ethical responsibility is a core element of a re-earthing aesthetic.

Elevating the role of art and ecology in community design and planning is also important. Artists and ecologists in residence (e.g., the role that Lorna Jordan, designer of the Renton Waterworks, played) in traditional agencies and offices, such as public works departments and transit agencies, might inspire new attention to these subjects. An ethicist in residence might offer similar insights, and bring similar badly needed perspectives on city building.

In the end, the challenges we face today—the profound environmental effects of population growth, resource consumption, and the juggernaut of

global urbanization—urgently call for a new urban aesthetic and ethical sensibility, one that enables us to look anew at the natural world and our place in it. In turn, our humanity and humility will be extended as we live more lightly in the world.

Notes

1. Herbert Girardet, *Cities, People, Planet* (Chichester, UK: John Wiley, 2004).

2. See Timothy Beatley, *Green Urbanism: Learning from European Cities* (Washington, DC: Island Press, 2000).

3. See Mathis Wackernagel and William E. Rees, *Our Ecological Footprint: Reducing Human Impact on the Earth* (Gabriola Island, BC; Philadelphia: New Society Publishers, 1996).

4. Kenneth Powell, "Architecture: How Green Was My Alley," *Independent* (London), July 19, 1999, Arts sec., 10.

5. See Beatley, *Green Urbanism,* esp. chap. 7.

6. Quoted in Amy E. Nevald, "Sewage Plant Gardens Put Water Cycles on Display," *Seattle Post-Intelligencer,* January 1, 2000.

7. Jack Kloppenburg Jr., John Hendrickson, and G. W. Stevenson, "Coming in to the Foodshed," in *Rooted in the Land: Essays on Community and Place,* ed. William Vitek and Wes Jackson (New Haven: Yale University Press, 1996), 115.

8. Kloppenburg, Hendrickson, and Stevenson, "Coming in to the Foodshed," 115–16.

9. Herbert Dreiseitl, Dieter Grau, and Karl H. C. Ludwig, *Waterscapes: Planning, Building and Designing with Water* (Basel and Boston: Birkhäuser, 2001).

10. Dreiseitl, Grau, and Ludwig, *Waterscapes,* 18.

11. For a review of these recent ecological districts, see Timothy Beatley, *Native to Nowhere: Sustaining Home and Community in the Global Age* (Washington, DC: Island Press, 2004).

4 Open Works

LANDSCAPE ARCHITECTURE, ARCHITECTURE, AND ART

Cowper Place,
entry plaza,
Duisburg-Nord,
Latz + Partner

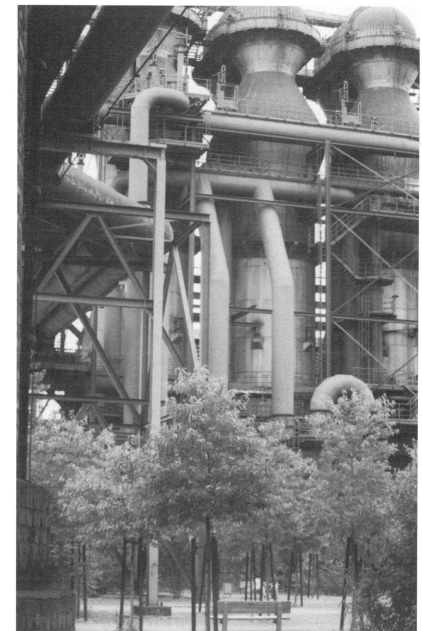

Gardens, Landscape, Nature: Duisburg-Nord, Germany

ELISSA ROSENBERG

In 1968 Robert Smithson wrote: "The 'pastoral,' it seems, is outmoded. The gardens of history are being replaced by sites of time."[1] Yet the pastoral landscape, with its bucolic imagery and its associated discourse of nature as a redemptive force, remains firmly rooted in the popular imagination and still operates as a default mode in landscape design. From its ancient origins, the pastoral ideal evolved into a uniquely American response to the accelerating pace of industrialization in the mid-nineteenth century,[2] becoming the dominant aesthetic for the design of the expanding public landscape of America's cities. But if the development of the pastoral aesthetic expressed our conflicted relationship to technology and industrialization at a particular moment in history, the current process of deindustrialization calls forth a parallel question: Is there a new landscape aesthetic emerging from industrial ruins? How, in this postindustrial age, do we reimagine our relationship to nature, technology, and landscape?

This is the question posed by Duisburg-Nord, the work of the landscape architects Latz + Partner, which opened in 1994 on the site of the former Thyssen steelworks in the northern Ruhr district of Germany.[3] The park has received much attention for its sensitivity in retaining the site's strong industrial presence. The sense of decay has remained intact, vivid, and sometimes surreal. But unlike many other projects on former industrial sites which celebrate the architecture of production, at Duisburg-Nord it is the industrial

landscape that is brought into focus. Not only does the design of the park play on the visual and spatial drama of the blast furnace itself—with its immense chimneys, gantries, and subterranean spaces—but, perhaps more provocatively, it takes as its subject the complex site surrounding the plant which, at first glance, appears as a chaotic landscape of rail lines, slag heaps, and volunteer species.

The landscape design subverts conventional expectations. The decayed forms are not treated as romanticized ruins or as a spectacle meant to instill an experience of the sublime. The aesthetic of the sublime, as theorized in the eighteenth century by Edmund Burke, Immanuel Kant, William Gilpin, and others, celebrated the experience of the divine and sense of the infinite inspired by extraordinary and terrifying natural landscapes—the rocky mountain tops, rushing waterfalls, or deep chasms that, by virtue of their immensity, power, and grandeur, would arouse deep emotions of wonder mixed with terror.[4] Though originally invoked by natural settings, the sublime was later expanded to include the constructed landscape in what became known as the "technological" or "industrial sublime."[5]

While the tendency of artists and designers working in industrial sites has often been to cultivate an aesthetic of the "industrial sublime," choosing to heighten the sense of awe inspired by the relics of industry, Peter Latz's work suggests a different relationship to the industrial landscape. Discussing his approach, he writes, "The result is a metamorphosis of landscape without destroying existing features, an archetypal dialogue between the tame and the wild."[6] The power of this place lies precisely in the tension that exists between "the tame and the wild": between intervention and neglect, between the ordinary and the bizarre. In this work, "nature" is not "wild"; it is inextricably bound up with technology and shaped by social relationships and cultural memory. David Nye notes that the sublime is by definition something extraordinary—it virtually requires that one be an outsider. The dualistic vision of man and nature, implicit in the aesthetic of the sublime, has been replaced at Duisburg by the clear realization that nature, too, has become a human artifact. Just as the work avoids trading in the imagery of the picturesque ruins, so too does it argue against an aesthetic of the sublime. Latz's work reframes the "strange" through a dialectic with the ordinary.

This dialectic is expressed at Duisburg-Nord most powerfully through

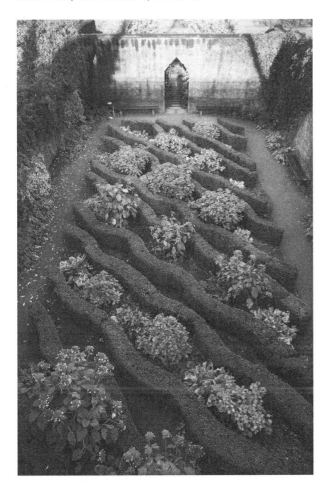

A knot garden in a
former bunker

the trope of the garden. A series of gardens have been planted within and around the ruins of the blast furnace, using a traditional horticultural language of clipped hedges, knot gardens, parterres, bosks, and rose gardens. The disjunction between this formal landscape vocabulary and its industrial setting is both unsettling and profoundly moving. Why the strange juxtaposition? What do the gardens mean, or perhaps more important, what do the gardens *do*?[7] What is their role in remaking the Thyssen site, and, more

subtly, how do they alter our relationship to the spectacle of decay and lay the ground for a new occupation of this space?

The garden is used variously as a counterpoint to the blast furnace and as a means of interpreting and reframing the industrial landscape. The garden articulates the theme of time,[8] understood at Duisburg in terms of the cycles of destruction and cultivation, as well as through its resonance with history and cultural memory. As such, it represents the antithesis of the sublime, which exists outside time and represents both an escape from history and a retreat from physical nature into the realm of human spiritual values.[9] On the other hand, the garden celebrates physical nature and the act of making; beyond the garden is the *gardener*—every garden holds the imprint of the human hand. Latz writes: "I believe that using gardens . . . is in fact the only way of understanding a landscape. You have to work with the actual material."[10] The garden is used to investigate, to express, and to experiment with the physical material of the site.

Perhaps more fundamentally, the use of the garden at Duisburg-Nord suggests an attitude to regeneration rooted in a social vision. In Latz's notion of "metamorphosis," site regeneration is bound up with cultural change. Regeneration begins by cleansing the site's polluted water and toxic soil, but is meaningful, finally, in the transformation of the blast furnace into a new social space. Latz notes that "what is useless acquires new value as an element through its use."[11] The design of the park succeeds in preserving this strange landscape while transforming its meaning, ultimately by altering our relationship to it and absorbing it anew into our everyday lives. The Duisburg gardens tame and refamiliarize this alienating landscape so that it might become used and lived in new ways: metamorphosed into a new public landscape.

Landscape "Syntax": The Structure of the Park

The commitment to decoding, understanding, and representing the physical site is at the philosophical core of Latz + Partner's work. The design of the park is based upon an analytic, almost archaeological approach that seeks to investigate how the industrial landscape was made, how its various components functioned, and what impact production has had on the shape of the land. It is the landscape's structure, not its imagery—however seductive or

sublime—that ultimately establishes a sense of place and offers a record of the site's history.

The search for site structure, or what they call its "syntax," leads Latz + Partner to reject the notion of a "master plan." The park is designed as a series of autonomous sequences or "layers" that are linked at specific points. There is no unitary composition or unfolding narrative as we move through the park, but rather a synchronic experience of vertically stacked systems.

Landform, in particular, plays an important role in the conception of the landscape, but not in a sculptural or object-oriented sense. The earth is not sculpted into a bizarre or extraordinary landscape, but instead is used to describe the ordinary landscape of production. Landform offers up clues to the systems that operated here, whether by tracing the patterns of the railroad through its embankments and tunnels, or of the canal system typical of the region. The composition of the park is thus expressed in stratigraphic terms.

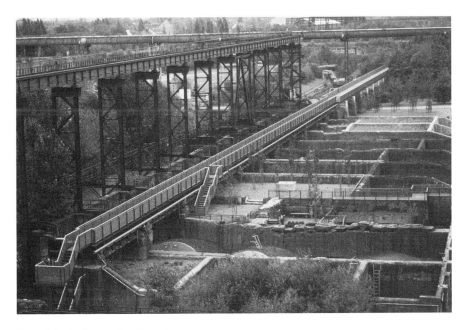

View of the bunker gardens from above

Emscher canal
after restoration

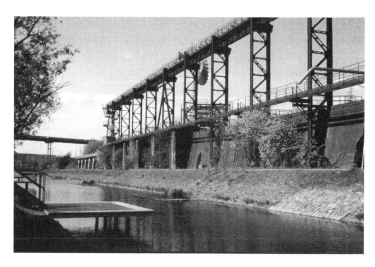

Each linear system slices through the park like a datum, defining and "explaining" the section. The selective preservation of the site's infrastructure serves to describe and map the history of industrial processes through their imprint on the land.

The primary layers of the park include the sequences of promenades, the Bahnpark (or Rail Park), and the water park, consisting of canals and reservoirs. Each of these sequences is meant to make the existing systems coherent, legible, and usable once again. The intricate structure of the rail lines, a defining feature of the region's urban form, provides the organizing principle for movement through the park. A new promenade has been built on the piers of the old railroad trestle that traverses the site. This elevated catwalk lets the body take the place of the machine, allowing a person to move through the park as the train once did—to experience physically the spatial logic of production, and to view the site from a new privileged vantage point. Other paths follow the imprint of the harplike railbed at the former switching yard, an elaborately engineered earthwork of ridges and depressions, now transformed into myriad parallel paths offering multiple choices of circulation.

The second system that structures the park is the Emscher canal. Like the railway, the canal system has become a defining feature of the Ruhr

landscape. The polluted Emscher canal, which once functioned as an open sewer, was one of the most visible reminders of the ravages of industry. One of the site's main transformations is a newly cleansed canal—now part of a closed recirculating system fed by rainwater, which is visibly captured from the buildings in existing overhead pipes and flows across pavements through a maze of open channels and rills that traverse the site.

"Accepting the Situation": Experimentation, Disturbance, and Regeneration

Latz's stance toward the industrial history of this region is reflected by his simple assertion that "people have to accept the situation."[12] He approaches the project without moralizing or judging history. His design aesthetic is based foremost on a careful reading of the site as it currently exists, and on an investigation of the exhausted industrial forms, the processes they evoke, and the disturbed landscapes they have left behind. The sense of depletion and decay is treated delicately, with full awareness of how easy it is to dilute the power of the existing landscape while redesigning it. Latz "accepts the situation" that nature has been disturbed and continually manipulated by man. This statement represents a profound shift in park design—from its roots in nineteenth-century progressivist ideology and its typically pastoral aesthetic, to the more contemporary ideology of the environmental movement of the 1970s. Implicit in this pragmatic attitude toward destruction is a significantly different approach to regeneration.

The design of Duisburg attests to the fact that Latz's notion of "accepting the situation" is not a passive one, but just the opposite; it is at the root of his inventiveness. His acceptance of the existing reality impels him, on the one hand, to discover and exploit its unique qualities in unusual ways; and on the other hand, to search for new solutions to the problems it poses. "Everything is *good*," says Latz, "even polluted soils (except toxic ones), since everything is recycled."[13] His approach is empirical, physical, and experimental, engaging all the materials of the site. Underlying this pragmatic position is an affirmation of the power of making—and remaking—and a sanguine belief in our ability to make choices. "Accepting the situation" is about being at home in the world—that is, in the physical, material world. It is about *making*, more than *healing*; it is about celebrating everyday life, not the sublime; it

is about living with contradictions in a fragmentary world, and abandoning any notion of an idealized nature, apart from man.

This position leads Latz to reject the conventional goals of site restoration by taking a different approach to disturbance. Rather than attempt to restore the site to its prior condition, he accepts the site's aberrant processes and materials, and works with them in order to encourage existing formations to continue to evolve. Latz notes that the resulting fantastical forms could not be created by either art or nature alone but lie somewhere in between.[14] This dynamic view of natural processes is in direct contrast to the notion of "stabilizing" a site, which would imply arresting the natural processes acting upon it. For example, Latz argues that "it is absurd [to] attempt to cover slag-heaps with vegetation." Erosion is a natural principle of the material and should not be prevented but rather encouraged, to allow strange and fantastic formations to continue to develop and express the condition of disturbance. Reclamation efforts, he notes, are generally directed toward preventing this—by planting, sculpting, and regularizing disturbed industrial sites to ensure that nothing at all will change.[15]

Latz + Partner have chosen to leave large parts of the site untouched. Most of the decayed ironworks have remained intact. Extensive areas of successional forest have also remained, leaving large birch groves that have colonized the black waste material of the coal-washing process. Other nonindigenous steppelike species grow on the thin soils of the coal-soot mixes, casting sediments, and the sands and slags of a former manganese ore depot.[16] This unusual vegetation is a serendipitous by-product of industrial waste. It is the discovery of such intriguing secondary phenomena that leads Latz to claim that "destruction has to be protected so that it isn't destroyed again by recultivation. New places have to be invented, new places at the fault lines between what was destroyed and what remained, between structures still recognized as cultural landscapes and those that are historically devastated."[17]

Underlying the work is a preoccupation with the meaning of history. Latz preserves the ruins on the site, to the greatest extent possible, as instruments of memory and as an evocation of a lost heritage—however fragmentary that representation has become. He lets the objects tell their own stories, without trying to synthesize or summarize; he is not interested in creating a

Climbing wall on
former ore bunker walls

monument to history, or a museum. The artifacts resonate with real associa-
tions. But the furnace is no longer a furnace; it has assumed another life. For
Latz, the site is meaningful as a park insofar as it transcends its particular
moment in history and becomes open to the future. The key design strategy
is to create a new context for these artifacts so that they lose their specificity
and begin to undergo a process of metamorphosis.

 This sense of metamorphosis is the focus of most critical discussions of
the work, and the surprising mix of new activities at Duisburg is, for many

A new play area along the bunker walls

critics, the measure of its success as a public park. The fantastic qualities of the derelict structures have attracted imaginative new uses—for example, the huge twelve-meter-high walls of the ore bunkers now serve as climbing walls where an alpine club with over 2,000 members makes its base. A diving club has also established itself in the park, exploring the underground lakes that have formed in the groundwater-flooded chambers of the lower storage bunkers. Along the bunker walls, a play area has been created in which a huge winding metal chute snakes through the walls like an ironic, oversized serpent. Large fairs and festivals are held in the central public areas, and performances take place in a new amphitheater built against the backdrop of the blast furnace. (The amphitheater is constructed of concrete mixed with recycled brick gravel, made from the ground stones of the former sintering plant.) In addition to these large group activities, the residential margins of

the park offer protected places for community gardens and children's playgrounds, and the extensive successional woodlands provide a large area for walking and cycling.

Just as "destruction has been protected" in the zones of the coal tailings to encourage exotic new forms of vegetation to take root, so too have the dreamlike destroyed forms of the old blast furnace been retained to inspire a new social space. Some of the new activities have established themselves spontaneously like colonizing species; others have been introduced intentionally through adaptations of the existing structures, or with the careful addition of new elements. But Duisburg's vibrancy as a public space depends less on "programming" the park in a conventional sense—that is, predetermining a fixed set of activities for each space—than on a subtle design strategy of recontextualization. This strategy has created an open-ended, improvisational quality to the life of the park, encouraging a diversity of uses and users to colonize the landscape. The interventions on the site serve to reframe the industrial landscape by making the strange familiar—and, perhaps more poignantly, the familiar strange.

At first, there is a frisson in the juxtaposition of foreground and background—of Turkish mothers wheeling strollers against the improbable, threatening backdrop of the blast furnace. But then the passage of joggers and cyclists and rock climbers and strolling old couples establishes its own rhythm, and we are shocked by how *unshocking* are these juxtapositions. Why shouldn't this be a jogger's path, or a baby's playground? This alienated—and alienating—behemoth becomes the new urban ground for casual rhythms of encounter, dissolving boundaries both physical and psychological between the space of domesticity and production. This reorientation is further reinforced by a larger urban strategy guiding the design: the park is used to connect the once discrete surrounding towns, which have now grown together to form a continuous urban fabric. What once operated as a marginal space outside the local residential realm now occupies the center of seven towns.

Yet remarkably, Latz + Partner have succeeded in recontextualizing the site without diminishing its strangeness or its scale. This is achieved by domesticating the space—that is, in the sense of making us *at home*—by inviting occupation, and invoking a sense of ownership through subtle and strategic interventions that reframe, rather than erase, the decayed relics.

Flowering bosk at
Cowper Place

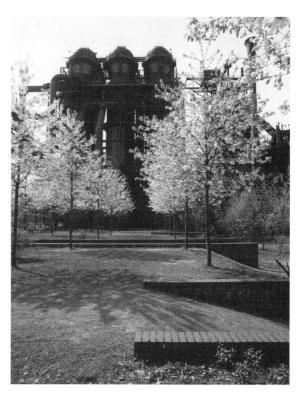

The industrial landscape becomes domesticated by implicating us in it. One of the foremost means of asserting a human presence within the site is through the introduction of new ways of moving through it—with stairs, catwalks, and promenades—so as to populate this landscape and suggest an alternate reading of its vastness. By inserting the human body into the machinery of production and altering our physical relationship to it, its monumental scale is transformed—as we touch the forbidding, rusting structure, see it up close, or climb up inside it. The overpowering image of the ironworks perceived from afar, and all that it suggests as an icon of sublime immensity, is challenged at the moment we engage it physically and experience it as occupiable space.

The other strategy used to assert a human presence within the site is

the planting of gardens. They first appear at the entrances to the park, beginning the process of recontextualizing the site—at the main entrance, Cowper Place, as well as at the many secondary entrances that form critical thresholds between the site and the loose, amorphous fabric of disparate towns that surround it on all sides.[18] These entrances, with their formal landscapes—circular clipped hedges around small parking lots, bosks, and allées—establish the urbane, civic language of a large city park. The visual paradox inherent in the use of such landscape codes and conventions is experienced most powerfully at the main entrance. Located in front of the blast furnace, the space of arrival is planted with a regular grid of blossoming fruit trees—a lavish, grand gesture evoking a public garden, played straight except for a single detail: the rusted COR-TEN stakes that support the trees.[19] The juxtaposition of the flowering bosk and the furnace presents the argument of the garden for the first time, at the moment of our first encounter with the blast furnace. While it might be said that the new windmill serves as the most obvious icon for the park, almost manifesto-like in its clarity and confidence as a symbol, it is the power and incongruity of the image of the garden and the blast furnace that most immediately conveys the essence of Duisburg-Nord.

In her work *The Garden as an Art*, Mara Miller claims that the role of the garden is

> to mediate those tensions or polarities which are important for a given culture. . . . The garden is a way of framing the terms within which verbal or theoretical debate can take place. Every garden is an attempt at the reconciliation of the oppositions which constrain our existence; the act of creating a garden, however limited it may be, is not only an assertion of control over our physical surroundings but a symbolic refusal of the terms under which life has been presented to us and an insistence on determining the terms of our existence. As such it is always an act of hope.[20]

To be sure, the simple image of flowering trees set against the blast furnace evokes the idea of renewal. But the profound sense of hope that it inspires derives not only from the power of the image itself—the dramatic contrast of its lush delicacy against the brutality of the ironworks, of new growth

A new windmill recirculates clean water from the channel to oxygenate the system and irrigate the gardens.

contrasted with the sense of decay—but from the conceit of the formal gesture, the civic language of the bosk as a portal to a grand public park. Latz + Partner reach back to a traditional landscape design vocabulary of garden making to reframe the Thyssen site as a public park, using a well-understood landscape convention to recode the site's function and meaning. The use of the garden, then, establishes a measure of familiarity. It also recasts the site as a recognizable public space, in a long tradition of public spaces, thus recovering this landscape from the urban margins and granting it a new civic meaning. The twinning of the furnace with the bosk puts the forbidding strangeness of the site we are about to enter on new terms. Together, these images affirm the possibility of reinventing the site, projecting it into a new future. The act of creating a garden, as Miller states, is an assertion of

control over our physical surroundings; it is a subversive act, and an act of hope.

The gardens are used expansively and eclectically at Duisburg, mixing the strange with the familiar. Latz + Partner ground their gardens in historical traditions and vernacular use; they also invent new forms that challenge accepted definitions of what a garden might be. Some of the gardens are used as signifiers of a civic landscape in bosks or allées; other gardens evoke the domestic scale of the front yard, composed of commonly used plants such as roses, boxwood, and hydrangeas (in the bunker gardens), muscari and scilla (in the Sinterplatz). This is the plant palette of local vernacular gardens, used here to establish familiar domestic tropes and resonate with a sense of the everyday. In other cases the gardens become a physical manifestation and elaboration of the conditions of disturbance. Pioneer species[21] adapted to disturbed soils are used to form bosks and allées: a bosk of ailanthus was planted near the former sintering plant, and at the Neumühl entrance we find an allée of fastigiate black locust.

Gardens have also been planted in the ruins of the bunkers that once held piles of ore and coal deposits. Viewed from a catwalk above, they form a series of garden rooms that have been inserted into the massive two-meter walls. New openings have been sawed through the concrete to create a series of doorways, allowing the visitor to occupy and move through the rooms in sequence. Some of the gardens are effectively roof gardens, growing above contaminated soils that have been transferred to the bunkers and capped to preserve the exotic vegetation that became established in these disturbed soils. Soft-textured, brilliant-colored lichens and mosses have taken hold in the extremely acidic soil in one of the bunker structures. Others are more self-consciously designed, suggesting garden follies: a formal knot garden fills one bunker "room," alongside an installation made from logs of indigenous birch, reminiscent of the work of Andy Goldsworthy. Some gardens express the ecological disturbance of the site; others seem to defy it by replaying traditional garden forms in this incongruous setting. The eclectic quality of the bunker gardens speaks to the artifice of the garden, whose materials might equally be prized horticultural specimens or the volunteer species of toxicity—"everything is good," and so, in some ways, interchangeable.

This message is even clearer at a small garden hidden in the woods, near

A *giardino segreto* of industrial detritus set within an old orchard

an abandoned orchard. Here we discover a series of garden plots filled with assorted industrial detritus—rusty screws, gravel, and other construction materials—laid out among the grid of apple trees. This industrial *giardino segreto* highlights the experimental nature of the garden, illustrating Latz's point that "we understand ways of managing the environment through the garden, like a scientist's research plot."[22] In this case, the garden is quite literally a research plot of scrap materials arranged to create a new scrap-yard taxonomy, sorting, measuring, and testing the recycled materials of the new garden.

There are utilitarian gardens at Duisburg, too: the gardens that most directly manage the environment are the "working gardens" that have been designed to actively regenerate the site, such as the water gardens that are planted to filter and purify storm water. Here the garden takes on an explicitly regenerative function of biofiltration, which gives physical form to the natural processes active on the site.

The analogy of the garden as a "scientist's research plot" reinforces the idea of the garden as a site of experimentation rather than a static work of art, whether intended for ornamental or instrumental purposes. True experimentation is defined by its open-ended quality, and the unpredictable results that often challenge the initial hypothesis. Here, the aesthetic of experimentation assumes, as its starting point, the dynamic flux of natural processes. Natural disturbance is accepted as part of that flux; it is neither aestheticized nor romanticized for the strange forms it produces. It is understood as a natural process that can be managed like any other within the overall design strategy—and should be manifested like any other. These processes are managed to different degrees; while some of the end states are predetermined, others are left open to natural succession and chance.

This view rejects the commonly held belief in nature's constancy and stability, an idea that is deeply ingrained in Western culture, and one that has dominated environmental thought.[23] Latz + Partner's conception of natural systems reflects the shift that has taken place in ecological theory in which the metaphor of equilibrium has been displaced by that of nonequilibrium, or flux. The definition of ecosystems as highly ordered, steady states, closed systems, has been challenged by recent reevaluations of the role of disturbance. In the earlier "equilibrium paradigm," disturbance was viewed as external to the system; when it would occur (usually as a result of human activity), succession would restore the system to an equilibrium condition, which characterized the mature state of any system. This theory was first articulated by Frederic Clements, in his 1916 work *Succession*, through the highly influential concept of the climax community, which was to dominate ecological research for the first half of the twentieth century. Implicit in this theory is the idea that the activities of humans are not part of the natural world and are often in conflict with its operation.[24] While Clements's concept of climax community has been questioned since the 1950s,[25] the equilibrium paradigm was challenged most forcefully in the 1980s by statistical and probabilistic approaches that have revealed disturbance to be a frequent, intrinsic characteristic of ecosystems. Findings point to a wide range of adaptations to disturbance, suggesting that succession is a highly probabilistic and contingent process, not the deterministic, universal, and linear process it was first thought to be. The nonequilibrium paradigm em-

phasizes "process rather than end point,"[26] focusing on how systems actually behave.

This fundamental revision to the understanding of ecosystem dynamics resonates with Latz's fascination with the phenomena of contingency, chance, and adaptation. With a deep understanding of ecological processes, he embraces the dynamic flux of nature, including the forces of disturbance, which he insists must not be erased to fit a preconceived image of what nature should look like. Just as there is no inherent "balance of nature," there can be no idealized conception of beauty in the landscape. Latz writes, "Our new conceptions must design landscape along with both accepted and disturbing elements, both harmonious and interrupting ones."[27] For Latz, nature cannot be thought of as pristine or autonomous, since natural processes are inextricably intertwined with the technologies that create and maintain them. This position undermines the idea of nature as a redemptive force, a consistent motif of park design since the mid-nineteenth century and still alive today in various guises.

Consider Dieter Kienast's proposal for Mechtenberg, another Ruhr site not too far from Duisburg-Nord. A group of artists, architects, and landscape architects met in the summer of 1992 in the Mechtenbergseminar to create a vision for the future of this steep landscape, a former mine. A small garden had been laid out at the top of the mountain at the turn of the century, surrounded by hawthorne hedges. This area, untouched for ninety years, gradually grew into a wood that swallowed up the original monument in the garden. This image gave rise to the new vision, which was dubbed "Sleeping Beauty"; the idea was to create a series of gardens that would be surrounded by tree trunks, preventing public access until the trunks would rot and fall down, "allowing the wood to grow undisturbed in this place for the next twenty years . . . it will remind us that the Sleeping Beauty eventually awoke, and tall and healthy trees will have risen from the polluted ground."[28]

The contrast between the designs of Mechtenberg and Duisburg highlights the widely divergent meaning of regeneration in the two works. Kienast's proposal withdraws the site from human use, based on the assumption that regeneration will occur when nature is simply "left to itself," undisturbed by human intervention: the site will be "healed" as a body heals itself. Kienast's proposal is a poetic interpretation of the notion of recovery

inherent in the "balance of nature" metaphor. At the same time, it draws upon a deeper mythic meaning, evoking the recovery of a lost paradise. In the work of Latz + Partner, the idea of the garden has been pried loose from the Edenic narrative. The Duisburg gardens do not gesture toward a state of ideal perfection or harmony; they are not compensatory or utopian or filled with a sense of loss. Latz has suggested that the metaphor of the oasis is a more fitting metaphor for the garden than paradise, evoking a sense of tension rather than harmony. Regeneration is distinguished from recovery, if we mean that recovery of the mythic fullness of nature for which Sleeping Beauty yearns, in her long, deep sleep.

The sense of loss and destruction that permeates our experience of the contaminated industrial landscape is allayed at Duisburg by the profound sense of possibility that comes with the belief in recycling, reuse, and, ultimately, reinvention. The gardens express a sense of the complexity of human engagement with nature, which is both destructive and regenerative. Yet their spirit of experimentation is inherently optimistic, based on an openness to new solutions, new forms, and new definitions that run counter to essentialist ideas of nature. The acceptance of disturbance and flux replaces the myth of recovery with an ethos of experimentation and making, and a renewed belief in human action. The gardens affirm that by "accepting the situation" of worldly imperfection and incompleteness, we also take responsibility for the repair of the world.

Notes

1. Robert Smithson, "A Sedimentation of the Mind: Earth Projects" (1968), in *Robert Smithson: The Collected Writings,* ed. Jack Flam (Berkeley and Los Angeles: University of California Press, 1996), 105.

2. See *The Machine in the Garden* (New York: Oxford University Press, 1964), Leo Marx's influential work on the pastoral as an enduring American ideal. Marx writes: "The pastoral ideal . . . is located in a middle ground somewhere 'between' yet in a transcendent relation to the opposing forces of civilization and nature" (23). The controlling theme of the pastoral, according to Marx, is the conflict between art and nature. In the mid-nineteenth century this was expressed as the conflict between an idyllic natural world and the "counterforce" of industrialization, represented by machine technology.

3. The 568-acre park is one of the best known public spaces within the 80-kilometer-long corridor known as Emscher Park, the site of a unique planning initiative coordinated by the International Building Exhibition (IBA). The IBA program (Internationale Bauaustellung)

was established in 1989 as a ten-year improvement program, following in a long tradition of building exhibitions in Germany. The regional redevelopment strategy was based on the creation of a 300-square-kilometer "landscape park" with a combined focus on economic and ecological improvements as well as the preservation of the unique industrial architecture (*The Emscher Park International Building Exhibition, IBA,* 1996).

4. Edmund Burke wrote in 1757: "Whatever is fitted in any sort to excite the idea of pain and danger, that is to say, whatever is in any sort terrible, or is conversant about terrible objects, or operates in a manner analogous to terror, is a source of the *sublime;* that is, it is productive of the strongest emotions which the mind is capable of feeling." Quoted in Denis Cosgrove, *Social Formation and Symbolic Landscape* (Madison: University of Wisconsin Press, 1984), 227.

5. This concept, developed most extensively by David Nye in his book *The American Technological Sublime* (Cambridge, MA: MIT Press, 1994), refers to the sense of awe inspired by great feats of civil engineering, such as the railroad, great bridges, dams, and machinery of production. Nye writes: "The industrial sublime combined the abstraction of a man-made landscape with the dynamism of moving machinery and powerful forces . . . (evoking) fear tinged with wonder. It threatened the individual with its sheer scale, its noise, its complexity and the superhuman power of the forces at work" (126). The term "technological sublime" was coined by Perry Miller in *The Life of the Mind in America* (New York: Harcourt, Brace and World, 1965), and also developed by Leo Marx in *The Machine in the Garden,* John Kasson in *Civilizing the Machine* (New York: Grossman, 1976), and others.

6. Peter Latz, "The Idea of Making Time Visible," *Topos* 33 (2000): 97.

7. Here I am referring to W. J. T. Mitchell's fundamental question regarding landscape: "not just what landscape 'is' or 'means' but what it does, how it works as a cultural practice." This follows from his understanding of landscape "not as an object to be seen or a text to be read, but as a process by which social and subjective identities are formed." See his introduction to *Landscape and Power,* ed. W. J. T. Mitchell (Chicago: University of Chicago Press, 1994), 1–2.

8. As Mara Miller wrote, "Gardens articulate space in the interests of articulating time." See *The Garden as an Art* (Albany: State University of New York Press, 1993), 39.

9. See William Cronon's discussion of wilderness, which was expressed in terms of the "sublime": "Wilderness represents a flight from history. Seen as the original garden, it is a place outside of time, from which human beings had to be ejected before the fallen world of history could properly begin." Cronon goes on to discuss the dualistic vision implicit in the idea of wilderness, in which the human is entirely outside the natural. See "The Trouble with Wilderness; or, Getting Back to the Wrong Nature," in *Uncommon Ground,* ed. William Cronon (New York: W. W. Norton, 1995), 79–80.

10. Peter Latz, "'Design' by Handling the Existing," in *Modern Park Design: Recent Trends* (Amsterdam: Thoth, 1993), 97.

11. Latz has commented that it is impossible to understand the Ruhr region without recognizing the role of the railway network in shaping the landscape. It was a functional system

that not only served the industrial plants but also influenced the layout of the towns. The railroad was laid out as a rational system, providing direct connections, in contrast to the street system, which was typically more haphazard and circuitous, and sectionally separated from the rail system.

12. Peter Latz, personal interview, June 1997.

13. Latz, interview.

14. The Piazza Metallica at Duisburg is an example of this postindustrial hybrid, where the machine becomes an extension of nature. In a former work yard of the ironworks, the production of iron is represented in both its molten and hardened states by a massive grid of forty-nine eight-ton iron plates that had been discovered in the pig-iron casting works. The intensity of the industrial processes gives them the primordial quality of natural geological forces; the eroded surfaces of the plates, which had been subjected to temperatures of 1,600 degrees, are like earth forms eroded by fluvial processes.

15. Udo Weilacher, *Between Landscape Architecture and Land Art* (Basel and Boston: Birkhäuser, 1996), 131.

16. Anneliese Latz and Peter Latz, "New Images: Metamorphosis of Industrial Areas," *Scroope—Cambridge Architectural Journal* 9 (1997): 39.

17. Peter Beard, "Peter Latz, Poet of Pollution," *Blueprint* 130 (1996): 35.

18. The once distinct towns of Duisburg, Meiderich, Hamborn, Kreuz, and Neumühl have now merged imperceptibly to form an almost continuous urban fabric around most of the park. However, the neighborhoods are demographically distinct, and the facilities located near the various entrances are meant to reflect specific neighborhood needs.

19. These original stakes were removed by the park administration after several years.

20. Miller, *The Garden as an Art,* 25.

21. A pioneer species is an early occupant of newly created or disturbed areas. It is a member of the early-stage communities in ecological succession.

22. Latz, interview.

23. See Daniel Botkin, *Discordant Harmonies* (New York: Oxford University Press, 1990), 12–13, for a discussion of cultural metaphors of nature that have influenced ecological thought—from divinely ordered, organic, and mechanistic models to a new model influenced by computers in which the distinction between organic and inorganic is no longer very clear. See also Daniel Simberloff, "A Succession of Paradigms in Ecology: Essentialism to Materialism and Probabilism," in *Conceptual Issues in Ecology,* ed. Esa Saarinen (Dordrecht: D. Reidel, 1980), regarding the impact of Greek metaphysical philosophy—Platonic idealism and Aristotelian essentialism—on ecosystem ecology.

24. For a discussion of this paradigm shift, see Daniel Simberloff's influential "A Succession of Paradigms"; and S. Pickett, V. T. Parker, and P. Fiedler's "The New Paradigm in Ecology: Implications for Conservation Biology above the Species Level," in *Conservation Biology,* ed. P. Fiedler and S. Jain (New York: Chapman and Hall, 1992); and Robert McIntosh, *The Background of Ecology: Concept and Theory* (Cambridge: Cambridge University Press, 1985). For a discussion of ecology's new paradigm and its meaning for designers, see Robert Cook,

"Do Landscapes Learn? Ecology's 'New Paradigm' and Design in Landscape Architecture," in *Environmentalism in Landscape Architecture,* ed. Michel Conan (Washington: Dumbarton Oaks Research Library Collection, 2000), as well as R. Pullian and Bart Johnson's "Ecology's New Paradigm: What Does It Offer Designers and Planners?" in *Ecology and Design,* ed. Bart Johnson and Kristina Hill (Washington, DC: Island Press, 2002).

25. See Michael Barbour's "Ecological Fragmentation in the 50s," in Cronon, *Uncommon Ground,* for a discussion of the debate between Frederic Clements and Henry Gleason over the concept of ecological communities.

26. P. M. Vitousek and P. S. White, "Process Studies in Succession," in *Forest Succession: Concepts and Applications,* ed. D. C. West, H. H. Shugart, and D. B. Botkin (New York: Springer-Verlag, 1981), quoted in Fiedler and Jain, *Conservation Biology.*

27. Latz, "The Idea of Making Time Visible."

28. Dieter Kienast, "A Set of Rules," *Lotus* 87 (1995): 67.

A Case for Openness: Ethical and Aesthetic Intentions in the Design of MASS MoCA

PHOEBE CRISMAN

America, you have it better than our old continent;
You have no ruined castles and no primordial stones.
Your soul, your inner life remain untroubled by
Useless memory and wasted strife.

—JOHANN WOLFGANG VON GOETHE, "DEN VEREINIGTEN STAATEN"

Goethe's mythical impression of a forever-new America without the burden of a past is a pervasive part of the American psyche. And yet, although in contemporary American culture the desire for "the new" is evident in everything from the planned obsolescence of consumer goods to suburban sprawl, there is also a contradictory desire for continuity, stability, and shared memory. The growing phenomenon of reconceptualizing nineteenth- and twentieth-century private industrial sites into cultural spaces for public use is an opportunity for these seemingly oppositional desires—the old and new—to coexist. Much has been written about the privatization of public space, but little scholarly work has studied the opposite condition. The lack of writing on the subject indicates the need for this analysis. In answer to the question of how to change a place without denying its past life and inhibiting its future, this chapter argues for a practice of architectural reuse that is gratifying both ethically and aesthetically—one that embraces openness to the past and future on multiple levels. Accepting that all conscious acts, including the making of architecture, are based on intentions, this chapter also considers the broader question of how one can create an architecture of ethical intention while leaving room for openness to reception and interpretation, and to considerations such as time, use, art, economy, and memory.

Numerous vacant American manufacturing facilities have been formally and functionally transformed into cultural sites, ranging from the Lowell

Contrasting textures at MASS MoCA

National Historic Park and the Old Slater Mill to museum complexes such as the Massachusetts Museum of Contemporary Art (MASS MoCA).[1] While this tendency is also evident in European projects, for example, the Tate Modern, the Design Zentrum Nordrhein Westfalen, and Landschaftspark Duisburg-Nord, this chapter focuses on the American condition and the specific case of MASS MoCA.[2] Listed on the National Historic Register, the formerly derelict, thirteen-acre Arnold Print Works in North Adams has been reimagined and physically reconfigured into MASS MoCA—a place of interrelated art production, exhibition, and performance. My direct involvement as MASS MoCA project manager and design architect with Bruner/Cott & Associates affords an insider's view of the design intentions and physical strategies employed in the transformation, while the passage of time provides a critical distance.[3]

During the professional design process, underlying ethical positions are rarely examined directly. Conflicts between client and architect, or within the design team itself, usually rest on unspoken philosophical differences embodied in stylistic or functional considerations. The aesthetics of MASS MoCA were generated from an interrelated set of ethical intentions for the transformation of the discarded materials and vacant architecture of the derelict industrial site. The material, spatial, functional, cultural, social, and economic aspects were addressed from a pragmatist point of departure based on the specifics of a particular place. In this way, the ethical intentions were not based on a priori or universalized positions or morals, but embedded in an understanding of the situation and ethos of North Adams. A case study into the complex relationship between ethical intentions and aesthetic outcomes, this chapter argues for a multivalent openness in the design process that is able to sustain the specifics of place embodied within a historically significant site, while shifting the buildings and landscape to new cultural uses and unimagined future activities.

Economic and Social Catalysts

Sited in 1860 at the confluence of two branches of the Hoosic River, the extensive collection of red brick and heavy timber mill buildings was erected over a forty-year period to house specific activities of the mechanized fabric printing process. The Arnold Print Works became the single largest employer

in North Adams, and its site constitutes nearly one-third of the downtown. It was sold in 1942 to the Sprague Electric Company, which occupied the mill buildings with thousands of workers producing electronic components. The strong and open architecture did not require significant modification to support the new industrial processes within. Sprague was the region's largest employer during the 1970s, when over 4,000 people worked for the company in a town of just 18,000. When Sprague vacated the site in 1985, the town's economic base disappeared, and unemployment in North Adams had reached 14 percent at the time of MASS MoCA's conception in 1986.[4]

Funded by a combination of public and private sources from the state of Massachusetts and the nonprofit MASS MoCA Foundation, the project was conceived as an economic catalyst for revitalizing North Adams, a means of preserving a historically significant and beautiful nineteenth-century mill complex, and a new laboratory for contemporary visual and performing art. Since the project opened in 1999 it has had a positive economic impact locally and become a significant social and cultural center in the largely working-class town.[5] Rather than being a bastion of high art removed from the ethos of North Adams, MASS MoCA offers job training, such as computer classes, and free Internet access, in addition to films, dances, and other cultural

The Arnold Print Works in 1875

Sprague Electric
Company workers

events. Local involvement is reflected in MASS MoCA's membership, half of which is made up of local residents. The diverse range of community activities harkens back to Sprague's heyday, when the institution "had its own radio station, orchestra, vocational school, research library, day-care center, clinic, cooperative grocery store, sports teams, and even a gun club with a shooting range on the premises."[6] Both physically and conceptually, the new "museum" still serves as a social condenser for the community. The link between town and architectural artifacts, and hence the art contained within, is not eradicated but transformed. From the initial idea to MASS MoCA's opening in 1999, the thirteen-year transformational process was long and complicated.

The Importance of Process

Many design processes begin with a singular and willful "big idea" that controls project development, leaving little room for revelations along the way. This was not the case with MASS MoCA. Here site conditions and discoveries during demolition and construction significantly affected the aesthetic outcome. The process of design focused on the experience of making and

ultimately inhabiting the place, rather than on creating a preconceived architectural object. The "big idea" was not formal or programmatic but primarily about acknowledging the existing place and creating an environment that would promote multivalent openness. This process-oriented approach is consistent with the idea that objects themselves are not ethical but are generated by ethical intentions and actions on the part of makers and inhabitants. This position is related to the conception of a "pragmatist aesthetics" articulated by the philosopher Richard Shusterman.[7] In the first chapter of his book, Shusterman writes, "The idea that art and aesthetic judgment should be seen as totally distinct from ethical considerations and sociopolitical factors is no longer very useful or credible." This statement is more immediately evident for architecture than for the other arts, since architecture must support purposeful action by human inhabitants, as well as disinterested aesthetic contemplation.

Openness to Reception and Interpretation

At MASS MoCA the primary conceptual and physical design challenge was how to convert the architectural remains of the Arnold Print Works to support a contemporary cultural use, while simultaneously preserving their historic qualities and encouraging future possibilities. Embedded within this problem was the necessity for openness—a condition that allows a place or an artifact to be available for reception and interpretation. Umberto Eco, along with Walter Benjamin, Roland Barthes, and others, have considered how art might activate the viewer. In *The Open Work*, Eco claimed that modern art has exploited the possibility for each work to produce an infinite number of readings, although he also acknowledged that art has always been potentially open.[8] The openness he advocated is different from the literal interaction between artist and viewer that characterizes "relational aesthetics" as defined by Nicolas Bourriaud,[9] or the impossibility of artistic intentionality theorized by poststructuralists. It is possible to relate the visual, literary, and performance art considered by Eco to built works of architecture. Because architecture supports human inhabitation through spatial and formal means, the reception or engagement of the inhabitant is necessarily direct. The specific design, however, can heighten that engagement and strive toward a contingent and improvisatory architectural experience.

This may be achieved by intentionally remaining open to time, use, and memory.

We are all familiar with buildings or places that have become closed to interpretation, owing either to overzealous physical restoration or to the return to a frozen "themed" moment in time. For example, Colonial Williamsburg transports us back to an idealized eighteenth century. Williamsburg possesses two forms of closure: both its purified architecture and staged period inhabitants bear no trace of the intervening time since the town's formative years between 1699 and 1780 and its restoration begun in 1926. Isolated from the passage of time, Williamsburg's presence in the world is denied. Arguing against this type of frozen building–centered approach, the preservationist Randall Mason wrote, "Historic preservation theories and tools need to reflect the notion that culture is an ongoing process, at once evolutionary and inventive—not a static set of practices and things."[10] The preservation strategy employed at MASS MoCA embraced the idea that as culture changes, so too does architecture and the significance invested in built artifacts. Although the buildings were originally constructed and functioned as the Arnold Print Works, current North Adams residents have known the complex as Sprague Electric since 1942. Except for the oldest residents, their desire to physically preserve the place is guided by memories of life associated with the Sprague factory. Arbitrarily restoring the architecture to the early twentieth-century heyday of the Arnold Print Works would not address the layers of significance and collective memory attached to the place in its various incarnations, including recent events and experiences generated at MASS MoCA.

Openness to Time

The mill sat vacant and neglected for fourteen years. Vulnerable to natural forces of water, wind, and sun, and to human acts of vandalism and theft, the thirteen-acre site was slowly transformed into a massive, powerful ruin. In the essay "Causality: Ruin Time and Ruins," Florence Hetzler defined a ruin as

> the disjunctive product of the intrusion of nature upon an edifice without loss of the unity produced by the human builders. Ruin time, proposed

Vacant buildings at MASS MoCA

as the principal cause of ruin, serves also to unify the ruin. In a ruin the edifice, the human-made part, and nature are one and inseparable; an edifice separated from its natural setting is no longer part of a ruin since it has lost its time, space and place. A ruin has a signification different from something merely human-made. It is like no other work of art and its time is unlike any other time.[11]

Sprague Electric displayed these characteristics before MASS MoCA's transformational process, and portions still do. The Sprague buildings,

however, were ruined not just by nature and the passage of time but by eco-
nomic circumstances and social consequences. These premature ruins at-
test to the passing of an industrial age and the town's previous way of life.[12]
The architects and the museum director, Joseph Thompson, were intrigued
by the simultaneous sense of absence and presence—of programmatic tran-
sience and physical persistence on the site. The design dilemma was the
conflicting desire for both a new cultural program and a continuation of the
processes of decay and temporal change.

The 4,800 tons of construction debris removed from the site provides a
sense of the extensive transformational process, which included the removal
of internal walls and floors and the complete demolition of one severely dam-
aged building. Nineteen of the twenty-six structures remain in varying states
of ruin, thereby providing a direct connection with the previous condition of
the place and awaiting inhabitation as MASS MoCA expands. Undoubtedly,
some of these buildings will be ruined beyond repair, slowly overwhelmed
by natural forces.[13] MASS MoCA's architects attempted to make visible a his-
tory in the process of disappearing, and along with it the loss of a way of life.
Layers of peeling paint mark the location of previous administrative offices
in institutional green or bathrooms in pink and blue, thus recording past
inhabitation. As at Pompeii, arrested time suggests a strange immortality.[14]
Unlike the fixed state of Pompeii, however, here new layers continue to ac-
cumulate as contemporary needs evolve. Each visitor will read and interpret
these layers differently, based on their knowledge of the place and their in-
dividual experiences past and present. The specific interpretation is not cru-
cial to the success of the architecture; rather, the architecture provokes an
open reception and interpretation, a questioning of what might have been
and what might be.

John Ruskin considered historical authenticity and interpretive openness
in "The Lamp of Memory" when he described architectural restoration as
"the most total destruction which a building can suffer."[15] Ruskin elaborated
on the importance of age for architecture. "For, indeed, the greatest glory of
a building is not in its stones, nor in its gold. Its glory is in its Age, and in that
deep sense of voicefulness, of stern watching, of mysterious sympathy, nay,
even of approval or condemnation, which we feel in walls that have long
been washed by the passing waves of humanity."[16] The productive changes

Wall as palimpsest

induced by physical weathering are lost when the "golden stain of time" is washed away. Marks of time are often understood in both restorations and new architecture as a debasement of the initial state of architectural perfection.[17] The past is erased and the future is precluded to the detriment of both.

The architects of MASS MoCA retained the signs of physical weathering and traces left behind by previous inhabitants both inside and outside the buildings. Given the significance of the place and its history to the North Adams community, a complete erasure, or whitewash, of the architectural surfaces was not an appropriate ethical or aesthetic decision. Instead, a range of galleries were designed that either retained found surfaces or added plaster

and white paint to create a new temporal layer suited to particular art display. These decisions were made in relation to volumetric and natural light considerations, as well as to conditions revealed as demolition progressed. For example, new spaces created by the removal of floors and interior walls were examined to determine what surfaces were beautiful and might be retained. Aesthetic decisions for each gallery were contingent on what the architecture offered, rather than a preconceived ideal. In that way the architects worked with an ethical attitude that was open and opportunistic to real-world conditions. This openness to material change was an attempt to achieve two things: to allow the past history of the building to be visible in the new museum, and to position the present changes as just another phase in the ever-changing transformations of a building. Architectural imperfection suggests an ongoing process of enrichment and accretion. The natural and cultural forces at MASS MoCA will continue to transform the buildings as each installation leaves some new trace. If enough time passes, however, excessive weathering becomes ruin—a condition that much of the Arnold Print Works had reached before MASS MoCA's creation.

Openness to Use

When first encountered by the architects, the abandoned site was like many places of past industrial activity that possess a powerful and poetic aura. Writing about such environments, Alberto Ferlenga noted that "the progressive or traumatic depletion of a building is accompanied by a dual process of liberation: from the temporal conventions that linked it to a given epoch, and from the functional conventions that linked it to a given use. As it is exhausted the building puts its forms, parts, meanings back in circulation, laying the groundwork for a possible rebirth, as long as conservationists are not allowed, with their taxidermic practices, to stifle the life of forms and the force of spaces."[18]

At MASS MoCA, architects had wanted to leave the ruin alone for the pleasure of occasional explorers, but the reality of rotted floors, falling bricks, broken windows, and ruptured plumbing meant that the buildings were legally uninhabitable and physically unsuitable for the making and exhibiting of art. This conundrum prompted a strategy to emphasize the layered and ambiguous spatial quality found on the site, thereby promoting the

physical exploration and psychological release that the architects found so compelling. By occupying just seven buildings and leaving the remaining nineteen for future inhabitation, the site is not consumed by use but left open for discovery. Visitors may freely roam about the labyrinthine site and encounter buildings in various states of decay and transformation. Alberto Pérez-Gómez eloquently articulated the existential connections possible in such *spaces in-between*. "Openness is key, but this is the nature of the works of imagination, open enough to invite participation, but engaging a critical view on the hegemony of technology and its systems of domination. There are alternatives to the voyeuristic conceptions of experience that are best exemplified in a place like Walt Disney World."[19]

Great effort was made to avoid turning MASS MoCA into a theme park offering a quasi-industrial experience. Some authentic industrial artifacts were retained, others were removed as necessitated by museum uses, and new interventions were identified. The process of making distinctions between old and new worked at many levels. For example, the black box theater volume was created by a new interior steel structure that remains visibly free of the existing masonry walls. The exposed structure's diagonal bracing intentionally crosses and is in formal contrast to the double-hung windows and their single-story logic. Heavy floor-to-ceiling curtains create another spatial layer and modulate natural light. A tension is created between the original building scale, composition, and material and the new long-span steel structure. Although each visitor may not appreciate the complexity of these aesthetic decisions, the disjuncture between old and new precludes a closed reading and opens possibilities for interpretation, and even use. The moveable and retractable tiered seating provides flexibility for a range of performances and spatial orientations. Most exterior and interior spaces were designed for diverse uses in this way, with a balance between specificity and changeability. For instance, Courtyard B is loosely configured for film projection, performances, parties, outdoor dining, and random exploration. The steel frame of a demolished boiler house was retained to support art installations, theatrical lighting, and other activities that might utilize its physical qualities.

Here it is important to distinguish between "program" in the architectural sense, meaning the human actions that a place can physically support,

Brick walls and new steel structure at theater

and cultural "programming," which determines what specific exhibitions and events are staged at that place. When a building is conceived too tightly around a specific function, the closed physical form often cannot house unintended events. Buildings may be designed, however, to offer opportunities for diverse actions without dissolving into formless flows and contrived mechanical or digital changeability. In the case of art museums, both architectural openness to use and diverse cultural programming are sometimes seen as distancing the architecture and institution too far from the "temple of art" model. In his essay "The Museum as Fun House," Roger Kimball critiqued many art museums since the 1960s, including MASS MoCA, as "all-purpose cultural emporia" where quantity outweighs quality, and notoriety, political programs, or coffee bars replace aesthetic excellence.[20] Conversely, museum director Joseph Thompson wrote: "If conventional museums are boxes, MASS MoCA is an open platform—a welcoming place that encourages dynamic interchange between making and presenting, between the visual and performing arts, and between our extraordinary historic factory campus and the patrons, workers and tenants who again inhabit it."[21] It would be enlightening to debate whether any art museum *should* be a "cultural factory" or "open platform" based on the Marxist view of art as cultural production, but a more relevant question for this inquiry is how the specific

architecture can support and interact with the art created, performed, and displayed within.

Openness to Interactions between Art and Architecture

An intertwined openness to temporal and programmatic change in the design of galleries and courtyard spaces at MASS MoCA also encouraged distinct and diverse interactions between the art and architecture. Since the museum's physical location had such a rich history and provocative existing conditions, uniform "white wall" galleries were rejected. When the site was placed on the National Register of Historic Places in 1985, the nomination report noted its "integrity, location, design, setting, materials, workmanship, feeling, and association with North Adam's late nineteenth century industrial heyday." The cited "feeling and association" would have been lost if the buildings had been subjected to a radical cleansing process or homogenous plaster surfacing. Since the architecture is not neutral but an evocative presence, artists and curators must envision ways in which the art may meaningfully interact with its powerful context.

One compelling example of interactivity was the installation of a Robert Morris sculpture in Building 5, a large gallery designed with operable windows and industrial exhaust fans for ventilation. Positioning the sculpture in relation to the exhaust fans created a new visual and spatial condition, while the strange similarities between the forms, regular disposition, and steel material of the fans and sculpture encouraged an interpretive dialogue. Beyond temporary installation encounters, the process of making visual and performing art on-site will incrementally change the architecture and surrounding landscape. This type of serendipitous interaction has already occurred in exterior spaces such as Courtyard A, where the artist Natalie Jeremijenko incorporated the foundation of demolished Building 1 into her sculpture *Tree Logic*. Although the architects did not know how the building foundation would eventually be used, it was retained for future reuse such as this.

Openness to Alchemy

Another type of openness grew from an environmental conviction and economic necessity to retain and creatively reuse materials, thereby minimizing

Ventilation fans in dialogue with sculpture installation, Robert Morris, *Untitled (16 Steel Boxes)*, 1967. Steel, each 36 x 36 x 36 in., overall, 36 x 252 x 252 in.

waste, reducing human labor, and limiting the need for new construction material. We discovered the ethical and aesthetic beauty of doing very little to create so much, an alchemy of sorts that takes unremarkable found conditions and magically transforms them. In this way, an aesthetic and an ecological agenda were pursued simultaneously, and what resulted was an overlap of the two, each maintaining distinctiveness and taking precedence at times, but ultimately creating new possibilities. Examples of this alchemy can be found in the seemingly haphazard assembly of buildings, bridges, and resulting outdoor courtyards. Both the Arnold Print Works and Sprague Electric Company added new buildings to the intricate assemblage as their production requirements changed and, in so doing, inadvertently recorded the passage of time in architectural form. At MASS MoCA, these courtyards

Courtyard B with boiler house ruins

are retained and used in quite different ways than originally intended. A former loading area becomes an outdoor cinema through the addition of a large projection screen. Sometimes art and architecture work together to give new meaning to a space with no literal or material change. For example, in 1999 the sound artist Ron Kuivila filled a narrow light and air shaft with the voices of past workers recalling their experiences in that place long ago. Titled *Visitations*, this installation included oral interviews, readings, radio broadcasts, Sprague advertising soundtracks, industrial sounds, and computer-generated noises. This ephemeral sound addition was radically transformative and pointed to the complex relationship of past, present, and future in our daily lives.

In other cases, the architecture itself has undergone significant physical changes in support of new use. For instance, the original multistory mill buildings were single-story spaces with a tight column grid to support the

Timber columns cut and transformed
into king-post trusses

short spans of heavy timber construction. The low and column-filled spaces
did not provide the open floor areas and double- and triple-story volumes
desired for museum galleries. To create these spaces, large floor areas were
subtracted within the existing mill buildings, thereby uncovering and inten-
tionally revealing layers of building construction. Rather than replacing the
heavy timber frame in multistory galleries, king-post trusses were created
by using steel cables and plates to structurally transform the existing tim-
ber beams and truncated columns. At a detail level, the column's history is
accentuated by the exposed cut that reveals the untreated wood within, in
contrast to the industrial-era paint retained on its surface. In this way, layers
of constructed time—echoes of industrial production and ongoing cultural
activity—overlap.

Judging by their comments, many visitors to MASS MoCA understand
the architects' intentions. One visitor wrote:

It is an old habit to think of a museum as the silent, blank walls that allow painting and sculpture to be heard in their full voice, undisturbed by anything but the sounds of visitors walking by. MASS MoCA turns that old habit inside out. You cannot walk through it without thinking of the countless gestures, some meant, some unmeant, that turned the blank brick of those factory buildings into the cumulative life's work of the many thousands of North Adams residents who toiled on this site for two centuries. This is a museum designed to honor the labor of artists, but one that inevitably honors the labor of the townspeople in whose midst it has been set.[22]

Openness to Memory

Architecture, perhaps more than most human artifacts, records experiences and evokes memories in palpable ways. The architectural historian Sandy Isenstadt termed this phenomenon "symbolic persistence," in that "works of architecture possess the power to remain meaningful long after their creators are dead. . . . I do not mean that any one particular meaning survives across time, but that a work of architecture retains its ability to prompt interpretation for generations beyond its creation." In discussing the ability of architecture either to promote interpretation or to explain, he claims that "symbolic persistence resides in this interpretive imperative, in the ability of a building or structure to move us to see and hear ourselves and our place in the world."[23]

The physical presence of the Arnold Print Works plays this role for both visitors and residents of North Adams, encouraging them to pause, reflect, and imagine a past to which they may or may not have a direct connection. The demolition of many historically significant mills has been justified by the explanation that previous employees did not want to be reminded of their past labors. However, interviews with former workers in the largely destroyed Amoskeag Mill found the opposite. "Industrial laborers are no more likely to see their own backgrounds as having been degraded than are any other societal groups. Identification of the mills with a degrading existence just does not fit their perception of their own past, irrespective of any particular hardship."[24] This position is supported by interviews with a number of past Sprague Electric employees. When questioned about MASS MoCA,

Aerial view of North Adams and Sprague Electric

they discussed the exact places in the complex where they and their family members had worked, fondly reminisced about the company dinners and parties, and complained about the long hours and low pay.[25] They chiefly remembered the experiences they had shared with so many others. In *American Ruins,* the sociologist and photographer Camilo José Vergara found similar but often more pessimistic sentiments in his travels to ruined industrial areas around the United States. He frequently heard former employees talk about "how nothing is made here now" and voice a profound sense of loss. Vergara observed: "A powerful longing for the city of smokestacks and paychecks lingers among those old enough to remember. People recite like an incantation the names of nearby abandoned factories and the products they used to make."[26]

Perhaps because most of Vergara's fieldwork was done in the severely distressed cities of Detroit and Newark, his interviewees commonly expressed loss and hopelessness for the future. Though not possible, it would be telling to compare current interviews with what past employees had to say about the Sprague Electric site after the 1985 closing but before the

creation of MASS MoCA. Would they have expressed the same despair for the future and nostalgia for the past? In either case, such sentiments do not fully explain the current proliferation of cultural sites that appropriate and commemorate places of industrial production. Discussing the inescapable presence of the past in our lives, the historian David Lowenthal writes, "The past remains integral to us all, individually and collectively. We must concede the ancients their place . . . but their past is not simply back there, in a separate and foreign country, it is assimilated in ourselves and resurrected in an ever-changing present."[27]

Industrial Site and Cultural Space

There are several explanations for why the abandoned Sprague Electric site was transformed into MASS MoCA. The most practical reason and initial inspiration for the project was the site's extensive and economical space. After visiting a German factory turned museum near Cologne, MASS MoCA's instigator Thomas Krens was struck by the spatial benefits of industrial architecture for contemporary art display. Since the inherited museum form could no longer contain the immensity of minimalist art, gigantic industrial spaces offered optimum architectural conditions.[28] The Sprague Electric complex was ideal, with over 720,000 square feet of interior space and a single building as long as a football field. Since many industrial sites are contaminated and negatively perceived, companies and communities are willing to sell such sites cheaply—an important incentive for nonprofit cultural institutions.[29] In addition, while private landscapes of labor are undesirable when abandoned, public sites of culture hold the potential to generate jobs and revenue, to upgrade a community's image and self-respect, to visually enhance the environment, and to promote social interaction in a new type of public cultural park. In speaking of MASS MoCA, the artist Robert Rauschenberg said, "What's so great about it is it was a totally useless space, except maybe for history. And now it's filled with activity. Incredible activity."[30] And yet despite these practical benefits, a more significant explanation may be found in the longing for a lost industrial life in an information age.

In a time of synthetic, "themed" places that substitute visual spectacle for real experience, MASS MoCA serves not only as a museum but also as a cultural metaphor. Beneath its practical use lies a story of how a place has

Corner of Building 4 gallery

changed from the production of textiles to electronic components to art. As in a palimpsest, contemporary art and sophisticated communication systems are overlaid on historic structures, and on accumulated memories and toils.[31] It is perhaps a simultaneous absence and presence, the coexistence and interdependence of the concrete and the abstract that makes the factory turned museum real for both visitors and residents of North Adams. While this landscape is clearly legible as a place of former industrial production, it has not been embalmed as such. It continues to be part of the world at large, participating in the ever-changing realm of ideas and their production.

Notes

1. A survey of historic mills reveals two major categories of cultural reuse. In the first case, the original function of the building is maintained as a museum with industrial machinery demonstrations and historical interpretations. The building is removed from the productive life of the city and serves a didactic purpose. For example, the Lowell National Historic Park in Lowell, Massachusetts, maintains "working" looms and commemorates the history of America's Industrial Revolution in physical form. A second type of conversion retains the historical buildings but converts them to another use. The Amoskeag Mills in Manchester, New Hampshire, once the world's largest textile producer, now contain the Manchester Historic Association Millyard Museum, the University of New Hampshire–Manchester, and various commercial uses. MASS MoCA is another example of this second type of reuse.

2. Built in London between 1947 and 1963, the Bankside Power Plant by Sir Giles Gilbert Scott was reopened in 2000 as the Tate Modern. Transformed into a contemporary art museum by the Swiss architects Herzog & de Meuron, the Tate Modern retains the perimeter brick shell and introduces a new steel structure, spatial configuration, and material palette within. Architects Foster and Partners converted the boiler house of the Zeche Zollverein colliery, a UNESCO World Heritage site in Essen, into the Design Zentrum Nordrhein Westfalen. The design retains significant aspects of the boiler house, while introducing a new material language and cultural program. Landschaftspark Duisburg-Nord is a former Thyssen Krup AG steel mill converted into a park by Latz + Partner (see the chapter by Elissa Rosenberg in this volume).

3. The Bruner/Cott & Associates architecture project team included Simeon Bruner, Henry Moss, Phoebe Crisman, Maria Raber, and Kim Markert.

4. For accounts of MASS MoCA's beginnings, see Jennifer Trainer, ed., *MASS MoCA: From Mill to Museum* (North Adams: MASS MoCA, 2000).

5. The economic benefit is achieved by encouraging tourism and by renting office and studio space within the MASS MoCA site. "Local unemployment has been reduced from 25 percent to just under 5 percent since the museum opened in 1998," according to Mark Johnson, in "Brownfields Are Looking Greener," *Planning*, June 2002, 14–19. For a detailed and regularly updated description of economic regeneration intentions and statistical results, see http://www.massmoca.org.

6. John Heon, "History and Change at the Marshall Street Complex," in Trainer, *MASS MoCA: From Mill to Museum*, 11.

7. Richard Shusterman, *Pragmatist Aesthetics: Living Beauty, Rethinking Art* (Oxford: Blackwell, 1992).

8. Umberto Eco, *The Open Work* (Cambridge, MA: Harvard University Press, 1989).

9. See Nicolas Bourriaud's collection of essays *Esthétique Relationnelle* (1998), trans. by Simon Pleasance and Fronza Woods as *Relational Aesthetics* (Dijon: Les presses du réel,

2002). For an illuminating critique of this position, see Claire Bishop, "Antagonism and Relational Aesthetics," *October* 110 (Fall 2004): 51–79.

10. Randall Mason, "Fixing Historic Preservation: A Constructive Critique of 'Significance,'" *Places* 16, no. 1 (Fall 2003): 70.

11. Florence M. Hetzler, "Causality: Ruin Time and Ruins," *Leonardo* 21, no. 1 (1988): 51. Also see Brigette Desrochers, "Ruins Revisited: Modern Conceptions of Heritage," *Journal of Architecture* 5 (Spring 2000): 35–45. For a relevant discussion of *art-value* and *age-value*, read Alois Riegl, "The Modern Cult of Monuments: Its Character and Its Origin" (1903), trans. Kurt W. Forster and Diane Ghirardo, *Oppositions* 25 (1982): 21–51. Alan Colquhoun analyzes this essay in "Thoughts on Riegl," ibid., 78–83.

12. For a discussion of ruins created by forces other than nature, such as cataclysmic political or economic events, see Michael S. Roth, ed., *Irresistible Decay: Ruins Reclaimed* (Los Angeles: The Getty Research Institute for the History of Art and the Humanities, 1997), 1–23.

13. Since MASS MoCA's opening in 1999, three buildings have been renovated and two ruined buildings demolished.

14. For a compelling analysis of Pompeii and the history of ruins, see Charles Merewether, "Traces of Loss," in Roth, *Irresistible Decay*, 25–40.

15. John Ruskin, "The Lamp of Memory," in *The Seven Lamps of Architecture*, 4th ed. (Kent: George Allen, 1883), 194.

16. Ruskin, "The Lamp of Memory," 186.

17. For a discussion of modern architects' attitudes toward weathering, see Mohsen Mostafavi and David Leatherbarrow, *On Weathering: The Life of Buildings in Time* (Cambridge, MA: MIT Press, 1993), 86.

18. Alberto Ferlenga, "Separazioni/Separations," *Casabella* 67 (December 2003–January 2004): 175.

19. Alberto Pérez-Gómez, "Spaces In-between," in *Present and Futures: Architecture in Cities*, ed. Ignasi de Solà-Morales (Barcelona: Actar, 1996), 278.

20. Roger Kimball, "The Museum as Fun House," *New Criterion*, February 2001, 5–11.

21. Joseph Thompson, "What We Do and Why We Do It . . . ," MASS MoCA Web site, http://www.massmoca.org (accessed July 12, 2005).

22. Verlyn Klinkenborg, "Editorial Notebook: Contemporary Art in a Factory Setting," *New York Times*, June 5, 1999.

23. Sandy Isenstadt, "The Interpretative Imperative: Architecture and the Perfectibility of Memory," *Harvard Design Magazine*, Fall 1997, 58, 62.

24. Randolph Langenbach, "Amoskeag Millyard Remembered," *Historic Preservation* 27, no. 3 (July–September 1975): 28.

25. Bruce Watson, "A Unique Home for Cutting Edge Art," *Smithsonian Magazine*, March 2000, 119.

26. Camilo José Vergara, *American Ruins* (New York: Monacelli Press, 1999), 99. For

another discussion of the ways that people have reacted to enormous economic and social dislocations wrought by late twentieth-century deindustrialization, see Lizabeth Cohen, "What Kind of World Have We Lost? Workers' Lives and Deindustrialization in the Museum," *American Quarterly* 41, no. 4 (December 1989): 670–81.

27. David Lowenthal, *The Past Is a Foreign Country* (Cambridge: Cambridge University Press, 1985).

28. Watson, "A Unique Home for Cutting Edge Art," 117.

29. MASS MoCA was constructed for approximately $70 per square foot, while the Guggenheim Bilbao cost $300 per square foot, the New York Museum of Modern Art's addition is projected at $600, and the Getty Museum required $1,000 per square foot (in 1999 dollars). For additional cost information, see Charles Giuliano, "MASS MoCA: The Phoenix Rises in North Adams," *Art New England* 21, no. 1 (December 1999–January 2000): 82.

30. For the interview with Robert Rauschenberg, see Craig Wilson, "MASS MoCA: Not Your Run-of-the-Mill Museum," *USA Today*, May 21, 1999, 8D.

31. MASS MoCA's historic brick buildings incorporate state-of-the-art digital and fiber optic networks, as well as new media technologies for making and performing art. These systems are not concealed but visibly layered on the existing conditions.

Looking at LeWitt: Notes on the "Open" Aesthetic Experience

SANDA ILIESCU

Surprising things happen when we look at art. A painting or drawing that moves us brings us into a world not only of forms and colors but also of feelings and ideas. What we see on the canvas or drawing paper enters our consciousness and reacts there with our innermost thoughts. At times, certainly, art can leave us indifferent, bored, or merely entertained. But it can also fill us with profound emotion, with "a motion of the heart and of the imagination," as John Berger writes in his 1985 essay "The White Bird."[1]

Such responses to art are not, strictly speaking, aesthetic; they concern neither direct sense perceptions nor formal artistic concepts. Instead, they touch on other realms of feeling, thought, and experience inside us. Occasionally such responses are colored by our values and beliefs, as when a work of art—let us say, Picasso's Spanish Civil War painting *Guernica* (1937)—arouses our sense of injustice in the world. The painting confronts us with the spectacle of war. As we contemplate the human race's enormous capacity to inflict suffering, we might feel anger, sorrow, or helplessness. What could be more heartrending than the mother's frozen scream amid that tangle of bodies, dying or panic-stricken, as she cradles the limp form of her dead child? On the other hand, we can experience a sense of hope when an artwork offers us a glimpse of human dignity or empathy. In Rembrandt's painting *The Return of the Prodigal Son* (1669), the old man's frail hands rest on his ruined son's back and reach toward the young man's scarred feet. The

Pablo Picasso, *Guernica*
(detail), 1937. Oil on canvas,
137 1/2 x 306 in.

unexpected beauty of this embrace suggests the possibility of other recon-
ciliations: a sense that deep wounds and terrible wrongs might be, if not
healed, then pitied. We might feel that human beings are not entirely adrift,
that there is genuine compassion in our world.

These are ethical sentiments. That part of us that considers what is right
and wrong, good and bad, is engaged. Mentioning ethics in the same breath
as art can be a troubling proposition, however. History teaches us that much
can go wrong when we confuse what is beautiful and what is good. All too
often the arts have been twisted and perverted in the name of some dubi-
ous "ethic." I myself grew up in a communist country, on a steady diet of
state-sponsored art. Plays, movies, and childhood stories demonstrated cer-
tain "right" ways of behaving. The ant in Aesop's fable was the good socialist

worker, while the cricket was a repugnant parasite. As a child I desired to be like the ant and dreaded slipping into cricketlike ways. I feared becoming lazy and learned to doubt the value of free, purposeless play. Art had made me a captive of an ideology.

Advertising in the West instills different fears and obsessions. When I came to America as a teenager, the luscious images I saw everywhere thrilled and enchanted me but filled me with doubts about myself. Magazines, billboards, and television taught me I could never be thin, pretty, or stylish enough. Like the communists' recasting of Aesop's fable, advertising saddles aesthetics with a singular message and purpose. It aims to convey the idea that certain beautiful presentations represent things that are so "good" and so well-suited to our needs that, to ensure our happiness, we must consume them.

While visual art is very different from advertising or propaganda, it is susceptible to similar dangers. Each of the two paintings I mentioned earlier has an explicit story and even a message. This message may easily dominate: *Guernica* could be viewed as an antiwar poster and *The Return of the Prodigal Son* as a pious illustration. As such interpretations take hold, we may forget to look deeply and attentively. Rembrandt's iridescent layers of transparent light and dark paint, or Picasso's intricately placed shapes and rhythmic arrangements recede: these silent, nonverbal perceptual qualities seem after all secondary to the larger human drama told by the story. Under the spell of the story we may forget to see and touch, or to question and experience. We become less engaged with the surfaces at hand, and we no longer look at what they actually offer us—the cracks in the old paint, the dirty feet, the screaming horse. The "message" smoothes and blurs these things, making them less palpable or shocking. It is after all so easy to feel gratified at having understood the scene and "gotten" the story.

In the 1830s painter Eugène Delacroix proposed that the best way to judge a painting was to squint away the specific subjects represented in it in order to perceive its musicality.[2] "There is an emotion peculiar to painting, of which nothing in [literature] can give an idea," wrote Delacroix in his journal. "There is an impression that results from a certain arrangement of colors, lights, shadows, and so forth. It is what one might call the music of the painting. Before you even know what the painting represents . . .

Rembrandt Harmensz van Rijn, *The Return of the Prodigal Son* (detail), 1668–69.
Oil on canvas, 104¼ x 80¾ in.

you are conquered by this magical accord."[3] For European painting this may have been a radical first step toward abstraction: toward questioning and eventually dispensing with art's requirement to represent specific subjects or scenes.

The term *abstract* is unfortunate, for it suggests remoteness, recalling, for example, the lack of detail in the abstract of an essay, or the disembodied intangibility of an intellectual abstraction. Yet such remoteness or lack of physicality was precisely what many modern artists wished to avoid.[4] In eliminating the narrative—the representation of a story or scene—modern artists sought to root themselves firmly in the visible and tangible forms of the painting itself. Freed from having to imitate the appearance of specific subjects, painting would be freed from the necessity of conveying particular moral messages. No longer so distracted, viewers and artists could contemplate the qualities of the painting itself: its inner logic or visual "musicality," its play of shapes, textures, and colors. These qualities in a work of art are so directly accessible to the senses, so visceral and palpable, that they may well be called "extraordinarily real" rather than abstract.[5]

Yet this focus on the artwork's "real" and tangible qualities could also lead to art that is disconnected from life outside the studio or museum and incapable of addressing the problems of human existence. In resisting conventional representation, art is free to become truly independent; but it is also free to dedicate itself to nothing more than the production of interesting patterns that delight our senses, or formal games that amuse our intellect.

Abstract art, then, has always held out both great promise and great risk. Can something that has no story or overt message to offer bear relevance to our lives, for example, to our sense of what is good and bad, appropriate or inappropriate? Without a legible narrative, can art arouse profound feelings in us such as anguish, hope, or joy? Can nonfigurative art touch us as profoundly as certain representational pieces like the paintings of Picasso or Rembrandt? In short, can abstraction retain art's capacity for broader meaning in our lives?

I will argue in this chapter that the answer to these questions is yes, that abstract art need not become self-absorbed or dryly formalist but rather that such art can move us in ways that are not purely formal or perceptual but that simultaneously engage our ethical sensibility and our social and political

conscience. I will focus on the work of artist Sol LeWitt and in particular his 1975 composition *Wall Drawing #260*. Starting with my own experience of this work, I will attempt to show more generally how an abstract artwork that communicates no overt narrative message may nevertheless, through the action of certain powerful perceptual elements, occasion in the viewer an experience rich in thought and emotion, one that is also filled with a sense of value and meaning.

That looking at a LeWitt wall drawing—with its conceptual thrust and simple, methodically painted shapes—could entail a varied and in a certain sense transparent mix of sensations may strike some as surprising. I will argue, however, not only that work as abstract and conceptual as LeWitt's is not experientially reduced or "closed" to a viewer's imagination but that it can in fact be experienced as a fundamentally "open work."[6] Through their very neutrality and refusal to advocate a specific interpretation, LeWitt's systematic, nonillusionistic, unexpressionist forms become open to a wider range of allusions and associations. Rather than fixing meaning in its form, LeWitt's art becomes a sort of pathway to a series of unfolding individual reflections. The ascetic precision and directness of LeWitt's wall drawings reveal the extraordinary capacity of aesthetic forms to be both intentional and fluidly engaged with particular places and unique human situations.

The analysis that follows, however, is as much about the aesthetic experience of the viewer as it is about LeWitt's particular composition. Specifically, I suggest that just as in creating his wall drawings LeWitt consciously moved beyond certain existing notions of how art "should" be made, the viewer of art may enrich his or her perceptions by looking beyond traditional ideas of how art "should" be viewed. In focusing on the experience of the viewer, I suggest that art is best understood not only as an object to assess but also as an experience to understand.[7] Like all human experiences, aesthetic experiences include many distinct yet interrelated components, such as sense perceptions, logical thoughts, feelings and memories. Our judgments about the world—our ethical sensibilities—inevitably come into play. Ideally, I will argue, such connections between aesthetic and ethical qualities of experience are not compelled by the artwork but rather are voluntary and free: to be imagined (or not) by each individual viewer according to his or her own unique sensibility and view of the world.

Wall Drawing #260

The starting point for all systems of aesthetics must be the personal experience of a peculiar emotion.—Clive Bell, *Significant Form*

I noticed the brightly colored postcard announcing the LeWitt show by chance, while waiting for an elevator in Rome, where I was living at the time. That evening someone mentioned the exhibit over dinner and handed me a page torn from an Italian train schedule: "It's in Paliano, in an old school, I think. Not far, you can take the train." I did not plan to go at first. I was not that interested in LeWitt's work and was busy with my own at the time. A few days later, however, Rome grew intensely hot, and the two fans in my studio brought irritating, whirring sounds but little relief. Exhausted, I packed my backpack and headed for the train station.

The trip to Paliano, a town thirty miles east of Rome, was longer than expected, and I arrived thinking I should not have come after all. The old school, however, offered a refuge from the heat. The large, rambling structure had concrete floors, thick masonry walls, and shuttered windows. The building was not air-conditioned, yet with the exception of a stairway facing south, it was refreshingly cool inside. There were no other visitors. For a while I wandered about, eventually coming to an inner, windowless room. Indirect light from an adjacent room filtered in through an archway. The walls of both rooms had been painted almost completely black. Through the darkness I saw a sparse pattern of thin white lines. This was *Wall Drawing #260*. There were no chairs, so I sat on the floor and looked at the walls. After a while, I had a thrilling sensation of having discovered something, something in myself but also tied up with the room and its walls. I felt a quiet sort of happiness I can best describe as a sense of hope.

How and why did *Wall Drawing #260* move me? The drawing had the same floating, dancelike quality as Matisse's late monumental collages and Brice Marden's *Cold Mountain* paintings. I realized, however, that LeWitt had rejected Matisse's color in favor of line and turned away from Marden's expressiveness to a neutral geometry. Perhaps, I thought, this drawing on walls was a way to make art that was even simpler than cutting colored paper shapes with scissors, as Matisse had done. Perhaps, too, this was a way

to reduce and lay things bare—to strip art of all lingering nostalgia, for example, the sentimentality of Marden's choice to emulate Chinese calligraphy by drawing with long twigs dipped in ink.

These reflections soon gave way to memories of geometry lessons and my grade school classroom, a rectangular room in a prefabricated concrete building with evenly spaced rows of seats. Partly it was the feeling of Paliano's schoolhouse that evoked these memories, and partly it was LeWitt's crisp, methodical drawing. Like chalk marks on a blackboard, LeWitt's lines looked smooth from afar, but rough and uneven up close. Yet this room's darkness was blacker and larger than a chalkboard's, and these walls seemed stranger and more massive than any classroom's. They brought to mind an impossible, fantastical landscape from my past: an image from my childhood in Romania conjured up by the phrase *Cortina de Fier* (the Iron Curtain). As a girl I had envisioned a curtain literally made of iron, extending endlessly and never moving. It was a frightening thing to imagine, and I feared that I would never be able to cross it. The rough blackness of the walls also gave me a sinking feeling, suggesting poverty and deprivation. In contrast, the delicate white lines seemed to fly and dance about, almost like birds. They struck me as free and hopeful, as I had once wanted to be.

I realized next that the black LeWitt had chosen for the walls was too perfectly colorless to recall any tangible material (such as slate or iron). A neutral, unbiased absence of color, it was simply darkness, unencumbered by real weight and material associations. For a while I imagined it as a void. Then this perfect emptiness gave way to another image: a dark forest with geometric white branches. The forest was at once mysterious and rational: perhaps it was not a forest but a grove carefully planted by human hands. I knew, more or less, how I might go about reconstructing its black territory and tracing its white branches. After painting the walls black, I would subdivide them into equal squares with thin graphite lines; in each square I would use a crayon to draft a combination of two white lines: corner arc and median arc, corner arc and straight diagonal, corner arc and wavy diagonal, corner arc and dashed diagonal. As I saw the drawing's thin, silvery construction lines and grasped its geometric economy, I felt the peculiar joy one experiences as a child upon solving a puzzle or mathematical problem,

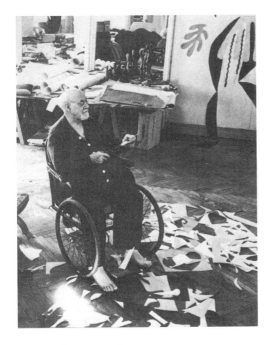

Matisse in his Nice studio, 1952 Brice Marden in his studio, 1992

when the answer becomes an immediate and "sensible" thing. The distance
between thinking and feeling seemed to vanish.

On the train home I considered the fact that *Wall Drawing #260* would be
whitewashed and Paliano's dark forest/grove would vanish. I remembered
that in my fifth-grade geometry class it had been my job to clean the black-
board with a wet rag, a task that often felt both satisfying and slightly dis-
tressing (satisfying because it seemed so empowering; distressing because
I could wipe out in a second what might have taken hours to construct). I
said to myself, LeWitt's drawing is so simple it will be re-created soon some-
where else, perhaps in another school. In this way the wall drawing seemed
to offer another kind of hope. Because it was deep down more an idea than a
thing, this "idea-drawing" could outlast its material form.

Like a scribble or a chalkboard drawing, LeWitt's drawing had a light

Sanda Iliescu, *Sketchbook drawing:*
September 6, 1994

Opposite page: Sol LeWitt, dia-
gram for *Wall Drawing #260:*
All Combinations of Arcs from
Corners and Sides; Straight Lines,
Not-Straight Lines, and Broken
Lines, 1973. Pencil on paper, 30 in.
x 22 in. Drafted by Hana Kim
(2007) after Sol LeWitt's
original 1973 drawing

touch: it was simple as an idea and ephemeral as an artifact. In contrast,
Paliano's walls were massive. It was hard to believe that a drawing so over-
whelmingly dark and painted with such opaque black paint could also be so
playful and so luminous. This paradox recalled for me Aristotle's peculiar
theory of colors. In *De sensu and de memoria* Aristotle had argued the strange
notion that appropriate mixtures of just two fundamentals, black and white,
could produce all the colors of the rainbow.[8] Yet by *melas* Aristotle meant not
just "black" but the darkness of such things as freshly plowed earth, the sea,
wine, and blood; *leukos* was not just "white" but the radiance of substances
such as snow, ivory, sand, and clear water.[9] *Melas,* the essence of darkness,
relates to our "melancholia," while *leukos* suggests the essence of light, lu-
minosity and perhaps lightheartedness. The impression I had felt upon first
seeing *Wall Drawing #260*—of both fragility and permanence, of something
that is floating and light alongside something that is heavy and unmoving—
resembled for me Aristotle's impractical yet perhaps "sensible" theory. Like
it, LeWitt's *Wall Drawing #260* is sparse yet also infinitely suggestive, brood-
ing and yet also hopeful.

ALL COMBINATIONS OF ARCS FROM CORNERS AND SIDES,
STRAIGHT LINES, NOT-STRAIGHT LINES + BROKEN LINES.
REDRAWN BY HANA KIM, FEB 23 2007,
AFTER SOL LEWITT, AUG 29. 1973.

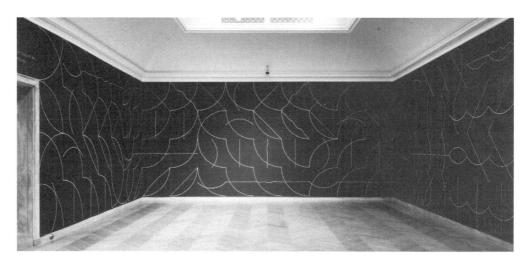

Sol LeWitt, *Wall Drawing #260*, 1975. White crayon on black wall. Installation at the Addison Gallery of American Art, Phillips Academy, Andover, Massachusetts, 1993

Seven Principles of the Open Aesthetic Experience

As I consider *Wall Drawing #260*, it is clear that my experience of it depended to a great extent on my openness to both the artwork and its surroundings. On that particular day I was able to see, touch, hear, and smell the room around me, and to imagine connections between this sensory experience and my own life experiences, judgments, and memories. In other words, my experience was not founded on my perceptions of visual forms alone but unfolded like a conversation between LeWitt's composition and me, or between art and life. From this preliminary observation, I will draw several brief conclusions or principles of the "open" aesthetic experience generally.

1. Aesthetic experiences awaken all our sense perceptions. It is impossible for me to imagine having been moved by LeWitt's *Wall Drawing #260* had I only "seen" it. Nonvisual sensations profoundly affected how and what I saw—the sounds of my own footsteps against the room's quietness, a sensation of coolness juxtaposed to the memory of heat outside, the walls' rough textures next to the scent of old, dank masonry. The massive presence of the

Sanda Iliescu, *Sketchbook drawing: September 6, 1994*

schoolhouse walls mattered, and so did the knowledge that, like other every-day walls, they would be whitewashed one day.

"A blind man can make art if what is in his mind can be passed to another mind in some tangible form."[10] LeWitt's statement is neither a dismissal of visual perception nor a simple argument for art's mental rather than physical apprehension. It is a view of art in which the "tactile" and other senses rise to the level of the traditionally dominant "visual."

The idea that blindness can have exciting aesthetic consequences did not originate with conceptual or even modern art. In his classic manual *The Natural Way to Draw*, Kimon Nicolaïdes featured a clay sculpture by Clara Crampton, an artist blind since birth.[11] Constantin Brancusi's *Sculpture for the Blind* was first exhibited inside an opaque sack with sleeves through which viewers could pass their hands to touch the smooth, ovoid form within.[12]

Like Brancusi and Nicolaïdes, LeWitt explores the nonvisual potential of visual art. His way of making art "blindly" is by inventing logical, systematic procedures for generating visible and tangible forms. His art, in the process, reaffirms the meaning of sight by eliminating visual clichés. Our ideas of

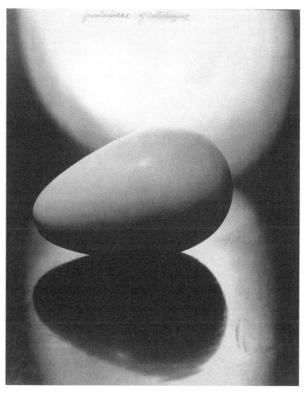

Clara Crampton, *Violin Player*

Constantin Brancusi, *The Beginning of the World,* ca. 1920. Gelatin silver print

beauty are challenged but also rejuvenated. Drawings such as LeWitt's can surprise and delight us with the "look" of a drawing made according to a nonvisual plan.

 2. Aesthetic experiences include logical and practical thoughts. For *Wall Drawing #260* LeWitt specified a collection of twenty different arcs and lines that, matched two at a time in each square of an extended grid, would produce 190 unique two-part combinations. The drawing was then executed not by the artist but by assistants according to the artist's diagram, as builders might construct a building following an architect's plan. Although this system was rational in the extreme, the drawing was surprisingly fresh and aesthetically exciting. My eyes followed constantly changing pathways across squares:

two adjoining arcs formed a large half-circle; several diagonals lined up, creating an extended curving pathway; four curves wrapped around a corner, linking one wall to another and reaching toward the doorway.

The critic Lucy Lippard suggests that in LeWitt's work the senses and rational thought may overlap.[13] Some of LeWitt's mute, inexpressive, not-pretty, nearly-nothing-at-all drawings fail almost to enlist our senses. Yet they are not "mere illustrations" of conceptual ideas.[14] Next to the space displaying *Wall Drawing #260* at Paliano, a small doorway led to a tiny chamber that seemed an empty closet, not part of the exhibit. Yet, as my eyes grew accustomed to the darkness, I began seeing the delicate, impossibly thin lines of a gray-on-black wall drawing. I "saw" lines and shapes partly because I understood their rational arrangement. Visually, the composition was on the verge of vanishing, existing on the precarious edge between perception and conception.

3. *Relationships between forms matter more than forms; such relationships extend to an artwork's surrounding environment.* At Paliano I was moved by a web of relationships connecting LeWitt's lines to each other and to forms and events outside the drawing. I perceived an arc not by itself but in relation to architectural elements such as a corner or doorway; I saw blacks and whites not in isolation but as interdependent; I enjoyed the room's quietness not in itself but in its contrast to the noise of Rome and memories of my two whirring fans. What mattered was not any one of these things, but their surprising abilities to compose what John Berger called a "field event."[15]

Formally, LeWitt's drawing is itself a nonhierarchical field within which no one element gains perceptual or conceptual dominance over another. The grid gives equal emphasis to horizontals and verticals, and each square receives no more and no less than two lines. *Wall Drawing #260* has no articulated center and no margins or periphery; the composition avoids hierarchies. In abstract paintings by Pollock, Rothko, or Brice Marden, the edges of the canvas form poignant in-between zones mediating from pictorial inner space to the outside space of wall, room, and viewer. In contrast, LeWitt's white lines employed no such transitions. They inhabited the same dark room in which I stood. Neither illusions nor allusions to any one thing, they challenged the very idea of a difference between an inner "artistic" world and an outer "real" architectural world. Like a door or window,

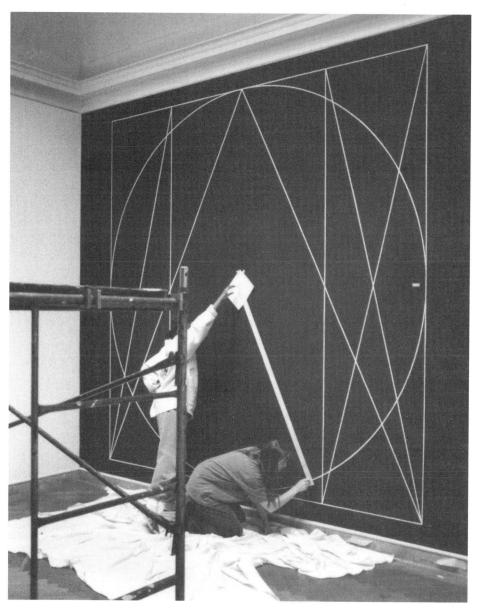

Students at work on the installation of Sol LeWitt's *Wall Drawing #295* at the Addison Gallery of American Art, Andover, Massachusetts, 1993

they did not represent but remained simply and merely themselves. I say "merely" because my perception of connections, rather than isolated events, was so strong that forms became unimportant in themselves. In his 1967 "Paragraphs on Conceptual Art" LeWitt wrote, "The form itself is of very limited importance . . . [the] arrangement becomes the end."[16]

4. Aesthetic experiences extend beyond the boundaries of "art." What distinguishes aesthetic experiences is the degree of interaction between one's perceptions, memories, and imagination, not the type of objects or events being considered. That *Wall Drawing #260* belonged to a distinctly artistic realm, a realm whose traditions I value, undoubtedly enhanced my experience. Yet many nonartistic things moved me that day: for instance, the school's glass and concrete stairway, which was filled with sunlight, formed a striking counterpoint to the dark, cool inner rooms. It is possible that nonartistic impressions—for example, climbing that hot, sunlit stair, or seeing, on my way to the train station, the flight of a flock of tiny swallows against a clear, luminous sky—enriched my experience of LeWitt's artwork.

As a specialized, professional realm, art is supported by people (artists, curators, the public) and institutions (schools, museums, publications). It does not, however, hold a monopoly on the aesthetic experience. A sunset, the sea's horizon, a child's face—the beauty of these things can move us profoundly, suggesting that we cannot reduce aesthetics to art. Once labeled "art," even the most casual of gestures becomes bound by professional expectations and methods of evaluation. Aesthetic experiences are "bound" in their own way, but less to cultural institutions and more to specific social and physical contexts and individual sensibilities. This different sort of binding renders aesthetics less culturally restrictive than art and more open to possibility.

5. Aesthetic experiences are purposeless yet rich in productive and beneficial consequences. My trip to Paliano had no predetermined goal: I went out of boredom and a vague feeling of restlessness. I did not anticipate being enlightened or achieving anything in particular. The encounter was a bit like a gift, something unexpected and free. Like Paul Klee's description of a drawn line in his *Pedagogical Sketchbook,* my experience was an "active line on a walk, moving freely, without goal"; it was a "walk for a walk's sake."[17]

While lacking a preconceived or practical purpose, my journey was

rich in results. I experienced hope and joy and remembered long-forgotten events from my childhood. In other words, it brought a measure of meaning to my life. Although "impractical," then, aesthetic experiences have a unique value and usefulness in our lives. Consider, for example, a walk as an aesthetic experience. Such a walk is not just physical exercise (although it can be that), and it is not getting one's body from point A to B (again, it may accomplish this as well). Unconstrained by any one predetermined purpose, the aesthetic walk is open to all such potentials but also to other unforeseen possibilities.[18] Not all walks become aesthetic experiences: some remain unremarkable, while others become significant experiences. What makes the difference is the extent to which the landscape around us awakens our internal landscape of thoughts, feelings, and memories. These intersections might be felt in certain peculiar ways, rendering the landscape of our walk, and our selves within it, comprehensible as well as movingly tangible. "In my room the world is beyond my understanding," wrote Wallace Stevens in his poem "Of the Surface of Things." "But when I walk I see that it consists of three or four hills and a cloud."[19]

6. *Each aesthetic experience is unique and tied to a specific place, time, and individual.* On September 6, 1994, my childhood memories were awakened as I looked at LeWitt's wall drawing in Paliano. This experience will not happen again, for, like all things, I am changing. Even if all the conditions of that day were re-created (the heat, train ride, dank smells of walls), I would not again make those same exact connections between forms and meanings. To claim that *Wall Drawing #260* reflects a vision of an iron curtain or ideas of freedom or imprisonment would be foolish. Similarly, to say that LeWitt's lines are like branches of a geometric grove would not be universally applicable. These things were only true for one person at one particular moment in time.

"Even if the same draftsperson follows the same plan twice," wrote LeWitt in 1971, "there would be two different works of art. No one can do the same thing twice."[20] Similarly, no one can have the same aesthetic experience twice. It may be that, for certain viewers, certain art tends to generate the widest range of potential responses. For example, some nonmimetic, nonrepresentational art might foster wider ranges of unpredictable experiences. In this sense, *Wall Drawing #260* reflects Umberto Eco's paradigmatic

"open work," a purposefully neutral composition encouraging viewers to invent, imagine, and choose for themselves. Although at Paliano I envisioned lines as immovable folds of an iron curtain, LeWitt's drawing resists any one closed narrative and denies any fixed links between forms and narrative meanings. Its lines remain simply and only themselves—open to the widest possible range of interpretations.

7. *Aesthetic experiences slow down our sense of time, allowing memories and immediate perceptions to mingle.* Unlike chronological time, which is concerned with actions and consequences and resembles the trajectory of a well-aimed line, aesthetic time is akin to a broad and layered surface in which present (what is seen, touched, smelled, tasted, heard) and past (what is remembered) are embedded. Past and present overlap, neither serving or being summoned for the sake of the other. Time becomes less a singular pathway we follow and more a textured surface we touch.

The aesthetic experience is like a drawing composed of many lines. Some lines seem bound for certain destinations, while others meander. Some may be distinctly practical, while others are purely sensual. Yet in a drawing, a single line can have multiple meanings: it may be seen as simultaneously a figure (a black mark floating against a white background) and a boundary (an edge between two adjacent white shapes). Similarly, on the aesthetic surface each thought, idea, or emotion may act in multiple ways: it may summon memories, heighten our senses, or question our beliefs and attitudes. The perceiver is no longer merely an isolated or static self, but a self on the verge of changing.

Art for Life's Sake

To sum up: aesthetic experiences are free and spontaneous.[21] They concern our awareness of relations between objects more than objects themselves, and they are influenced by our life patterns, education, and beliefs. Such experiences involve all our senses, our memory, and our powers of reason. What we conventionally call "art" is only a subset—to be sure, an especially rich and valuable one—of a much wider field of aesthetic possibilities. The most homely objects and places can occasion aesthetic experiences.

In this vision of the aesthetic experience, aesthetics and ethics may, and ideally do, complement one another but also remain essentially distinct.

Sol LeWitt, *Ten Thousand Lines about 5" Long, within a 7" Square,* 1971. Pencil on paper, 11½ x 11¼ in.

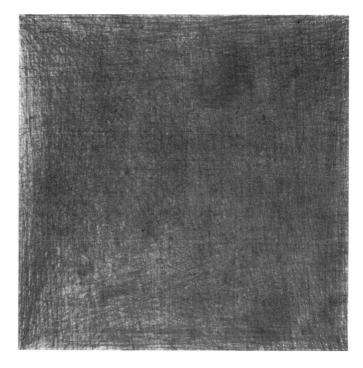

They are like two overlapping planes of glass, one blue, the other yellow. Their transparent superimposition results in a new quality of "greenness," that composite of ethics and aesthetics that can move us so much. Yet while experiencing shades of "greenness" we are also simultaneously aware of the contingent, fluctuating nature of this experiential convergence. The blue and yellow planes remain free to be considered separately, each in its own terms. Their overlap, however, also enriches our awareness of each plane: for instance, next to perceptions of greens and yellows, the blue becomes richer and more capable of certain depths, perhaps a denser blue tinged with violets or green blacks.

Far from obscuring distinctions between ethics and aesthetics, an aesthetic encounter of the kind I am describing may enhance our awareness of these two planes of our consciousness. For instance, ethical sentiments may challenge aesthetic notions of what we consider beautiful. They may

Sol LeWitt, *Lines Not Straight, Not Touching, Drawn at Random, Uniformly Dispersed with Maximum Density (Wall Drawing #73)*, 1971. Installation at the Lucy Lippard Residence, New York. Pencil on brick wall, 216 x 319 in.

help us discover new ways of making and appreciating not only art but the physical places we inhabit—the rooms, hallways, and backyards sheltering and shaping daily life. For example, the ideal of a democratic community in which each person has equal rights and responsibilities might suggest a new way of looking at *Wall Drawing #260*. An egalitarian visual field, the drawing rejects hierarchies and insists that every element be as important as every other.[22] LeWitt's unwavering formal equivalences, his refusal to privilege any one particular color or shape, might in turn illuminate the beauty of other nonartistic events. We might, for instance, begin to enjoy and value other such egalitarian visual fields in our daily life: for instance, the tiled black and white floor of a bathroom or an open meadow of common grasses interspersed with wildflowers.

If it is fairly clear that ethical ideas can enrich aesthetics, how aesthetics may deepen our awareness of ethics might seem a more difficult question.

Certainly it is possible to argue that aesthetic presentations can cloud our ability to choose thoughtfully between right and wrong; we need only consider the problem of Nazi propaganda art or manipulative advertising campaigns to see what a negative potential aesthetics holds for ethical thought. Must it necessarily be so, however? Or, to put the question another way, can't aesthetics contribute something of value to our lives?

Again, I am reminded of my childhood in Romania. Under Communism, Romanians managed to resist official myths by telling jokes and injecting humor into everyday gestures. A Bucharest bus driver who liked to listen to stories on Radio Free Europe would occasionally turn up the volume on his radio so all his passengers could hear the antigovernment jokes being aired. Some folks smiled knowingly while others laughed out loud, unaware of the jokes' dangerous source. Eventually all would begin to laugh, some at this very discrepancy in responses, and some for the pleasure of laughter. The jokes on the radio, which were also propagandistic only anti- rather then progovernment, no longer mattered. Laughter would fill the bus. It was an aesthetic experience, devoid of explicit utility, yet filled with life's promise as well as an awareness of its troubles. Shared laughter became an act of political resistance, as well as a way to face each "other." Yet the bus driver's act of defiance could also be regarded as reckless. Did he have the right to endanger himself and his passengers? Does the artist, much as Chris Burden did in his 1971 *Shoot* performance (in which a friend shot him in the arm with a .22-caliber rifle), have the right to endanger or even inflict harm for the sake of art?[23]

It has always been difficult to say "no" to unjust power, whether totalitarian or capitalist. All around us, the "beautiful" and the "good" are so skillfully manipulated that it is difficult to maintain the habit of choosing thoughtfully and deciding freely whether an appealing surface represents something useful, fair, or appropriate in a particular circumstance. Certain kinds of aesthetic acts and experiences can remind us of our freedom, however. Like the people on the Bucharest bus, we may want to welcome such experiences. We may need to laugh more, laugh not only to dismiss manipulation and force but to preserve the realm of our lives that is beyond such manipulation. Although aesthetics may not trump ethics, art does after all

have a deeply ethical role in helping us to see our world both for what it is and what it could be.

Notes

This essay is dedicated to the memory of my mother, Zorica Vasiloiu (1934–2004).

1. John Berger, "The White Bird," in *The Sense of Sight* (New York: Vintage Books, 1993), 7.

2. The critic Dore Ashton refers to Delacroix's notion of "musicality" in her 1977 essay on the work of Robert Slutzky. See Ashton, "Poetics of Deductive Painting," in *Robert Slutzky: Fifteen Paintings, 1980–1984* (San Francisco: Modernism Gallery, 1984).

3. Baudelaire glosses Delacroix's passage as follows: "The appropriate way to determine whether a painting is melodious is to look at it from a distance so as to be unable to comprehend its subjects or its lines. If it is melodious, it already has a meaning and has taken its place in the repertory of memories." Both Baudelaire's and Delacroix's quotations come from *Symbolist Art Theories: A Critical Anthology*, ed. Henri Dorra (Berkeley: University of California Press, 1994), 3.

4. "The type of emotion peculiar to painting is, so to speak, *tangible*," wrote Delacroix in his 1853 journal. See *The Journal of Eugene Delacroix*, trans. Walter Pach (New York: Crown, 1948), 336.

5. I am indebted to Nathaniel Coleman and his essay in the present volume for the phrase "extraordinarily real."

6. For the concept of the "open work of art," see Umberto Eco, *The Open Work* (Cambridge, MA: Harvard University Press, 1989).

7. Asked in a 1993 interview, "Should art have a social or moral purpose?" LeWitt responded, "No, artists should have a social or moral purpose." Since ethics concerns human actions, motivations, and intentions, "art" as inanimate, fixed form cannot be evaluated ethically. Only when considering art as human experience can we open the possibility for ethical-aesthetic relationships. See Andrew Wilson, "Sol LeWitt Interviewed," *Art Monthly*, March 1993, 9.

8. Aristotle, *De sensu and de memoria*, trans. G. R. T. Ross (Cambridge: Cambridge University Press, 1906), 57, 59, 69.

9. In contrast to our familiar ROYGBIV spectrum, Aristotle arranged visible colors according to their intrinsic darkness, progressing from yellow (the closest to white), through medium reds and greens, to dark blues and violets. For a summary of Aristotle's color theory, see Alan Shapiro's "Artists' Colors and Newton's Colors," *Isis* 85 (1994): 600–630.

10. Sol LeWitt, in a 1981 interview with Andrea Miller-Keller, in *Sol LeWitt: Twenty-Five Years of Wall Drawings, 1968–1993*, exhibition catalog, Addison Gallery of American Art and Phillips Academy, Andover, MA (Seattle: University of Washington Press, 1993), 37.

11. Kimon Nicolaïdes, *The Natural Way to Draw: A Working Plan for Art Study* (Boston: Houghton Mifflin, 1941), 6–7.

12. It is uncertain whether Brancusi intended this sculpture to be touched only, or seen as well as touched. According to Henri-Pierre Roche's recollection, the work was exhibited in a sack with "sleeve-holes for hands to pass through" in the 1917 Society for Independent Artists Exhibition in New York. See *Constantin Brancusi: 1876–1957*, exhibition catalog (Philadelphia: Philadelphia Museum of Art, 1995), 180–81.

13. Lucy Lippard, "The Structures, the Structures and the Wall Drawings, the Structures and the Wall Drawings and the Books," in *Sol LeWitt*, ed. Alicia Legg, exhibition catalog (New York: Museum of Modern Art, 1978), 15–20.

14. Although the critic Donald Kuspit described LeWitt's drawings as "mere illustrations" of conceptual ideas, it is more accurate to see them as "perverse visual provocations," as suggested by Lippard. Donald B. Kuspit, "Sol LeWitt: The Look of Thought," *Art in America* 63, no. 5 (September–October 1975): 43.

15. John Berger, "Field," in *About Looking* (New York: Random House, 1980), 199–205.

16. Sol LeWitt, "Paragraphs on Conceptual Art," *Artforum*, June 1967, 79–83.

17. Paul Klee, *A Pedagogical Sketchbook,* trans. Sibyl Moholy-Nagy (London: Faber and Faber, 1953), 16.

18. Francesco Careri, *Walkscapes: Walking as an Aesthetic Practice,* trans. Steve Piccolo and Paul Hammond (Barcelona: Editorial Gustavo Gili, 2002).

19. Wallace Stevens, "Of the Surface of Things," from *Harmonium* (1923–31), in *The Collected Poems* (New York: Vintage Books, 1990), 57.

20. Sol LeWitt, "Doing Wall Drawings," *Art Now,* June 1971.

21. I am indebted for the expression "Art for life's sake" to Donald Sherbourne's "Meaning and Music," *Journal of Aesthetics and Art Criticism* 24 (1966): 583.

22. For LeWitt, "Each individual part [is] equally important, and all parts [are] equal." Wilson, "Sol LeWitt Interviewed," 3.

23. Howard Singerman discusses Chris Burden's *Shoot* in his chapter in this book.

The last section "open works" is a series of case studies: AN ABANDONED STEEL WORKS in Germany turned public park, an shuttered factory in N. Adams MASS turned into MASSMOCA, AND a reflection on the openness of art illustrated in the work of Sol Lewitt. Though each essay touches on ethics, they do nothing to advance a theory of interaction in any way. If anything, they all draw on and illustrate the Critique of Judgment. It is mostly in the "practitioners" not the "theorists" molds. The question this book raises is not, can practitioners and theorists coexist? Clearly, they can. The Question is, what do they learn from

Afterword: Replacement

W. G. CLARK

Architecture, whether of a town or a building, is the reconciliation of our-
selves with the natural land. At the necessary juncture of culture and place,
architecture seeks not only the minimal ruin of landscape but something
more difficult: a replacement of what was lost with something that atones
for the loss. In the best architecture, this replacement achieves an intensifi-
cation of a place: landscape emerges no worse for human intervention, and
culture's shaping of a place to specific use results in a heightening of the
beauty of the landscape. In these places we seem worthy of existence.

We don't know why we are here on this earth. We do know, from the
most primitive to the most sophisticated among us, that our presence here
is probably harmful, an imposition. That knowledge causes us to want to
assuage the fouling and killing aspects of our existence in order to simply
be at some ease with our occupation. We want to belong rather than only
use. Sick at killing the cow, yet having to eat, we make rules of propriety and
economy governing the slaughter. We must eat the whole cow; we may not
kill extra cows; we may never take pleasure in the kill. In a bare existence,
economy is necessary for survival. But it is also, in any existence, an ethical
act that regrets the taking; imposing itself as a respectful, if insufficient, act
of atonement.

In terms of settlement, we are only comforted when we see evidence
of the necessity to occupy. So we are pleased by a settlement based on

one another?

cultivation where, at least to our minds, we offer the economy of cultivation as an assuagement of the inevitable destructive result of habitation. We are also pleased by deference to the landscape in the places we refuse to occupy, the places we save from ourselves. We vacation in those places, where we have either left the earth alone or have engaged it in a way that is satisfying, where there are the fewest needless and senseless acts to represent our being. In our towns and in our isolated buildings we search for this deference and economy. We want civilization to be a good thing. We want our habitats and artifacts to become part of the place and to substantiate our wish to belong. We want our things, like those of the civilizations we admire, to form an allegiance with the land so strong that our existence is seen as an act of adoration, not an act of ruin. We are only happy where this occurs, where we have managed to make something to replace what we have taken. Always, we must start from that initial, crucial, puzzling recognition: that we are seeking justification through deference—and failing that, through economy and respectful use. That is why farms, barns, and silos always seem appropriate and beautiful. That is why we like pigpens and deplore theme parks, because it is not necessary that buildings be beautiful, but it is necessary that they be necessary.

There was a mill near my hometown. It was a tall timber structure on a stone and concrete base that held the waterwheel and extended to form the dam. One did not regret its being there, because it made more than itself; it made a millpond and a waterfall, creating at once stillness and velocity; it made reflections and sound. There was an unforgettable alliance of land to pond to dam to abutment to building. It was not a building simply imposed on a place; it became the place, and thereby deserved its being, an elegant offering paid for the use of a stream. Its sureness made other buildings look haphazard.

I cannot convince myself that settlement, even the most economical, the most beautiful, is better than wilderness. Even the mill is not better than no mill; but the mill is necessary for our existence, and therefore worthwhile. It is an image that keeps returning, proof that use of the earth need not be destructive, and that architecture can be the ameliorative act by which, in thoughtfulness and carefulness, we counter the destructive effect of construction. Nothing else is architecture; all the rest is merely building.

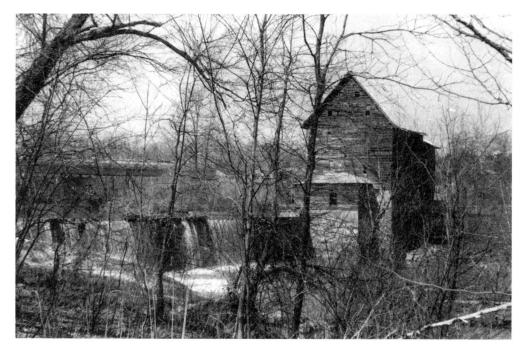

Byrd Mill, Louisa County, Virginia, 1740

The American landscape is being sacrificed to building. The result is dismal, adding up to nothing satisfactory or significant except as an accurate self-portrait of our cultural and ethical dissolution. This is an observation neither rare nor subtle. The condition is one that we all see and feel daily, one that we abhor yet perpetuate, a senseless spread of profit-motivated building that has none of the good characteristics of a settlement, and looks remarkably more like a midway, rootless and designed to be put up anywhere. The comparison becomes more apt with the realization that most of the things built are unnecessary.

Settlement implies a benign and sympathetic occupation, the selection of a specific and favored place, and the engagement of that place to economical use; settlement is the establishment of home. Our growth is the opposite of settlement. We have forgotten the rule that the use of a place must

not be separate from the abiding in it; we are intent on uses so disrespectful and unnecessary that the place becomes unabidable.

And it is not so surprising that a culture such as ours, preoccupied with the notion of a heaven hereafter, would abuse its landscape. How can Eden be properly cared for if it has already been abandoned for a deferred paradise for which the earth is a mere staging area? When a land is removed from worship it is no wonder that conscience regarding the use of that land is profoundly deficient. We have no sacred places. We have no Delphi. Where there was once spirit, in the Serpent Mound, in the kiva, there is only curiosity, the haunting relics of an earthbound reverence.

Nor is it surprising that a culture which has traditionally thought of the rural as good and the urban as bad would insist on populating the former until it is no longer there. We fail to recognize that cities and towns by their very conciseness are great acts of conservation, and that they alone offer any hope of protection of the land. We fail to realize that good cities have distinct edges, whether natural or designed, and furthermore that the placement of cities, their allegiance to the natural setting, is as important as that of the built form. Like the mill on the stream, a city must engage its place and replace loss with offering.

The sickness of the heart that I believe we all feel when we see development spreading from every town into the country is the recognition that our settlement represents not only lost nature but lost settlement. What home have we made? Given a new world, we have let the land degenerate into real estate, and architecture into style. The implication is frightening: that we don't belong here, that we are no longer of the land but on it, a lost colony in a lost paradise.

Yet that very sickness of heart and its universality is hopeful; it is what has always spurred reformation. When we build, we ought not to ignore it but let it guide our efforts. We ought to keep before us the images of settlements that have successfully established a reverence for a place necessary to the making of a collective home.

I like to read Thoreau, especially his chapter called "Economy," because of his terrible, thoughtful struggle with the matter of building. At first he seems to be only carefully constructing a house. His consideration seems failed, doomed, artificially precious out there in the woods by the pond. But

gradually I see the care with which he builds, not just a grudging, tightfisted building, but one imbued with the most luxurious and deep images. He is not a dirt dauber, locked only in the immutable pattern of his genes, but a sentient, worried, thoughtful being, determined to be at one with his place, and not knowing how; drawing profound analogies to nature, to the elements, and to his curious earthly existence with every act of building, looking finally not for a way out of the forest but for a way to stay there with grace. All of which is simple for the dauber, and not too hard for the primitive human mind, but extraordinarily difficult for Thoreau's great intelligence.

I think it will always be difficult to build; it should be difficult. We cannot always succeed and sometimes will not even recognize our own success or failure. But we want to stay with grace, and therefore do what we can, whether we are making a tiny house in the woods or a great city. Our gradual understanding is that we are not real colonists, with our home elsewhere. Our home is here, and what we build will be its parts.

Note

A version of this essay was originally published in Richard Jensen, *Clark & Menefee* (New York: Princeton Architectural Press, 2000). Reprinted with permission.

Contributors

TIMOTHY BEATLEY is Teresa Heinz Professor of Sustainable Communities in the Department of Urban and Environmental Planning at the University of Virginia, where he has taught for the last twenty years. Professor Beatley holds a PhD in city and regional planning from the University of North Carolina at Chapel Hill. His recent research investigates creative strategies by which cities and towns can reduce their ecological footprints while at the same time becoming more livable and equitable places. He has published extensively, including the following books: *The Ecology of Place* (1997, with Kristy Manning), *Natural Hazard Mitigation* (1999, with David Godschalk and others), *Green Urbanism: Learning from European Cities* (2000), *An Introduction to Coastal Zone Management* (2002, 2nd ed., with David Brower and Anna Schwab), and *Native to Nowhere: Sustaining Home and Community in a Global Age* (2004).

THOMAS BERDING received a BA from Xavier University, and an MFA from Rhode Island School of Design. He is currently associate professor of painting and chair of the Department of Art and Art History at Michigan State University. In addition, he has served as a visiting artist at a number of institutions and has previously held academic appointments at Dartmouth College, Indiana University, and Southwest Missouri State University. An exhibiting artist, he has received awards from the National Endowment for the Arts and the Pollock-Krasner Foundation.

W. G. CLARK graduated from the University of Virginia School of Architecture in 1965 and began his practice in Charleston, South Carolina, in 1974. He is the

recipient of three American Institute of Architects National Honor Awards, for the design of Middleton Inn, the Reid house, and the Croffead house in Charleston. He has won several national design competitions, including the New Orleans Museum of Art in 1983, the South Carolina Aquarium in 1987, and the Clemson Architecture Center in Charleston in 2005. His work has been published extensively here and abroad. He joined the faculty of the University of Virginia as chair of the architecture department in 1989 and now holds the Edmund Schureman Campbell Chair of Architecture. His professional firm, W G Clark Associates, is located in Charlottesville.

NATHANIEL COLEMAN received his BFA and BArch degrees from the Rhode Island School of Design, a master of urban planning degree from the City College of New York, and MSc and PhD degrees in the history and theory of architecture from the University of Pennsylvania. He has practiced architecture in New York and Rome. He is currently Senior Lecturer in Architecture at Newcastle University, UK, where he has also served as director of the architecture program. He previously taught in the United States, including at the University of Pennsylvania, the Boston Architectural Center, and Washington State University. He is a recipient of a Graham Foundation grant and three British Academy research grants. His first book, *Utopias and Architecture*, was published in 2005.

PHOEBE CRISMAN is an associate professor of architecture at the University of Virginia and a practicing architect and urbanist with Crisman+Petrus Architects. She received a BArch from Carnegie Mellon, an MArch in urban design with distinction from Harvard University, and a Netherlands-America Fulbright Fellowship. She is the recipient of numerous awards, including the AIA Education Award, ACSA Collaborative Practice Award, NCARB Prize, and EDRA/Places Planning Award. Crisman has lectured and published on sustainable architecture and urbanism; fragmentary and overlooked places, processes, and materials; and relationships between architectural theory and design practice. Her writings have appeared in *Journal of Architecture, Places*, and *Journal of Architectural Education*.

ROBIN DRIPPS is the T. David Fitzgibbon Professor of Architecture at the University of Virginia, where she has taught for more than thirty years. During that time she was chair of the Department of Architecture and founding director of the Program in American Urbanism. The ACSA recognized her outstanding teaching with the Distinguished Teaching Award. Ms. Dripps received her BA in architecture from Princeton University and her MArch from the University of Pennsylvania.

Her book, *The First House: Myth, Paradigm, and the Task of Architecture,* received a Phi Beta Kappa book award. Recent essays include "Groundwork," in *Site Matters,* and "Constructing the World," in the *Humanities and Technology Review.* Her architecture has been published and exhibited in Europe, Asia, and America. As part of her research into materials and fabrication, Professor Dripps has designed and driven a vehicle that holds a current world land speed record.

SANDA ILIESCU is a practicing artist and associate professor of art and architecture at the University of Virginia. She holds a BSE in civil engineering and an MArch, both from Princeton University. Her awards include the Distinguished Artist Award of the New Jersey State Council of the Arts, a Graham Foundation grant, and the Rome Prize. Iliescu's paintings, drawings, and collages have been exhibited in New York, New Jersey, North Carolina, and Italy. Her artwork is represented by Vagabond Gallery in New York City. Iliescu's recent writing focuses on collage as an interdisciplinary concept with the potential to connect and expand ideas in contemporary art, architecture, and landscape architecture. Her recent publications include "The Garden as Collage," in *Studies in the History of Gardens and Designed Landscapes,* and "Beyond Cut-and-Paste," in *Places.*

STEVEN A. MOORE is the Bartlett Cocke Professor of Architecture and Planning at the University of Texas at Austin, where he teaches design and courses related to the philosophy, history, and application of technology. Moore is director of the graduate Sustainable Design Program and formerly codirector of the Center for Sustainable Development. He received his undergraduate degree in architecture at Syracuse University, his PhD at Texas A&M University, and is a Loeb Fellow of the Harvard Graduate School of Design and a Fellow of the National Endowment for the Arts. As the design principal of Moore/Weinrich Architects in Maine, he has received numerous distinguished awards. He has published articles in national and international journals. His books include *Technology and Place* (2001), *Sustainable Architectures* (with Simon Guy, 2005), *Alternative Routes to the Sustainable City* (2007), and *Philosophy and Design* (with Peter Kroes, Pieter Vermaas, and Andrew Light, 2008).

JOAN OCKMAN was director of the Temple Hoyne Buell Center for the Study of American Architecture at Columbia University from 1994 to 2000. She has taught architecture history and theory at many schools in the United States and Europe. She holds an undergraduate degree in literature from Harvard University and a professional degree in architecture from the The Cooper Union. In 2000 she edited

The Pragmatist Imagination: Thinking about Things in the Making in conjunction with an international conference at New York's Museum of Modern Art. The *New York Times* selected Ockman's edited volume *Out of Ground Zero: Case Studies in Urban Reinvention* as a best architecture book of 2002. Her prize-winning book *Architecture Culture, 1943–1968: A Documentary Anthology* appeared in its fourth edition in 2005.

ELISSA ROSENBERG is an associate professor in landscape architecture at the University of Virginia. She received a BA from the University of Toronto and an MLA from Cornell University. She was a visiting professor at the Technion Institute, Israel (1996–98), and served as chair of the Department of Landscape Architecture at the University of Virginia from 1998 to 2002. She has written on a variety of urban issues such as space and gender in the work of Jane Jacobs, and the relationship of landscape architecture, ecology, and engineering in the city. Her chapter in this volume is part of a larger project on memory and regeneration in contemporary landscape architecture.

WILLIAM SHERMAN received a BA in architecture and urban planning from Princeton University and an MArch from Yale University. He is a practicing architect and associate professor of architecture at the University of Virginia, where he also served as the first chair of the newly merged Department of Architecture and Landscape Architecture. He has taught at Rice University and the University of Miami. His work has been published in *Progressive Architecture* and *Architecture* magazines as well as in the journals *Details* and *Ottagono*. His research and teaching investigate relationships between building design, climatic forces, and cultural qualities of urban forms, with a focus on the multiple, intertwined roles of the building envelope.

RICHARD SHUSTERMAN received a BA and MA in philosophy from the Hebrew University of Jerusalem, and a DPhil in philosophy from St. John's College, Oxford University. From 1998 to 2004 he served as chair of philosophy at Temple University, and was then appointed the Dorothy F. Schmidt Eminent Scholar in the Humanities of Florida Atlantic University, Boca Raton. Author of *Practicing Philosophy* (1997), *Performing Live* (2000), *Surface and Depth* (2002), *Body Consciousness* (2008), and *Pragmatist Aesthetics* (2nd ed. 2000; translated into twelve languages), he is editor of *Analytic Aesthetics, Bourdieu: A Critical Reader,* and *The Range of Pragmatism and the Limits of Philosophy.* He has received senior Fulbright, NEH, and Humboldt research fellowships and other academic honors.

HOWARD SINGERMAN is associate professor of art history at the University of Virginia and the author of *Art Subjects: Making Artists in the American University* (1999). He has contributed essays to numerous exhibition catalogs, among them the retrospective surveys of Chris Burden, Mike Kelley, and Allen Ruppersberg. His essays and criticism have appeared in a number of journals and magazines including *Artforum, October, Oxford Art Journal,* and *Parkett.* Before coming to Virginia, he taught at Barnard College, the California Institute of the Arts, and UCLA, and was museum editor for the Museum of Contemporary Art, Los Angeles.

Illustration Credits

Scala/Art Resource, NY. **Page 108:** Archives du Collège de France. **Page 110:** Civico Museo d'Arte Contemporanea, Collezione Jucker, Milano. **Page 111:** Uffizi, Florence; photo, Erich Lessing/Art Resource, NY. **Pages 112, 113:** Courtesy of Zaha Hadid Architects. **Page 127:** Photo by Nathaniel Coleman, © 2007 Artists Rights Society (ARS), NY/ADAGP, Paris/FLC. **Pages 128, 130:** Photo by Nathaniel Coleman. **Page 131:** Photo by Hannie van Eyck. **Page 139:** Private collection; courtesy Lucian Freud. **Pages 144, 145:** © Terry Winters, courtesy Matthew Marks Gallery, New York; photo by Lawrence Beck. **Page 146:** Collection of Clifford P. Diver, Lewes, Delaware; © Jessica Stockholder; courtesy Mitchell-Innes & Nash, New York. **Page 147:** © 2007 Succession H. Matisse, Paris/Artists Rights Society (ARS), NY; photo © The Museum of Modern Art/Licensed by SCALA/Art Resource, NY. **Page 148:** The Museum of Modern Art, New York, © The Estate of Philip Guston. **Page 176:** Sketch by William Sherman. **Page 178:** Leigh Herndon and William Sherman: graphite drawing/ digital collage based on Le Corbusier; courtesy Artists Rights Society (ARS), NY/ADAGP and Fondation Le Corbusier, Paris. **Page 181:** Graphite drawing/digital collage, Leigh Herndon and William Sherman. **Page 182:** Graphite drawing, Leigh Herndon and William Sherman. **Page 188:** Courtesy Donald Carlson. **Pages 192, 197, 199:** Photo by Tim Beatley. **Page 194, 195:** Courtesy Michael Singer; photos by David Stansbury. **Page 201:** Photo by Sanda Iliescu. **Page 208:** Photo by Elissa Rosenberg. **Pages 211, 213, 217, 218:** © Michael Latz. **Pages 214, 220:** © Christa Panick. **Page 222:** © Peter Schäfer. **Page 224:** © Latz + Partner. **Pages 232, 238, 240, 246, 247:** Photo by Phoebe Crisman. **Pages 234, 235, 249:** Courtesy of the North Adams Historical Society. **Pages 243, 251:** Photo by Michael Petrus. **Page 245:** Solomon R. Guggenheim Museum, New York, Panza Collection, 1991, © 2007 Robert Morris/Artists Rights Society (ARS), NY; photo by Michael Petrus. **Page 256:** Artists Rights Society (ARS), NY; photo, Erich Lessing/Art Resource, NY. **Page 258:** Photo, Scala/Art Resource, NY. **Page 263** (Matisse): Courtesy of Xavier-Gilles Néret. **Page 263** (Marden): Photo by David Seidner. © International Center of Photography, David Seidner Archive. **Pages 264, 267:** Sketch by Sanda Iliescu. **Page 265:** Courtesy of Sol LeWitt. **Page 266:** Courtesy of Sol LeWitt and the Addison Gallery of American Art; photo © Richard Cheek. **Page 268** (Crampton): From *The Natural Way to Draw* by Kimon Nicolaïdes (Boston: Houghton Mifflin, 1941). **Page 268** (Brancusi): Musée national d'art moderne, Centre Pompidou, Paris; © Artists Rights Society (ARS), NY; photo, CNAC/MNAM/Dist. Réunion des musées nationaux/Art Resource, NY. **Page 270:** Courtesy of Sol LeWitt and the Addison Gallery of American Art; photo by Jock Reynolds. **Page 274:** Collection of Sol LeWitt; courtesy of Sol LeWitt. **Page 275:** Collection of the Museum of Fine Arts, New Mexico; gift of Lucy R. Lippard, 1999; courtesy of Sol LeWitt. **Page 281:** Courtesy of the Library of Virginia.

Index

abstraction and modern architecture, 116–33, 156; abstraction as "the unveiling of relationships that carry a charge," 120–21; Adorno and abstraction's subversive power, 156; Amsterdam Orphanage (van Eyck), 129–33, *130, 131;* architecture's emotional function, 122–23; contemporary "meaningless" architecture, 116; Convent of La Tourette (Le Corbusier), 124–27, *126;* extreme aesthetic autonomy and its "diminished" architecture, 117–20; influence of modern art on architecture, 117, 120–24; rationalist vs. "humane" modern architecture, 116–17; Salk Institute (Kahn), 127–29; social function and architectural beauty, 118–19. *See also* ethics and aesthetics, dialectic between in modern architecture

Adorno, Theodor: *Aesthetic Theory,* 156; autonomy of art, 46, 85–87, 156; theory called "backward," 156–58

advertising, 19, 20, 257, 276

aesthetic and ethical convergence, philosophy of. *See* convergence of ethics and aesthetics, philosophical roots of the argument

Albers, Josef and Annie, 16

Alberti, Leon Battista, 119

Altieri, Charles, 11, 18, 63–64

architectural preservation. *See* MASS MoCA

architecture and land use in America, 279–83

architecture and sustainability, 153–68; Adorno's aesthetic realm set apart from society, 156; the four points of design (Moore), 166–67; history of architecture licensure laws, 153–54; importance of aesthetics to sustainability, 165–66, 168; need for balance between pursuit of theory and action, 167–68; the planner's triangle (Campbell), *164–65;* pragmatism vs. relativism, 154; pragmatist critique of aesthetic autonomy, 153–58; roots of sustainability theory in philosophy, physics, biology, politics, economics, public health, 158–63; sustainability's future in architecture, 163–68. *See also* sustainable cities